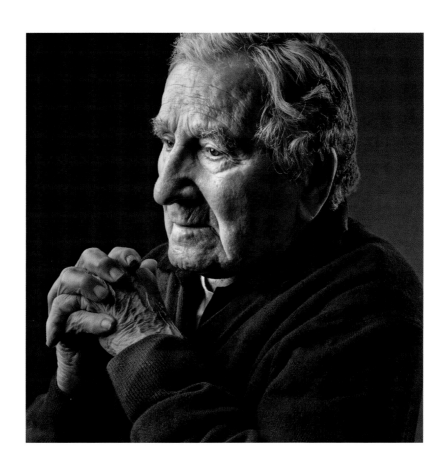

If I Live to Be 100

THE WISDOM OF CENTENARIANS

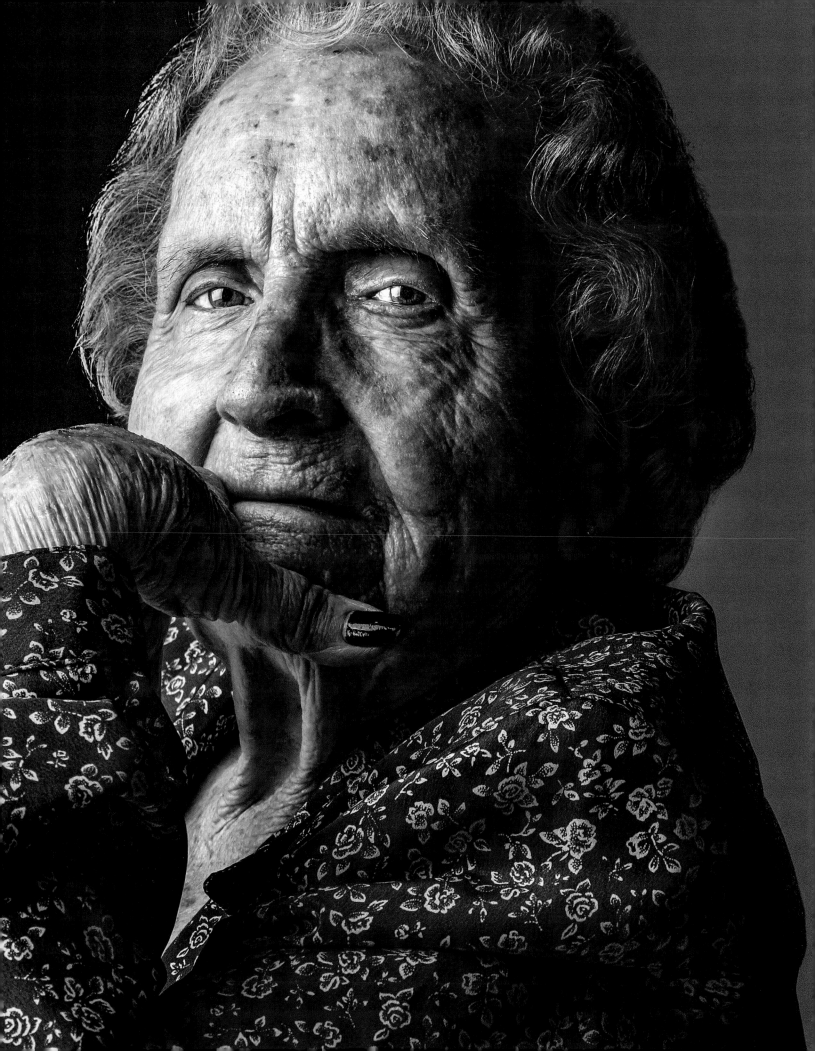

If I Live to Be 100

The Wisdom of Centenarians

Portraits by Paul Mobley

Interviews and Essays by Allison Milionis

Foreword by Norman Lear

welcome
BOOKS

CONTENTS

PAGE 1: Irving Phillips, born October 10, 1914, photographed in Los Angeles, California, at age 101.

PAGE 2: Doris Barrett Smith, born May 21, 1907, photographed in Hillsboro, Ohio, at age 102.

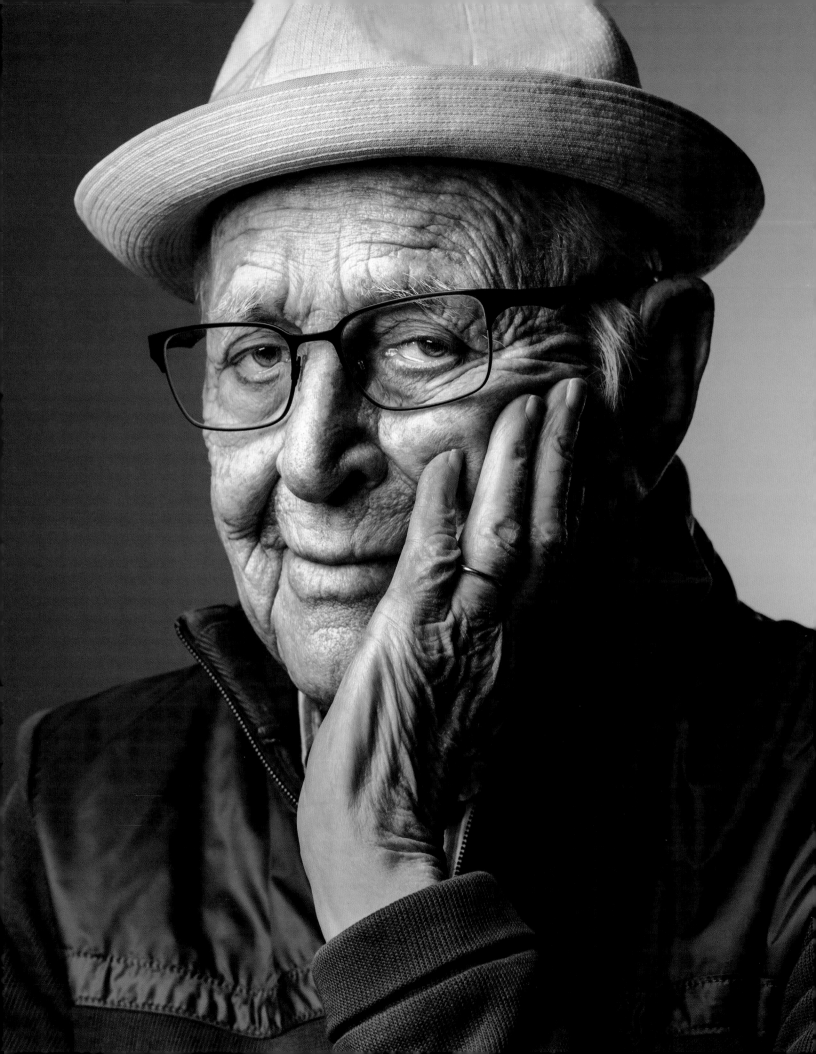

FOREWORD

Norman Lear

WHEN I WAS IN FIRST GRADE I FOUND THAT I COULD TURN my eyelids inside out. There was another kid in my class who was a bit of a bully, but he stopped harassing me—and protected me from other harassers—when my trick made him giggle. I did it only once a day and just for him. At six years of age, I'd discovered the power of laughter.

Now, at ninety-four, I look back with a smile at such memories. Thirty-four years ago, at sixty, I expressed it in my notes this way: "I'm very interested to see what kind of an old man I'll be. I don't want to rush it, but I approach that period with considerable interest."

Twenty years before that, at forty, I thought I'd be an old man when I reached my seventies. But by the time I reached sixty, I figured I wouldn't dodder until perhaps my eighties.

The big surprise to me is that the dodderer has yet to arrive, and that today I still don't feel old. I continue to look down at my arm as I peck away at the computer and wonder what my father's hand is doing hanging out of my sleeve. Maybe the fact that I've been thinking about longevity as far back as I can remember has something to do with it. At twelve, I had a giant shock of black hair so thick that I had to wash it daily in order to comb and brush it, and then apply a hairdressing called Slickum. One day I thought, "What if this is the secret to a long life, washing your hair at the same time every morning?"

From that moment to this there have been dozens of other odd activities that have caused me to ask myself the same question. Most people shower in the morning or before they go to bed. I shower only when the thought of getting all wet appeals to me, and that could happen at any hour of the day or night. How do we know that that—showering irregularly and only on impulse—isn't the secret to longevity? There isn't a single piece of scientific evidence to challenge that possibility.

The same is true of a kid who, in his teens, then in his thirties, his fifties, later in his eighties, and now in his nineties, frequently finds himself dancing to music in front of a full-length mirror, absolutely and ridiculously naked. There is no guarantee that three minutes of such buck-naked tomfoolery does not add a decade to one's time here. Has any parent, any professor, any scientist ever proven that dancing nude before a mirror does not add years to your time on this planet? Case closed.

But, fanciful guesses aside, I believe—as did Norman Cousins, whose book *Anatomy of an Illness* chronicled how his watching the Marx Brothers and *Candid Camera* reversed the progress of a degenerative disease—that one of the most effective life extenders is laughter. No wonder so many hospitals and ambulatory care centers have incorporated special rooms where materials—and sometimes people—are there to help make people laugh.

My experiential guess is that a good laugh can add four to twelve seconds, perhaps a full minute, to one's life. And while my habits of getting regular exercise and eating healthily are likely to have contributed, I give even greater credit for my longevity to how hard and often my risible has been tickled. For me, it could have been anything from a slapstick scene in a Laurel and Hardy film to an exchange by Noël Coward to any given moment I'm living that reflects the foolishness of the human condition.

Before my tenth birthday my father was arrested for selling phony bonds and was sent to prison for three years. My mother, unable to bear the idea of continuing to live among our neighbors in such disgrace, instantly decided that we had to move to another city, and she opened our home to let friends and relatives purchase our possessions. As I watched a stranger buy my father's

"My experiential guess is that a good laugh can add four to twelve seconds, perhaps a full minute, to one's life."

living room armchair, someone—maybe an uncle, maybe a neighbor, but definitely a horse's ass—placed his hands on my shoulders, looked deep into my eyes, and declared somberly, "Remember, Norman, you're the man of the house now." Then, noticing the tears I was fighting to hold back, he added, "No, no, son! A man of the house *doesn't cry*!" This had to be the moment when my awareness of the foolishness of the human condition—the absurdity that accompanies the gravity of our existence—was born.

I've never been in a situation since—however serious, fictional, or otherwise—where a hint of humor didn't serve to elevate an empathetic reaction. A good laugh, like an intravenous, can carry an otherwise unwelcome thought or emotion to the very heart of a viewer or an audience. And there is nothing more rewarding than to stand behind an audience when they are experiencing comedy that way and laughing from the belly. They tend to come out of their chairs in unison, fall forward, and rise back up—a swelling wave of bodies in ecstasy.

It has been my privilege to have experienced that thousands of times, and that is why I think this: If my fates originally saw me leaving this earth long before I turned ninety-four, it's because they weren't informed that I was going to be involved with the likes of Martha Raye, Dean Martin and Jerry Lewis, Carroll O'Connor and Jean Stapleton, Sherman Hemsley and Beatrice Arthur, Redd Foxx and Louise Lasser—to name just a few of those who made their audiences and me belly laugh together. With their truth-seeking madness, these people were adding time to my life.

So, here I am in my nineties. I don't walk as sturdily as I did, I have aches and pains I choose not to dwell on, and I am well aware of my mortality. Despite these physical realities, and however old I may look, I do not feel like an old man. I feel more like your peer. Whether you are fifteen, thirty-five, or seventy, I am your peer.

For all I've lived through in my nine-plus decades, I still have a lot to learn. Paul Mobley's portraits show the true heart and soul of his noble subjects, and I'm sure a good deal of what I'm lacking I'll find in his gorgeous book.

INTRODUCTION
Allison Milionis

On a warm spring day, I paid a visit to Irving Olson at his elegant apartment in a beautifully landscaped retirement village outside Tucson, Arizona. When I arrived, Irving was sitting at his desk in his office, working on one of his unusual photographs of colorized water drops. I didn't need a formal introduction; we were already Facebook friends.

At 102 years old, Irving continues to experiment with photography. He's no less interested in creating than he was the first time he picked up a simple Brownie camera as a boy. Before I met him, I didn't think a person could or would want to make art beyond the century mark. Nor, for that matter, could I imagine a centenarian swimming a quarter mile, which is what Margaret Wachs did to celebrate her 100th birthday. I didn't dream anyone was still driving at 100 years—that's how Orlando Ricci gets around town—or ballroom dancing, like Alice Sumida. Clearly, my view of life after 100 was limited. But that has changed. Midway through my first interview for this book, I realized I was on the cusp of something great and I was about to be schooled in the game of life.

With each conversation, it became evident that life has no guarantees and we will undoubtedly be challenged. There is no sure path, roadblocks are plentiful, and with love comes pain. Several centenarians featured in this book survived the horrors of World War II: as a young woman, Frieda Roos-Van Hessen hid from the Nazis for four years, and most of her family perished in Auschwitz. Eli Zebooker was in a US military unit that arrived at Dachau immediately after World War II ended. He was the first dentist to examine survivors of that notorious concentration camp.

In the United States, African Americans endured terrific injustices and struggles for equality. Walter Jackson received death threats for being the first African American to be elected to the school board of trustees in Vero Beach, Florida, and Audrey James's application to nursing school was denied because of her race.

Yet in every conversation with these wise centenarians, no matter what they had encountered and survived, I heard stories of resilience and hard work. I sensed inner peace and heard profound expressions of gratitude for family and friends and the opportunity to witness a century in flux. And what a century to witness! For those born at the end of the nineteenth century, the teen years came just as Ford Motor Company introduced the assembly line. The *Titanic* sank the same year Besse Cooper turned sweet sixteen. When World War I broke out in 1914, Walter Breuning had just turned eighteen. That was the same year the Panama Canal opened. A year later, the suffrage movement inspired tens of thousands of women to flood Fifth Avenue in New York City, demanding the right to vote. By then, Edna Parker, born in 1893, was a young woman.

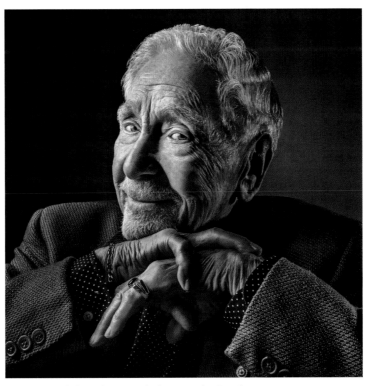

Jack Sokolov, photographed in Overland Park, Kansas, at age 100.

Of all the early twentieth-century events, the Great Depression seemed to make the deepest impression. Jack Sokolov still regrets that he wasn't able to attend a university and get a degree. Seymour Cohn had to drop out of school because his family couldn't afford tuition, and Claire Morrison's family had to move to New Orleans for her father's work. She and her siblings also took jobs to help keep the family afloat. Vernon Zickert remembers how he socked away 200 dollars in the bank, only to get seventy dollars back when he took a withdrawal.

When asked to describe the most memorable events, however, nearly every person said it was their wedding day, a vacation, or a moment in time when they were surrounded by family or friends. Indeed, memories of children, laughter, music, and love rose above the clang and clatter of industrial and technological evolution. Sure, the moon landing was amazing to watch on television, but those horse-drawn buggy rides to elementary school, thrilling first dates at the town movie house, big family dinners, or early morning farm chores—those were the memories that lasted and made the best stories.

Paul Mobley's portraits so beautifully tell a big part of the story. Note the distinctive lines around the eyes and mouths, the tilt of the head, or the position of the hands—each portrait is as complex as the 100 years lived. Yet in them we recognize love, loss, hope, and grief, and we're reminded that they are the essential ingredients of a full life.

Near the end of this project, I attended a 100th birthday party for my great-aunt Queveene. By then I'd spoken to dozens of centenarians. Still, I was in awe of her age and her demeanor. I watched her graciously accept her guests and laugh at silly jokes about the historical events she had witnessed. I thought if I live to be 100 I hope to exude the same ease and sense of peace. I know it's not something that comes easy, but it certainly reflects a life lived long and well.

"I'm just a kid from Jersey City."

HOWARD MUNCE

Westport, CONNECTICUT
November 27, 1915

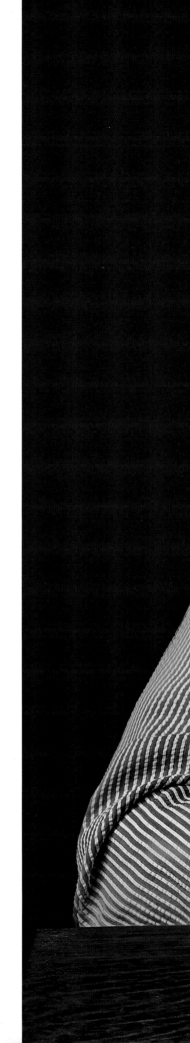

WHEN HOWARD MUNCE WAS A YOUNG MAN IN SCHOOL, a teacher saw something special in him. He wasn't particularly interested in academics, but Howard could draw and he liked art. His teacher encouraged him to do more of it, and he has never stopped. Howard's home in Westport, Connecticut—the one he shared with his beloved wife, Geraldine (Gerry), for more than fifty years—is filled with his illustrations, drawings, paintings, sculptures, essays, and poetry. Indeed, Howard has been prolific, indefatigably expressing his thoughts and observations through his art and writings for a century.

If the teacher who recognized Howard's talent hadn't encouraged him, there's no telling how Howard would have found his way to a creative career. At home in New Jersey, where he was raised by his grandparents, such pursuits were not considered a viable means of earning a living—making art was a luxury. But Howard marched to the beat of his own drum, and after high school he applied and was accepted to Pratt Institute of Art in Brooklyn. He moved in with relatives in Westport and commuted into the city for classes. He met others who shared his passion and made lifelong friends. By the time he graduated in 1939, Howard had blossomed into a confident artist.

But then World War II broke out and Howard's plans were temporarily stymied. He enlisted in the Marine Corps and was stationed in the Pacific for three and a half years, rising to the rank of first lieutenant. Still, Howard didn't stop drawing. He sent illustrations and letters from theaters all over the Pacific to his good friend and fellow artist Steven Dohanos. The drawings were later donated to the New Britain Museum of American Art's military collection, and Howard was recognized as a veteran artist in the documentary film *Art in the Face of War*.

Howard returned to the United States at the end of 1945 and for a while took temporary jobs in various agency art departments in New York City. At the same time, he wrote a column and articles for the *Westport News,*

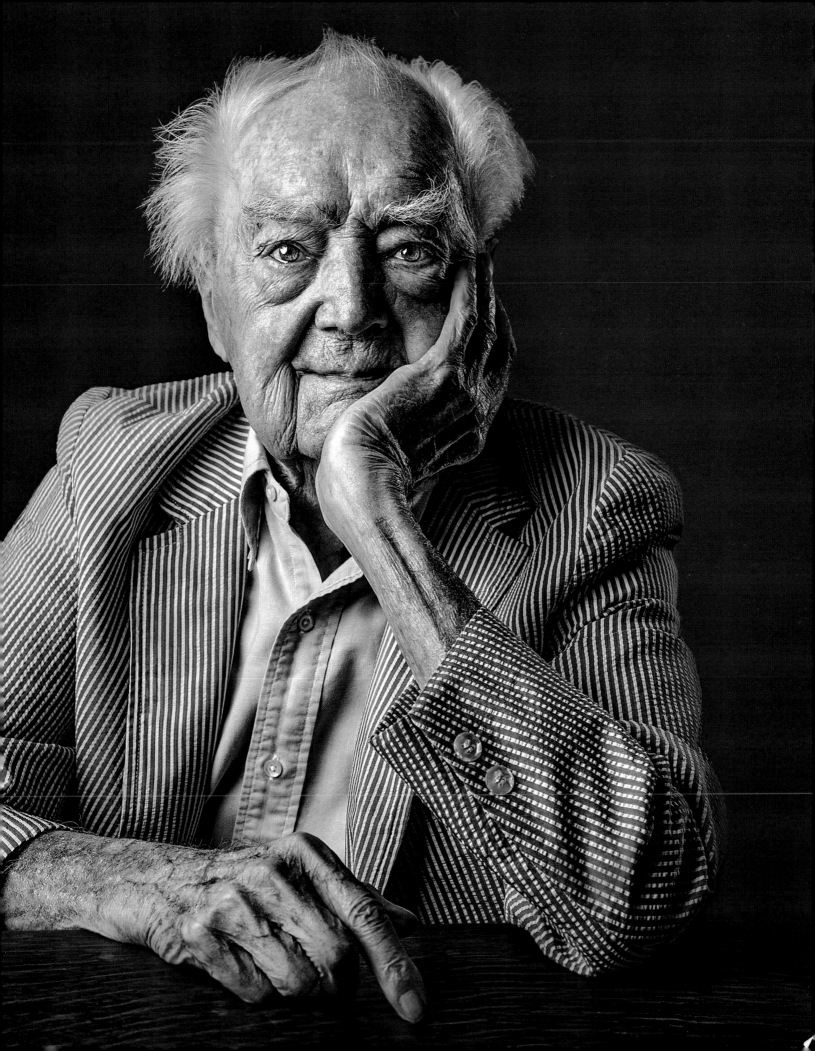

one of which was nominated for a Pulitzer Prize. His time in the Pacific had made him realize the true cost of war; this realization followed through in his writing and art for several years. In the summer of 1947, Howard moved to East Hampton, New York, to study with painter Julian Levi and, in passing, became friends with Jackson Pollock's pet crow (Jackson was also a neighbor). The experience made a profound impression on Howard. The two artists developed a friendship and, over the years until Julian's death in 1982, Howard often visited his mentor in the Hamptons or at Julian's city apartment.

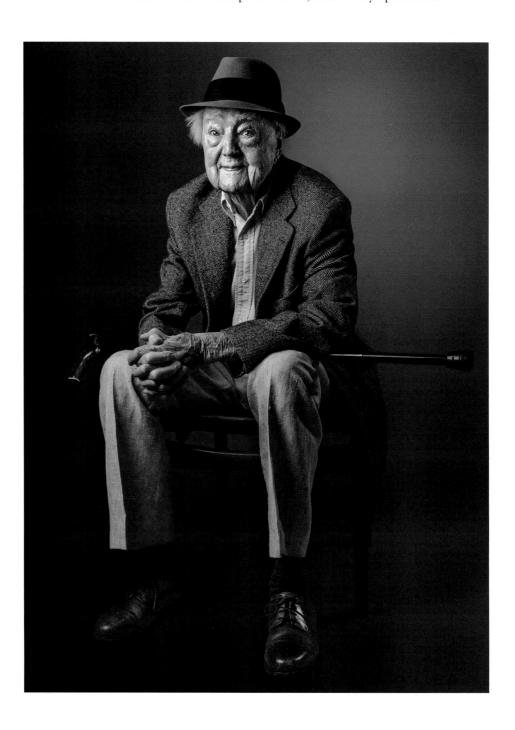

In 1949, Howard landed the job that set his career trajectory: copywriter at the highly respected New York agency Young & Rubicam. Although he was trained as an artist, Howard was an equally clever and accomplished writer. He had taken the position to get his foot in the door, and it wasn't long before he was promoted to creative director. He also had the good fortune of meeting Gerry at Young & Rubicam. She was head of the secretarial pool. "I think for my dad it was love at first sight," said Mary, Howard's daughter.

Howard and Gerry married in 1950 and had their first child, Andrew, a year later. They remained in New York City for a few years, but eventually moved to Westport shortly after Mary was born in 1954. Howard started commuting into the city again. In spite of the long days and hour-long commute each way, he loved the routine. Howard's last position before he became a freelancer was at Foote, Cone & Belding, where he was the creative lead on the Rheingold Beer account for a number of years.

In the late 1960s, Howard and Gerry remodeled their home, creating an art studio. Howard once told a reporter that he had a "deadline" side of his studio where he did his commercial work, and he reserved the other side for his own art. Although he stopped commuting into the city on a daily basis, he continued freelancing for a number of agencies, as well as creating cartoons for newspaper columns, serving as art director for a corporate magazine and a graphic arts publication, and curating a number of corporate art collections— including GE in Fairfield, Connecticut, Marketing Corporation in Westport, and the Westport Library collection. He wrote and illustrated his own book, *Sounds from the Bullpen*, and edited many others. Howard also taught at the Paier College of Art in Hamden and at Fairfield University. When most men would retire, he returned to creating sculptures, participating in sketch classes with friends, and curating exhibitions. He has never slowed down. "My father is really quite something," said Mary. "Nothing really gets in his way of doing what he wants to do."

Howard is still a leader and celebrated member of his local arts community. In 2015, the Westport Historical Society honored him for his many contributions. *Howard Munce at 100: A Centennial Celebration* was dedicated to Gerry and curated by fellow Westport illustrator and author Leonard Everett Fisher. The exhibition was divided into two parts: one to showcase Howard's work, the other to chronicle his long creative career and life.

Howard doesn't have any regrets about his life. It has been a fulfilling century, and he has been surrounded by a loving family, good friends, and his art. Still, he often wonders how he has lived such a long life. "I'm just a kid from Jersey City," he said.

WALTER JACKSON

Vero Beach, FLORIDA
December 9, 1903

WALTER JACKSON GREW UP IN Indian River County, Florida, and spent most of his life there. He experienced poverty and segregation as a child, and racism throughout most of his life, but Walter always looked for the best in every situation.

Walter was the oldest of six children. His father worked as a "grubber," a laborer who used a grub hoe to work the fields. Although Walter was interested in receiving a good education, the opportunities for an African American boy in the segregated South were limited. As a child, he attended elementary school during the summer and spent the rest of the year doing farm work. When his father unexpectedly passed away in 1924, Walter took over most of the responsibilities on the family's homestead and also picked up work as a grubber, like his father, earning seventy-five cents a day.

Although there was very little time to study, Walter's mother believed education was essential to their future, so she encouraged her children to pursue their schooling. By sharing the responsibilities at the homestead with his siblings, Walter was able to receive a formal high school education at Edwards Waters College in Jacksonville, with help from the African Methodist Episcopal Church. All of his siblings, except one, followed in his footsteps.

After graduating, Walter took a job with a local citrus grower. Several years later, using what he learned about growing citrus and the industry, Walter and his brother Theodore purchased a few acres and planted their first trees. "We figured if we could do it for someone else, we could do it for ourselves. So we set out to do it," Walter told a reporter in 2005.

For many years, the brothers invested in land and trees. By the 1950s, they had established a good-size, highly reputable citrus grove. They also invested in real estate and retail and were increasingly involved in civic organizations. Walter was the first African American to be elected to a public position in Indian River County as a member of the school board of trustees. He served on the Vero Beach Chamber of Commerce for three years, was a PTA member, volunteered for Habitat for Humanity and Meals on Wheels, and was a lifetime member of the NAACP. As if he wasn't busy enough, Walter was also active in his church as a trustee, choir member, and Sunday school teacher.

Walter was married to Mary, a teacher, for more than thirty years before she passed away in 1973. They had a son, Thomas, who became a respected cardiologist in Vero Beach, Florida. Walter married his second wife, Ossie, in 1977. She passed away in 2005, and Thomas died of cancer at the age of fifty-six.

Walter used to say it had been a difficult life, but he thoroughly enjoyed the work. Near the end of his life he was buoyed by Barack Obama's presidential campaign. "He never dreamed in his life he'd see an African American president," said Ronald Hudson, one of the young men inspired by Walter's leadership in the community. "I think it was a reinforcement to his belief that if you work hard and are committed, you can be what you want to be."

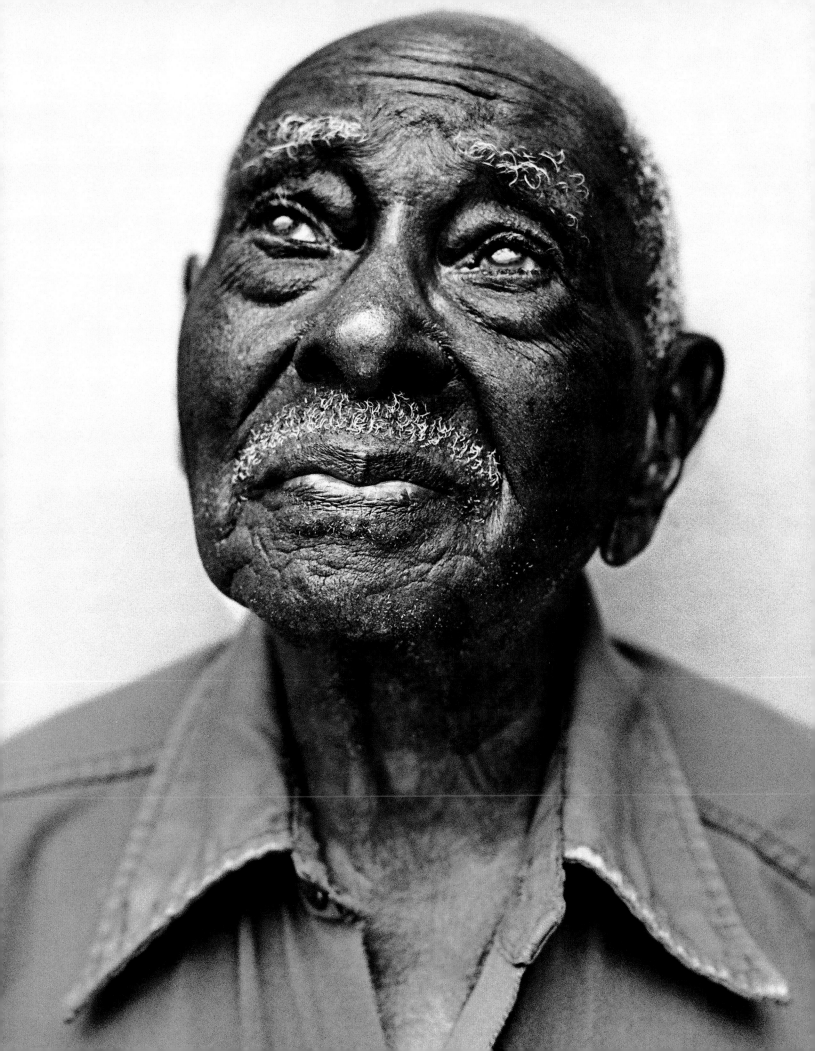

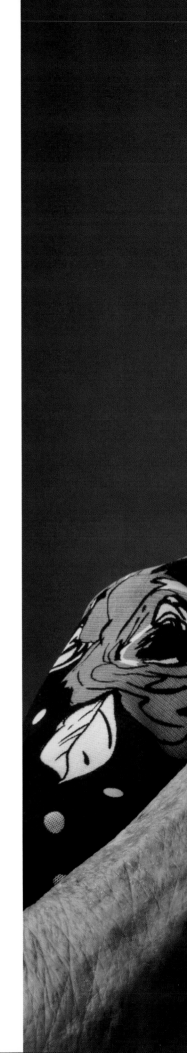

MARIE CASSADY

Louisville, KENTUCKY
December 8, 1912

I T WAS TWENTY-SIX DEGREES BELOW ZERO THE NIGHT MARIE CASSADY entered the world. The wind was biting and the snow was piled high in the Minnesota countryside where her parents lived. But Marie survived her chilly entrance into this world and, perhaps, it better prepared her for the highs and lows that are guaranteed in a long life.

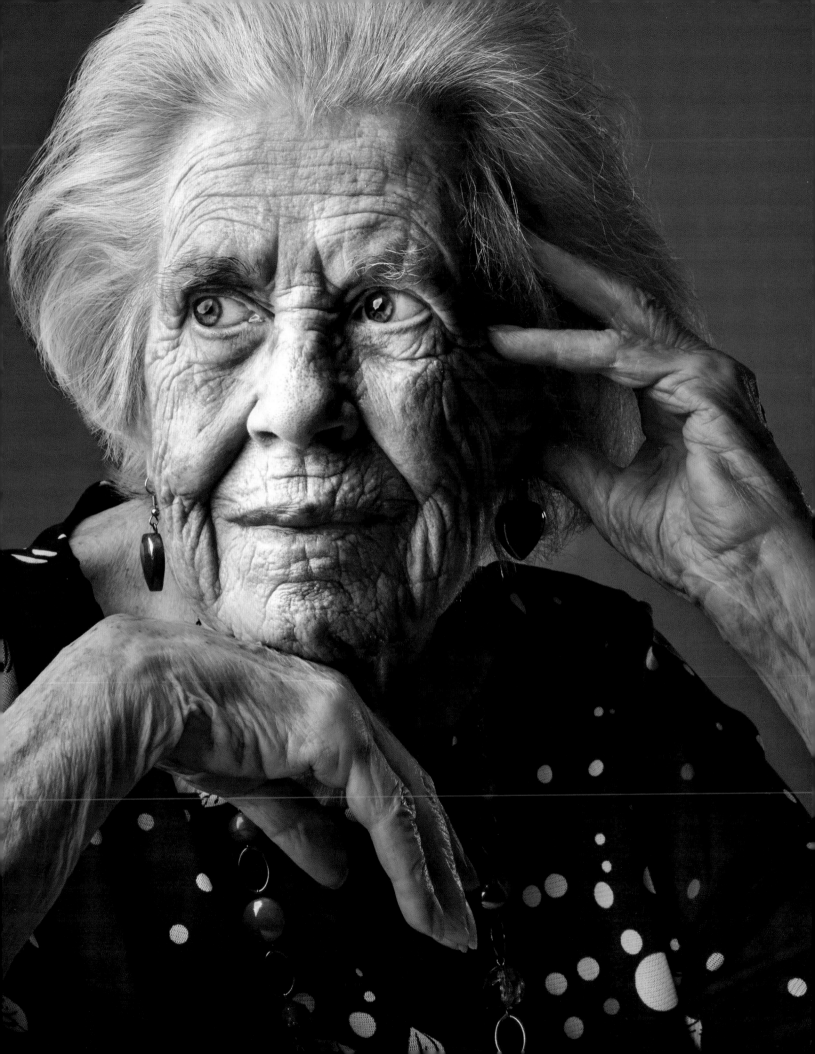

Marie was the firstborn of four children, three of them Minnesota natives. The youngest child was born in Louisville, Kentucky, where Marie's father moved his family for a job. Marie grew up there and attended two years at the University of Louisville before the Great Depression changed her plans. Her father was a home builder and was forced into bankruptcy. The family house was sold, as well as other rental properties. To make ends meet, Marie's father opened a chicken sandwich stand twelve miles out of town. He sold his sandwiches to laborers for ten cents. No longer able to afford university tuition, Marie enrolled in business school instead.

As a young woman, Marie and four female friends became local celebrities when they bicycled for six days on the open roads of Kentucky and Indiana. With their luggage balanced in wire baskets and clean clothes wrapped in oilcloth, the women rode through rain and heat, sleeping in hotels and on picnic tables in parks. Facing the hilly ride home, they accepted a lift from a truck driver instead, thus ending their cycling adventure.

Marie's first husband, George Gossman, was an aspiring actor. Shortly after their wedding, they packed their bags and moved to Los Angeles so he could pursue his dreams of stardom. Although Marie enjoyed some aspects of California life, her husband struggled to land a substantial role—one with enough earning power to support their growing family. Three years later, they returned to Louisville and divorced soon after, while their two daughters (Roberta and Marcia) were still young.

*"We don't know what's going to happen in our lives...
it's your attitude that does everything for you."*

Marie kept her small family together by working a number of jobs. She also continued to sing in the choir at church (she still does) and kept an active social life. Then one night she was introduced to folk dancing. She was hooked. Marie learned local traditional dances as well as folk dances from around the world. She danced at night after work, on the weekends in events, and attended folk dance camps. "When I found folk dancing, I was thrilled," she said. "I met a lot of interesting people through dancing."

She took a short break from dancing after marrying her second husband in 1966. Frank Kimbel wasn't interested in dancing, so Marie gave it up to share activities with her new husband and his daughter, Ann. They lived in the country and Frank kept a horse that everyone enjoyed. Tragically, Frank died

unexpectedly only three and a half years after their wedding. Marie was forced to return to work, and she moved back to Louisville, where she once again turned to dancing.

Eventually, Marie was globe-trotting with a dance group she started in Louisville. They toured Japan, the Philippines, Indonesia, China, and Bali, as well as South America and Europe. It was an exciting time to travel the world. Marie and her third husband, Frank Cassady, danced together and in different groups as well. Frank was a musician and composer with a background in classical music. Folk music and dancing was not in his repertoire, but he soon learned to enjoy it as much as Marie. They sang, danced, and traveled together for more than thirty years, until he passed away in 2008. Frank had two sons, David and Kevin.

Dancing kept Marie in good health, enhanced her life experiences, and broadened her circle of friends. But it also served as her salvation during the most difficult times in her life. Marie lost her daughter, Roberta, in 1971, when the plane she was in went down in the Bermuda Triangle. Then her other daughter, Marcia, became a paraplegic at the age of twenty-one after a terrible accident. There were also many rocky years spent with her third husband, Frank. Still, Marie is philosophical about it all. "We don't know what's going to happen in our lives, even bad things happen," Marie said. "It's your attitude that does everything for you."

Marie was at the center of Louisville folk dancing for a half century. She continued to teach Hawaiian dance classes until she was ninety-nine, and was even dancing after she turned 100. "You gotta dance and be happy. Dancing is good for your heart," she said.

The two dance groups that she started—Louisville Country Dancers and the Peasant Dancers, which combined with Louisville Ethnic Dancers—are still going strong. Marie goes to folk dance events on occasion, and her former dance partners and students are always glad to see her. Although she relies on a walker now, she still likes to watch other people dance the steps she knows so well. "I can enjoy it that way," she said. "I can even do the steps with my feet when I'm sitting!"

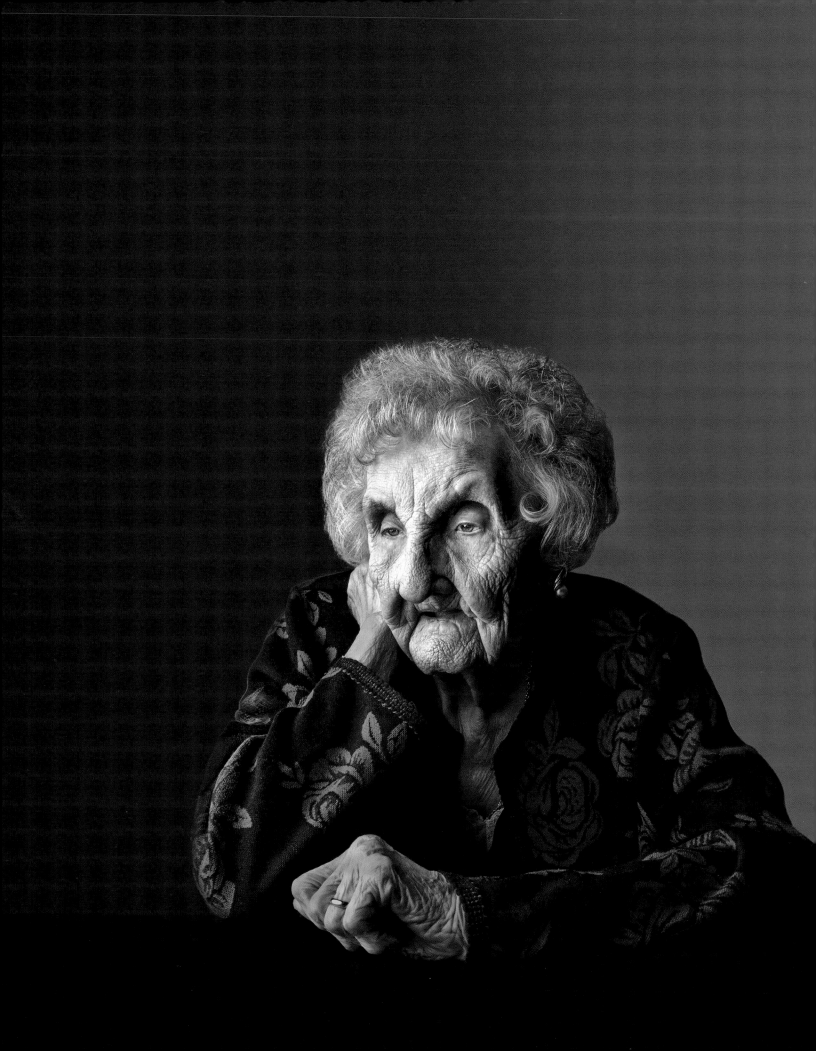

RUBY HOLT

Columbia, TENNESSEE
December 13, 1913

RUBY HOLT ALWAYS PLACED THE NEEDS OF OTHERS AHEAD OF her own. She grew up in rural Tennessee, working hard on the family farm. She remained in the area after marrying Gentry Holt and raised four children (Hassel, Jimmy, Andrew, and Joyce). She was always too busy taking care of kids and tending to the farm to travel. Decades later, when the staff at Brookdale Senior Living in Columbia, Tennessee, found out she had never been to the ocean, they applied to the Wish of a Lifetime organization. To their delight, the application was accepted and they surprised Ruby with a trip to Orange Beach, Alabama, where—for the first time in her life—Ruby experienced the sensation of sand on bare feet. She dipped her toes in the water and watched dolphins frolic nearby. Ruby spent two nights at a resort with a view of the Gulf of Mexico. Her trip attracted media attention, and when asked by reporters what she thought of the experience, she told them she'd always wanted to visit the beach but just hadn't found the time.

BESSE COOPER

Monroe, GEORGIA
August 26, 1896

I F THE PINE TREES ON BESSE COOPER'S LAND in northern Georgia could talk, they might tell us of a quiet, contemplative woman who lovingly tended her gardens, cared for feral creatures, and walked the forested trails appreciating her good fortune. Besse spent more than seventy years on the fifty-acre parcel she purchased in 1926. She and her husband, Luther, raised four children (Angeline, Luther Jr., Sydney, and Nancy) in their nineteenth-century farmhouse, and when Luther died in 1963, Besse stayed on the farm, living alone for more than forty years. She was 105 years old when she moved to a care facility and, even then, held out hope she would return to her land.

Besse was born to Richard Brown and Angeline Berry in 1896. She grew up in a modest log cabin, the third of eight children, in a small Appalachian community. She was particularly close to her beloved older brothers and two younger sisters, and had an insatiable appetite for learning that was encouraged by her parents. She attended East Tennessee State University (then called East Tennessee State Normal School) and graduated with a degree in education when it was rare for a woman to pursue a career. After teaching for a couple of years, Besse heard about opportunities in Georgia that paid significantly higher salaries—double in some cases—and shortly after left Tennessee for a teaching position and new life.

In 1920, before women had the right to vote, Besse joined the suffrage movement, which had been slow to catch on in the South. Many women considered politics a dirty business and argued that the most important roles were that of wife and mother. Besse disagreed and worked with groups that promoted women in politics. Eventually, the efforts of the suffragettes paid off, and on August 13, 1921, the women of Georgia were finally given the right to vote. Besse was there to help many of them register for the first time.

Within five years of that historical event, Besse was married and had moved with Luther to their farm outside Monroe, Georgia. She had her first child at age thirty-three and subsequently left teaching to focus on her family. Besse encouraged all four of her children to pursue higher education as she had done and kept the bookshelves filled with books to pique their curiosity about the world.

Throughout her life Besse read a great deal, from the daily newspaper to the classics. Her grandson, Paul Cooper, said she spent a portion of each day with a book or paper in hand. "If she wasn't in her garden or entertaining a guest, she was reading," he said. During the winter months when it was too cold to work outside, Besse read books on horticulture, biology, nature, and spirituality. There was hardly a topic that didn't interest her.

In 2011, Besse made history by becoming the oldest person on the planet. Three months later, she had to relinquish the title when it was discovered that Maria Gomes Valentim of Brazil was forty-eight days older. Within three months,

Maria passed away, volleying the title back to Besse. Besse's status as the oldest person alive received world recognition and a bridge in Monroe named after her, but she didn't think much of the attention. Besse was a private person. Although warm and sociable, she preferred a quiet existence out of the spotlight. Her supercentenarian status wasn't something she had actively pursued; it just happened. Over the years, Besse was often asked to explain the secret to her long life. "I mind my own business," she responded. She also said she didn't eat junk food. Besse was healthy most of her life, but Paul said she was also mentally strong. Even after moving to three different care facilities in eleven years and dealing with diminishing eyesight, she adapted and pushed on. "She was a very centered person," he said.

Inspired by his grandmother, Paul founded the Besse Brown Cooper Foundation in 2013. The nonprofit organization is dedicated to providing financial, legal, medical, and public relations support for supercentenarians worldwide.

CLAYTON MARX

Louisville, KENTUCKY
June 17, 1911

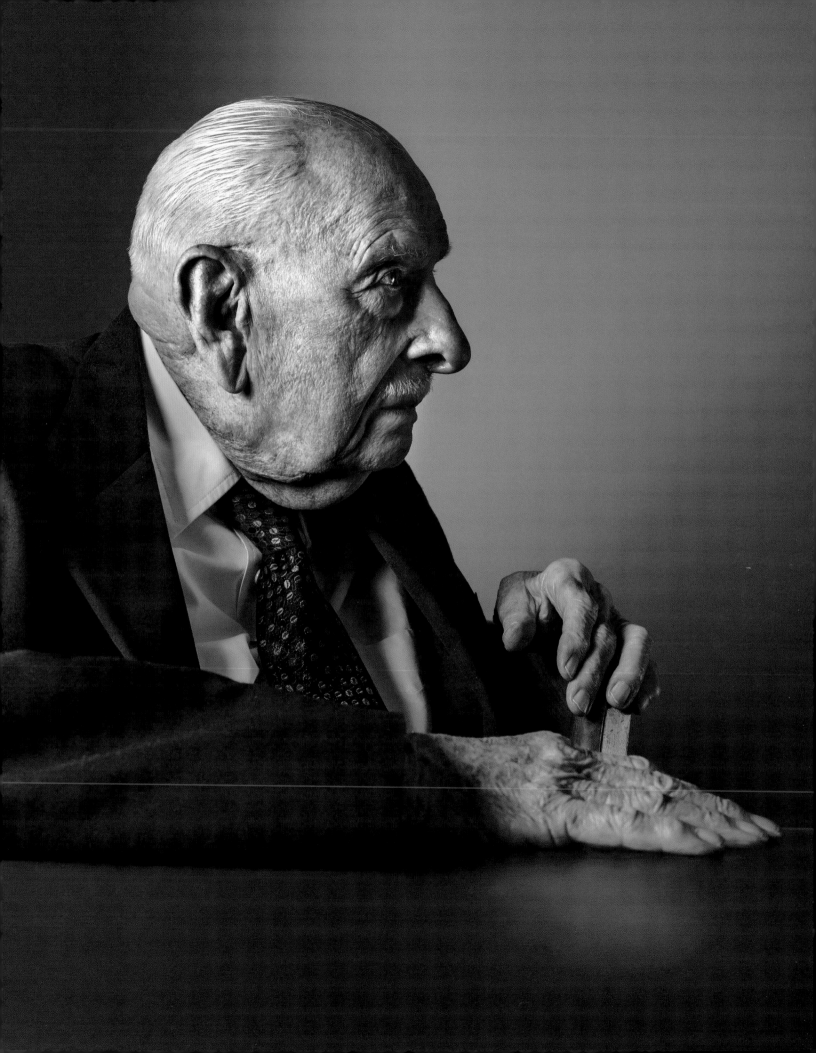

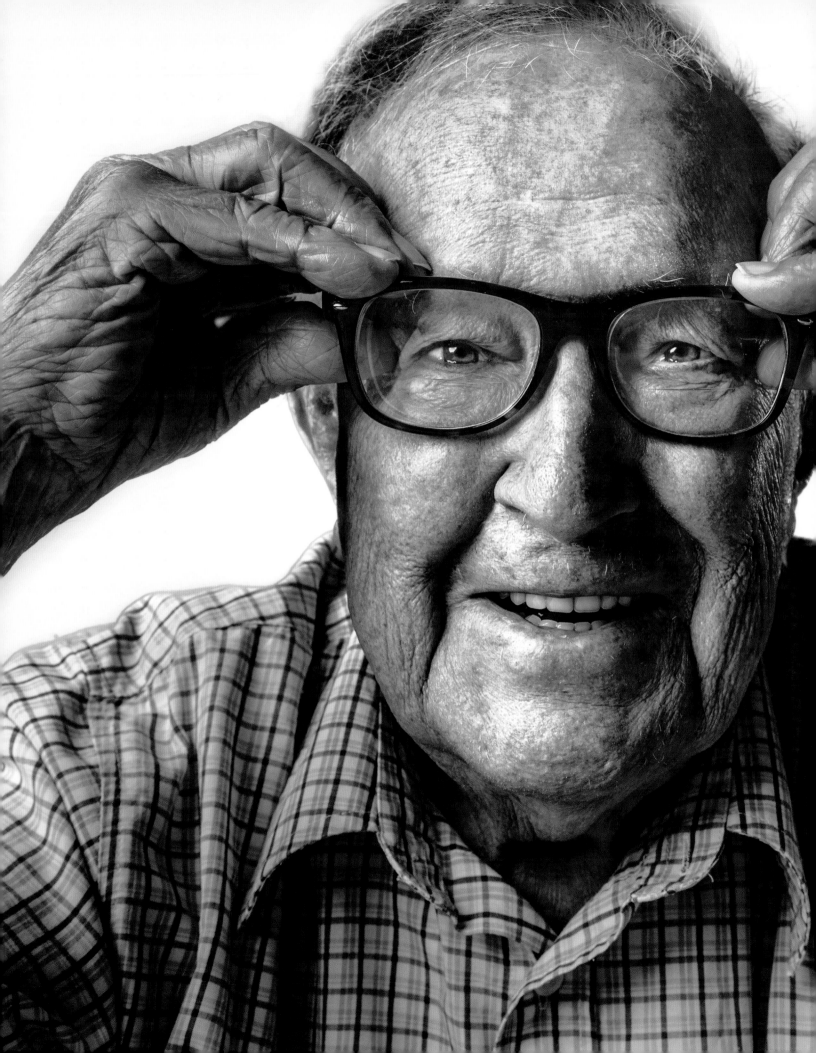

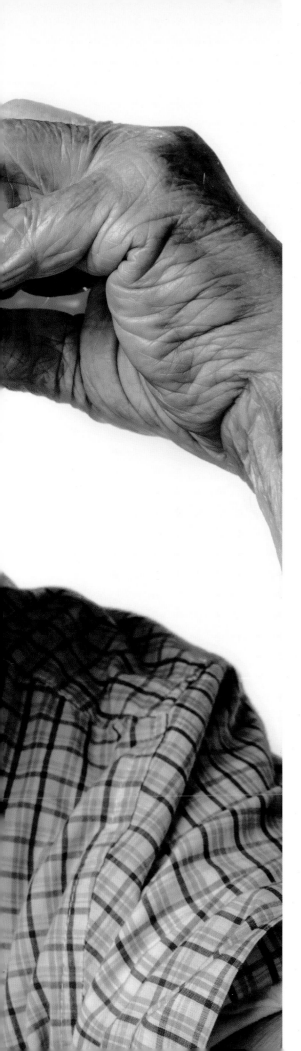

JOE JOLY

Cranston, RHODE ISLAND
June 2, 1915

JOE JOLY HAS SEEN HIS SHARE OF LOSS. HE HAS OUT-lived all three of his wives and a dear companion. He also lost his son, Gerard, when he was a young man. Indeed, Joe's life has been punctuated by grief. But Joe has not let this diminish his enthusiasm for life and his appreciation for every day that he has with friends and family. "If I had to do it all over again it would be the same way," he said. "Some of the things that happened I wish hadn't happened. But I'm happy—happy to be here and happy to have what I have."

Every Thursday night, Joe goes to dinner with his only daughter, Jane. It has been a ritual for a number of years and they both look forward to sharing time together. They take turns paying. Joe joked that he likes to choose the most expensive item on the menu when it's Jane's turn to pay.

Other days, Joe gets together with his oldest son, Frank, who also lives nearby. Another son, David, lives in Florida. Joe and Frank meet at the Pawtuxet Athletic Club, where, according to Joe, there are no athletes. The two play pool and then get a bite to eat and "a little something to drink." Maybe Joe has a fruit juice, or maybe a Jim Beam and ginger ale.

Of all the things Joe has accomplished in life, he's most proud of his children. "They are like all children," he said. "They were a pain in the A growing up. But we got through it." He's pleased they all turned out to be good people. Jane fondly remembers her dad borrowing the company pickup truck and taking the family to the beach every weekend. The kids and the dog would pile into the back of the pickup and off they'd go. Then there were the not-so-pleasant memories of Joe interfering in her teenage pursuits. Jane recalled the time she went to a dance without asking her parents. "I went up to the school and there she was in the middle of the dance floor with a young man," said Joe. "All I did was look and point my finger, and she came home with me. Girls are difficult to bring up, you know that?"

Unlike his children, Joe didn't have a happy childhood. He grew up the youngest of eight children, or, as he described himself, "the runt." His mother died when he was seven, leaving him rudderless through childhood and adolescence. Then, in high school, his sister introduced him to a girl named Helen. On their first date they didn't do anything special; Joe didn't have a lot of money. But he impressed her nonetheless. By the end of summer after their senior year, the two were married. Joe adored his mother-in-law and being a part of Helen's family. "I used to call her 'Momma.' I was like one of the family over there," he said.

So began a long and happy marriage. Early on, Joe and Helen shared a two-family house with Helen's sister and her husband. They were all best friends and went everywhere together. Later, Joe and Helen cared for two of Helen's unmarried, elderly aunts. They moved into the third floor of the couple's Cranston, Rhode Island, home when they could no longer care for themselves.

For many years, Joe worked a range of factory and manual labor jobs, from jewelry work to wire manufacturing during World War II, and later worked for a fence company. Then one day on the way home from his job building fences, he decided he'd had enough. The next day, he cleaned up,

rummaged through his closet for some nice clothes, and drove to Providence to apply for a job at Kennedy's men's clothing store. He wasn't wearing a suit, and his clothes were too big, but he impressed them and got a job.

Joe worked in sales at Kennedy's for thirty-five years. Even though it was a competitive, "dog-eat-dog" commission environment, Joe thrived. The store was located in downtown Providence and was abuzz with commerce during the day. He enjoyed the activity and people. Gone were the dungarees and work boots; at Kennedy's, Joe was a dapper dresser in fine suits and elegant ties. "I used to have a size thirty-two waist," he said. "I don't know where it went but I don't have it anymore!"

"If I had to do it all over again it would be the same way."

Helen passed away in 1994, after fifty-five years of marriage. Joe said he was so distraught he didn't care what happened to him. Eventually, though, he started to see Ruth, a friend and coworker who'd lost her husband. They were together for a few years before Ruth passed away unexpectedly. A couple of years later, Joe dated and then married Lorraine. After Lorraine died, Jane fixed Joe up with a friend's aunt. Joe and Alice were together for a number of years before she required nurse care. She moved into Saint Elizabeth Home, and Joe visited her every day until she died in 2012.

During his visits to Saint Elizabeth Home, Joe got to know the staff and would help out in the dining room. After Alice died, he told them he'd like to be a regular volunteer, so he went through the training program, including the special training for memory care. Now he's at Saint Elizabeth Home every Wednesday and Friday, using the state-funded RIDE program to get there. He has a lot of different responsibilities, one of them being to help patients unable to feed themselves. Residents like to talk to him and find comfort in his presence. He's beloved by all, and Joe finds the work very rewarding. He said he'll continue to help as long as he's standing. "It makes me feel good," he said.

RUTH ADLER

Chicago, ILLINOIS
January 11, 1905

RUTH ADLER WAS MORE THAN FIFTY years old when she launched her own company. She'd had a comfortable life with her husband, Sidney, but she was bored. In the 1950s, there were few professional opportunities for women, but surely there were more options than volunteering in women's clubs.

Sid gave Ruth her first taste of market research when he suggested she gather some friends together for an informal meeting. He was in advertising and one of his clients wanted to know what women thought about their laundry products. After several similar experiences, Ruth took a job with Arbitron for a dollar fifty a day asking people what they were watching on television. Within five years, she'd launched her own market research firm from the kitchen of their North Side apartment in Chicago. She hired women with limited job opportunities to interview people about new products and shortly thereafter formed a partnership with Betty Weiner.

Adler Weiner Research opened an official office in Lincolnwood and by 1970 they'd opened a second one in downtown Chicago. In 1989, they expanded west to Los Angeles, then to Orange County. Ruth loved her work so much that she put off retirement until she was eighty-nine years old. Today, members of Betty's family run the firm.

Ruth grew up on Chicago's South Side, the daughter of Polish and Russian immigrants. She was the youngest of five children in a family of comfortable middle-class standing. Her father owned a hardware store that delivered orders by horse and carriage. Unfortunately, he died young,

and Ruth's mother was unprepared to manage his business affairs. "My mother had to learn how to handle the money," said Ruth. "I also learned how to handle money at a young age. And without [that training], I wouldn't be where I am."

Ruth still remembers the first time she met Sid. It was the 1920s and she'd gone out for dinner and dancing with another guy. Sid was there with a date too, and soon it was clear that he and Ruth had more in common than their respective dates. "He asked if I'd mind if he called. I said sure," Ruth recalled. They went out for coffee on their first date and the spark they'd had at their first meeting was still there. Within the year, they were married.

Sid traveled a lot for his job, but the two also took trips together throughout the United States and abroad. They shared a rich social life, had lots of friends, and were very involved in their synagogue. When Sid died in 1988, the couple had been happily married for sixty-two years. "I had a wonderful husband. He just left me too early. We had a beautiful life together," Ruth said.

There is a longevity streak that runs in Ruth's family. One of Ruth's brothers lived to be 101 years old, and other family members have lived into their nineties. Still, Ruth doesn't know how she has lasted so long. It still surprises her.

"Ruth always says that she has good genes and that the 'guy upstairs' isn't ready for her," said Jody Weinberg, a cousin and close companion to Ruth. "But I think that her longevity is partly due to her capacity for long-lasting relationships. She turns every acquaintance into a friend."

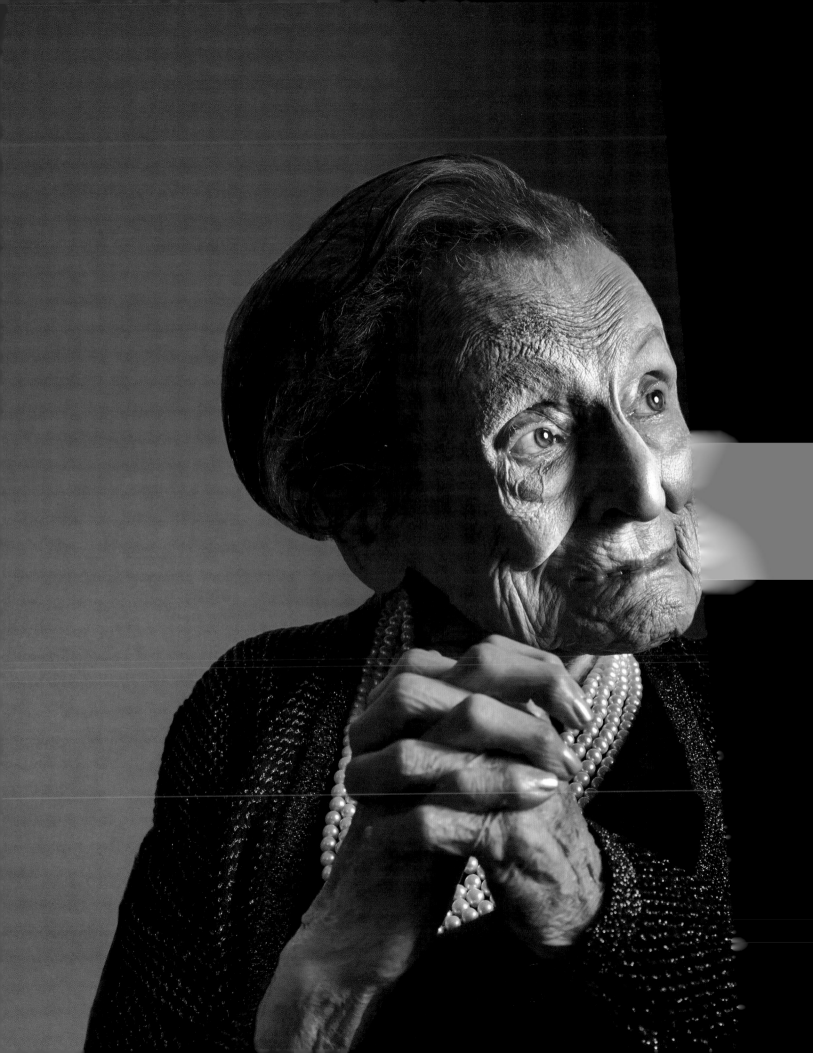

"Don't cheat anybody…always make sure it's a square deal."

LES FRITZ

Belfield, NORTH DAKOTA
March 15, 1915

L ES FRITZ ALWAYS HAD A FAVORITE HORSE. AS A RANCHER, HE relied on a good mount to help herd cattle or traverse miles of ranchland. Over the years he had dozens of horses, but a few rise to the top of his list: Peanuts, Tiger, Boots, and the draft team Chummy and Dempsey. He probably logged thousands of miles in the saddle over his lifetime. In fact, Les was still riding in his late eighties, as well as roping and branding cattle into his mid-nineties.

Les was born to Joe and Lucy Fritz in Belfield, North Dakota, and grew up on the family homestead twenty miles north of town. The middle child of five, Les accepted his responsibilities on the ranch at a young age. He went to school through the eighth grade, graduating at sixteen, but even then he missed a lot of days. From spring through fall he spent most of his time helping on the ranch. Not that Les minded; he was a good student but didn't care much for sitting in a classroom. He preferred to herd cattle.

During the 1930s, money was hard to come by and nature was anything but cooperative. Drought, heat, dust, and grasshoppers devastated the region. To earn extra income, Les's father ran for sheriff of Billings County and was elected. He served for four years before moving the family to a different property south of Belfield. Then he took a job as chief of police, leaving Les and his younger brother Hank in charge of the family ranch.

Les set eyes on Ollie Smedley in the early 1940s when she was visiting her mother at a nearby ranch. Raised in Fox Island, Washington, Ollie went back and forth between home and her mother's place in North Dakota several

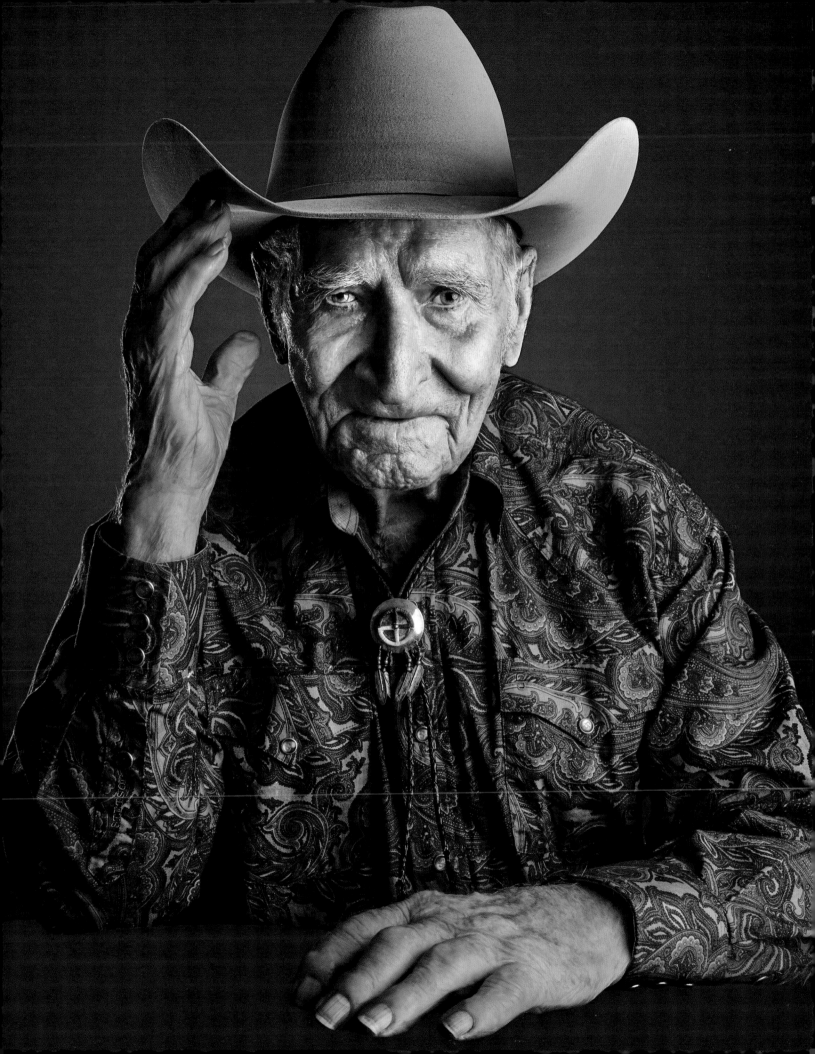

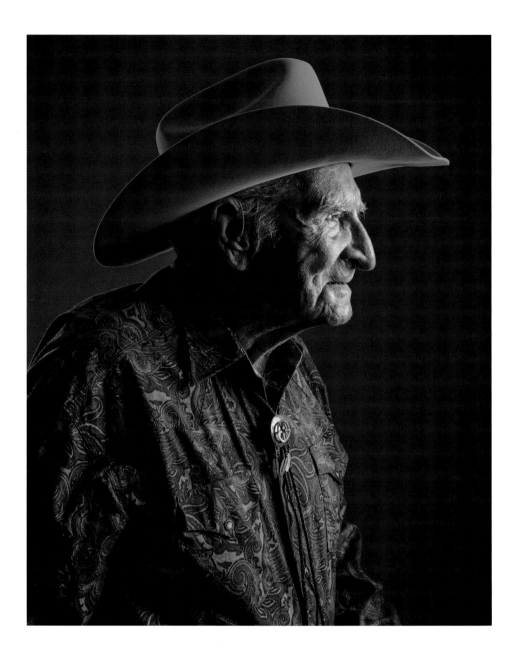

times before she and Les married in 1945. Les says his fondest memory is the day Ollie agreed to marry him. She took to ranch life without missing a beat and grew to love North Dakota as well.

Shortly after they married, Les was given a unique opportunity to run a ranch owned by the Norwegian Lutheran church. At the time, the church owned a lot of property in North Dakota, Montana, and Wyoming. They leased land and hired farmers and ranchers to run their operations. Les and Ollie ran the "church ranch" until the 1960s, eventually purchasing the property. They raised Hereford cattle, as well as draft and saddle horses. Les always kept four or five milk cows around and Ollie grew a garden. They even tried their hand

at pig farming. After realizing that pigs had a tendency to wander away from home, however, they got out of the pig business.

Les and Ollie raised three children: Connie, Larry, and Rocky. As kids, they rode to school on horseback or drove a team, no matter the weather. Les trusted the horses would safely deliver the kids home—and they always did. All the kids worked alongside their father on the ranch. He taught them how to work hard and fulfill their responsibilities. "Don't cheat anybody," he always told them. "You always make sure it's a square deal." The children agree it was a wonderful way to grow up and credit their parents for instilling in them a good work ethic and appreciation for ranching. "Really, you couldn't ask for a better father," said Rocky. All three kids grew up to become ranchers. Rocky and his wife Darlene and Larry and his wife Linda ranched on their parents' property; Connie and her husband Lynn have a ranch in South Dakota.

Although Les and Ollie traveled some after their kids were grown, Les preferred to stay close to home, letting Ollie explore the world. She had an adventuresome spirit and loved to travel. After they moved to a house in Dickinson, North Dakota, Les continued to help his sons on the ranch. Both brothers and their families had moved to the property to ranch in the 1970s and '80s. Les was in good shape and strong enough to help with various ranch chores. But eventually he gave that up as well, spending more time playing cards with Ollie and their many friends.

It's remarkable that Les remained so strong and healthy throughout his life in spite of the fact that he smoked until his mid-sixties, chewed tobacco until he was seventy-six, and ate pancakes and bacon for breakfast possibly every day of his life. He wasn't completely immune, however. In his seventies he surprised his doctor when he told him he'd had a heart attack as a young man. He hadn't gone to the hospital at the time; he'd just "come out of it then took some time to recover." The news was a surprise to his family, but not entirely. "Dad is a very strong person," Rocky said.

After Ollie suffered a debilitating stroke, she was moved to a care facility. Les remained by her side for eight months until she passed away. He moved to Evergreen Assisted Living shortly thereafter and found his niche. Rocky said he thinks his dad can fit in anywhere. At first, Les filled his time playing horseshoes and card games. Now, he's not able to see well enough to play horseshoes, but he hasn't given up card games and cribbage. Friends, former neighbors, and even their children still drop by to say hello. He helped a lot of people over the years and they haven't forgotten his generosity. When Les looks back at his life, there's nothing he would change. He has worked hard and had a good, loving partner. These things, he believes, are the right ingredients for a good life.

38

LILLIAN WILLIAMS

Monkton, VERMONT
November 27, 1914

LILLIAN WILLIAMS DOESN'T THINK BEING A CENTENARIAN IS AN
achievement. She takes her age in stride, believing it's "how happy
you are on the way" that's most important, not longevity. In spite of
her accomplishments, such as raising five children (Joan, Marilyn,
Ed, Stanley, and Clarence), and all that she has seen along the way, she's quite
uncomfortable with being in the spotlight.

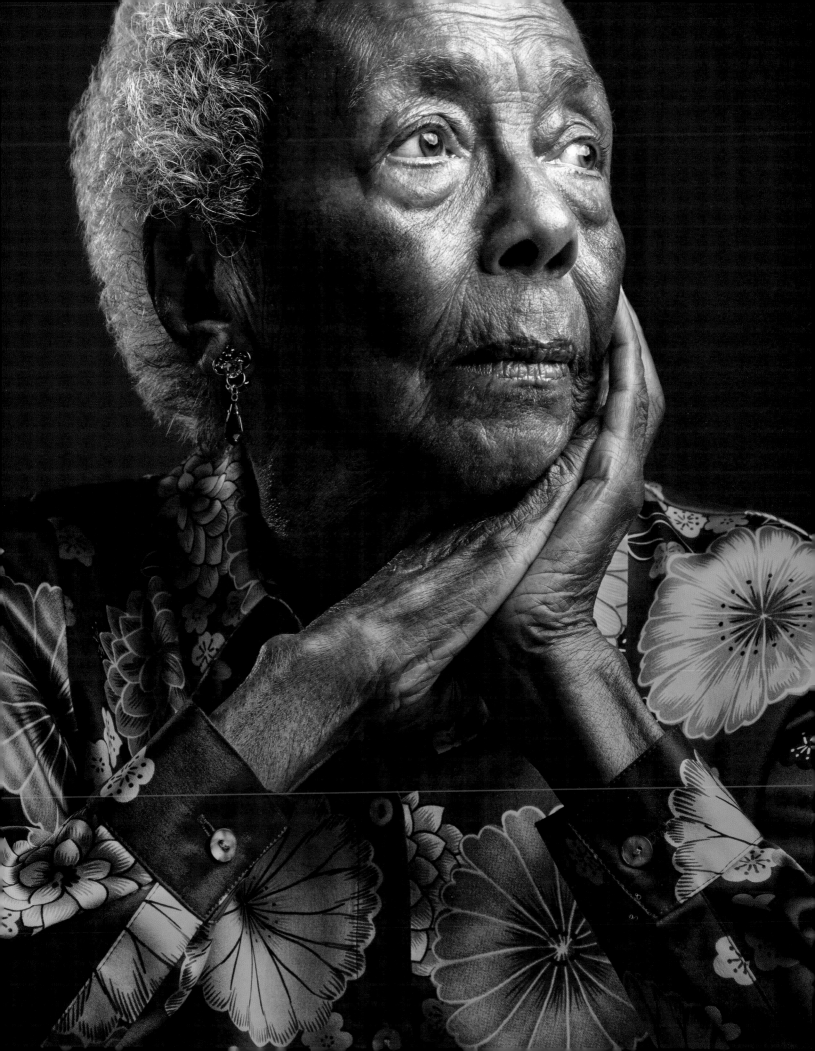

Lillian is as petite and demure as she is strong willed and independent. She moved in with her son Ed and daughter-in-law Mary at the age of ninety-nine, only when it became too difficult to care for her daughter, Joan, who had suffered a stroke with some paralysis a year earlier. Aside from the six months Joan had spent in a convalescent facility after the stroke, the two had lived together in Springfield, Massachusetts, since Lillian's husband, Bucky, died in 1999.

Lillian spent most of her life in Springfield. She and Bucky moved there from Pittsfield, Massachusetts, in 1942, after he got a job at the Springfield Armory. The armory was the leading producer of small arms for the US military from 1777 until it closed in 1968. During World War II, the armory produced four and a half million M1 rifles for the troops fighting abroad.

The Williamses lived in Mallory Village at the edge of Springfield, a 300-unit development funded by the US government exclusively for defense workers and their families. The duplex and quad units were thoughtfully laid out and landscaped. There were play areas, a multiuse hall where community events and kindergarten classes were held, and, within walking distance, the junior and senior high schools, grocery stores, and other amenities.

Mallory Village was a cultural melting pot. "Our immediate neighbors included families of several different ethnic backgrounds. They were of African American, Irish, Italian, French, Polish, and German Jewish descent," said Ed. "It was a great place to grow up and live."

"I still don't see what all the fuss is about!"

Lillian played the piano and organ during services at the Episcopal church where the Williamses were active members for many years. She'd learned to play as a child and was accomplished enough to teach beginning students. Learning to play piano was one of many things Lillian had achieved as a young, disciplined student. She graduated from high school with mostly As, loved to read, and had a superb memory. She was also fluent in French, having studied it for seven years.

If the circumstances had been different, Lillian would have attended college. But she was born into a large family with limited means. Around 1920, her father left Pittsfield for Philadelphia (where the family had previously lived and where Lillian was born) to find employment. He was unsuccessful at finding work, so Lillian's mother took a job to support the family. Even with full-time employment, it was difficult to make ends meet. Subsequently,

Lillian was sent to live with family friend Alice Cope and her husband. Lillian spent fourteen years with "Auntie" and Uncle Joe. Her adopted caretakers gave her many opportunities to develop her inquisitive mind. They encouraged education, discipline, and hard work.

Lillian's father never returned to Pittsfield. The few memories she has of him are faint now, but she recalls them with fondness. In particular, she still remembers his affectionate pet name for her; he called her his "Thanksgiving turkey."

When Auntie died, Lillian returned home to her biological family. After graduating from high school, she did housecleaning, cooking, and helped care for her younger sister. She also became reacquainted with Bucky, who had grown up near her childhood home. In 1936, the couple eloped. At first they moved in with Bucky's mother, and Lillian helped care for Bucky's young siblings. Eventually, Bucky and Lillian took over the house, remaining there until Bucky got the job at the Springfield Armory.

Lillian has had poor eyesight throughout her life. Even as a child she had difficulty seeing. Still, she has always had and still has a book (mainly fiction) on her lap or within arm's reach. When she doesn't have a book in hand, she watches her favorite programs: *Monk*, *Murder, She Wrote*, the NCIS series, or one of the British comedies on public television.

Aside from hearing and some memory loss, she's a beacon of good health. At the age of ninety-nine, Lillian started taking yoga classes. Ed said she has always been proud of her small size and good health. She has also maintained a good outlook. "She welcomes each day with a positive attitude," said Ed, "and she still insists on helping out around the house."

Lillian wakes up each morning and greets the day with a smile. She thoughtfully chooses her outfit and tidies her room. She appreciates the help from Ed and Mary but prefers to do as much for herself as possible. Her age makes no difference to her, and she doesn't expect to be treated special because of it. Nor does she understand why she has attracted attention. "I still don't see what all the fuss is about!" she said.

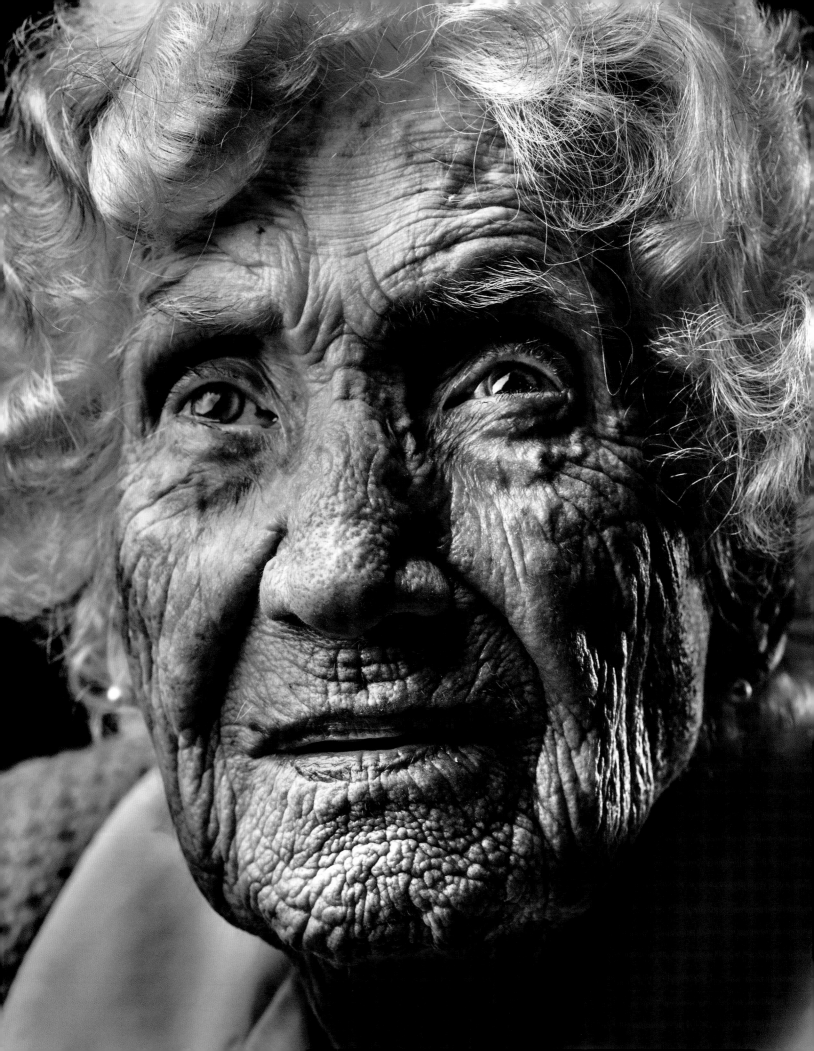

FRIEDA NEAS

Georgetown, DELAWARE
January 8, 1909

FRIEDA NEAS IS SURPRISED SHE HAS LIVED such a long life. Although longevity runs in the family, no one else she knows lived beyond 100 years. Perhaps it's her strong will, or maybe it's her joyful disposition. She's outgoing too. Her son Hans said she was always comfortable talking to people, whether she knew them or not.

Frieda has survived wars and great loss; she has worked hard and lived with very little. As a child growing up in Scharfenort, Germany, she learned to sew and do needlepoint—skills that served her well and were also a source of great pride and comfort.

The eldest of four siblings, Frieda grew up in a supportive and loving home. Her father was a shoemaker and her mother was a seamstress. Up at 5:00 a.m. every day, Frieda worked from the time she was a young woman. She learned her craft at a vocational school, and within a few years word spread throughout the town about the talented young seamstress. People lined up at the door for Frieda's handwork and beading.

Frieda married Wilhelm in 1928. They met in Oberhausen; he was seven years her senior and worked in a steel mill outside of Hallendorf. During World War II, the mill was bombed and the majority of the workers, including Wilhelm, perished. With two boys to raise, eight-week-old Hans and fifteen-year-old Herbert, Frieda earned her income using the skills she'd learned as a girl.

Life was very difficult during the war. Food and goods were rationed, and because Frieda had not joined the Nazi party, her access was further limited.

The stress of her situation created feelings of insecurity that she was not able to shake, even years after the war ended. Frieda remained frugal throughout her life, repurposing things like clothing and household goods several times over until they were too worn out to be reused. Even years later, she didn't take the availability of food and comfort for granted.

In 1950, Frieda married Wilhelm's younger brother, Walter, after he returned from Norway, where he'd been a prisoner of war. Four years later, they immigrated to the United States, where Herbert had also resettled. At first they lived in New Jersey and Walter worked at a nearby motorcycle manufacturer. They moved to Maryland in 1970, then Pennsylvania in 1989, before finally settling in Delaware.

Frieda worked a wide range of factory jobs—from making handkerchiefs and clothing to radios and microwaves. Finally, in 1970, Frieda was able to retire from a job in a clothing factory where she'd been a seamstress. With her free time. she continued sewing and making crafts for family, friends, and those in need. "She would always rather give than receive," said Hans.

Throughout her life, Frieda kept her hands busy—at her sewing table, in the kitchen, or in the garden. She was 105 when her hands became tired and her eyesight too poor to do her fine needlework. Now she enjoys the company of her family and friends and eating good German food—the richer, the better. "But I leave room for dessert," she said. When asked what she attributed her long life to, she took a moment to reflect: "Work hard, and don't smoke or drink."

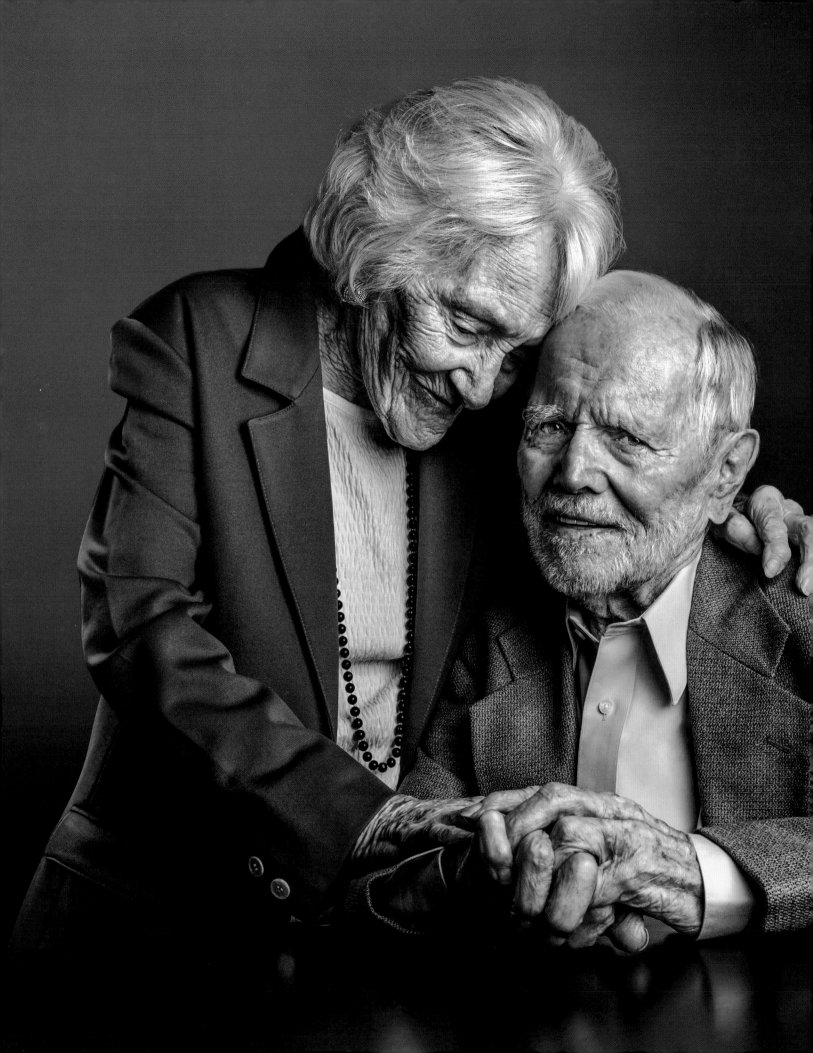

FREDDIE GRIFFIN & PRENTICE HARRINGTON

Greenbrier, ARKANSAS /
Maumelle, ARKANSAS
December 13, 1914 /
August 19, 1912

FREDDIE GRIFFIN GREW UP IN A HOUSE FULL OF BOYS. But she didn't mind; she played and worked right alongside them on the family farm in Greenbrier, Arkansas. Freddie and her older brother Prentice Harrington are the last surviving siblings out of six born to Joseph "Pack" and Virgie Harrington. Their late brothers include Russell, Eldridge, Ferrell, and John.

Although they lacked running water and electricity, Freddie said she and her brothers had happy childhoods. There was a lot of laughter and music in their home. Their father was one of the finest fiddlers in the area; he taught his kids to play the harmonica and they often sang together. Freddie loved the rough-and-tumble life she shared with her brothers. She wore her hair short and called herself a tomboy. "I thought I could do anything the boys could do," she said.

She met her husband, RD, at a party when she was seventeen years old. Sparks flew when their eyes met across the room. "He asked who I was, and I asked who he was," recalled Freddie. Within a year, they were married. One of the first big purchases they made was a nice little Ford Model A with a rumble seat. Then they started having babies. The young couple had a farm in England, Arkansas, raising everything they needed to feed their four children: twins Eldridge and Jackie, Geneva, and Juanita. Freddie said their life was simple and they worked hard, but they were happy and enjoyed each other's company.

She recalled when they first got a washing machine and she didn't have to do laundry in a tub anymore. She said it was the one modern invention that made a big impression on her life. In 1950, the Griffins got their first television. Theirs was the only house in the area with a TV and it drew friends and family. Freddie fondly remembers everyone gathered around the set, eyes fixed on the black-and-white screen.

Freddie and RD moved back to Greenbrier in 1961. RD passed away in 2000, and Freddie still lives in the same house they purchased together. She still misses RD. "He was a precious husband. Everyone loved him—young and old," she said.

Freddie's older brother Prentice was unemployed with a family to feed and waiting to be drafted when he decided to enlist in the Army in 1944. Prentice assumed he would be sent overseas, and he was right. After boot camp at Fort Bliss, Texas, he took a train to New York and then boarded a ship for Wales. From there, he went to England before arriving in Germany as the war was nearing its end. He spent two years there as a gunner on a half-track with the 833rd Antiaircraft Battalion.

As his battalion marched into one war-torn German town, Prentice saw a violin lying in a yard. The case was broken, but the violin was still in good shape so he picked it up. The instrument stayed close to Prentice throughout the rest of the war until he could take it back to Arkansas, where he presented it as a gift to his father.

Eventually, the violin was handed back to Prentice, but he doesn't play it as much as his harmonica, which is always tucked in his front pocket. He

also sings—still in perfect pitch. Prentice and his wife, Esther, were married seventy-three years (she passed away in 2008). He said she was fond of telling the story of how they met: Prentice was on a street corner playing his harmonica when she caught sight of him. Shortly after, they were married—he was twenty-two and she was fifteen—which didn't go over well with Esther's parents. After learning the young couple was to be wed, Esther's parents tried to get to the pastor before they could finish their vows. But it was too late. The pastor and his wife quickly diffused the situation. "They told her daddy that he was too late, and that I was a good boy," Prentice said.

"*I thought I could do anything the boys could do.*" —Freddie

Although Prentice tried farming for a while, he soon discovered that his calling was the gospel. He spent thirty years in the ministry and also had a weekly radio show. Prentice's strong voice and stature were the perfect ingredients and he thrived in his chosen profession. Prentice and Esther also raised five boys—Charles, Dave, Parker, Robert, and Mark—and they have eleven grandchildren and twenty great-grandchildren.

Freddie and Prentice have not lived close to each other since they were children, but they still share common values and a deep appreciation for where they came from, their families, their spouses, and their faith. Both are in good health, and while their individual formulas for life have suited them, Freddie and Prentice aren't interested in telling others how to live. Prentice doesn't equate age with wisdom. Freddie credits the Lord. Still, they agree that they got a happy start to life, and it set the tone for everything that followed. "I was raised happy and I've always been that way," said Freddie.

CLAIRE MORRISON

Long Beach, MISSISSIPPI
April 12, 1915

CLAIRE MORRISON CAN SAY SHE HAS lived through some of the most significant events of the twentieth century: women earning the right to vote, the first transatlantic flight, moon landings, and world wars, to name a few. She once traveled by horse-and-buggy, and can remember having to turn a crank to make a phone call. But the events that made the biggest impression on Claire were not designed by humans—they were the work of Mother Nature.

Claire was born in 1915 in Long Beach, Mississippi, to William and Claire Boggs. She and her five siblings grew up on the waterfront property—later named Boggsdale—purchased by her grandfather in 1870. Claire spent most of her life on the land. She was only six months old when she experienced her first hurricane there. A self-described "tomboyish girl," Claire climbed trees, rode horses on the levee, and ran around without a care. "Free as a bird" is how she described her childhood.

During the Great Depression, she moved with her family to New Orleans, where her father, a banker, had been transferred. Claire and her siblings took jobs and pooled their earnings to help keep the family afloat. Living in the city was difficult for her. She'd only known the country; New Orleans was busy, noisy, and rough for a young provincial girl. But Claire found her way and it turned out the experience helped her develop the resilience to get through the challenging times ahead.

She also met her husband in New Orleans. Claire was introduced to Stanley through her sister-in-law. She said it wasn't love at first; they were just good friends. But eventually they reached a crossroads. "We decided we either had to marry or break up," she said. The couple returned to Mississippi to raise seven children—twins Robert and Florette, Claire (nicknamed Jo), Mary, William (nicknamed Bill), Anaise, and Martha—on the Boggs' Gulf Coast property.

Claire's second hurricane experience was in 1947. She was a young mother then, with four babies. The eye of the storm passed directly over New Orleans, and was estimated at twenty-five miles in diameter. Claire lost an aunt in the storm, and the original home site of 1870 was severely damaged. Holding tight to her children, she helplessly watched from across the street as parts of their house washed away. Although they rebuilt the house, Claire was deeply affected by the experience.

When Hurricane Camille hit in 1969, Claire and Stanley had just married off a daughter. "We thought we better go to the hotel on high ground," Claire recalled. "And we didn't take anything but cards to play poker and the last bottle of champagne. We were high and dry. The men even went on the balcony to watch. We thought everything was fine at home; we thought it would stand. But it didn't."

The Morrisons salvaged what they could of the house known as Wil-Stan I, took out a loan to

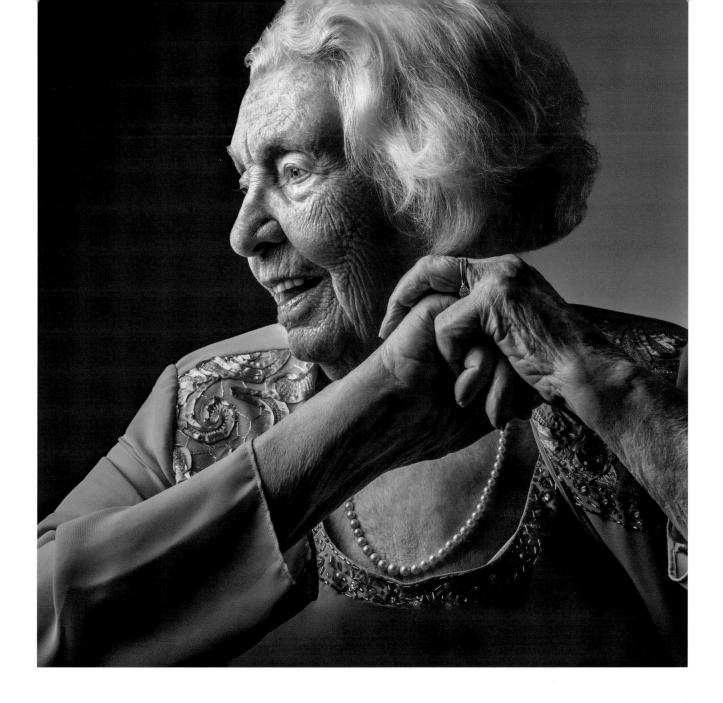

rebuild, and named the repaired home Wil-Stan II. The grand, rambling house was the epicenter of the Morrison family for thirty-five years. Then came Hurricane Katrina in 2005. The hurricane was too much to withstand and the Morrison house was destroyed beyond repair. By this point, Claire was ninety years old, too tired to rebuild on the coast again. Stanley was gone (he died in 1988), so Claire purchased a home with minimal storm damage farther inland, made the repairs, and moved in. She has been there since. All the homes her children and their families had built on the family compound were also wiped out. Although they all remained in the area, none of Claire's children chose to rebuild close to the water. "Katrina was the worst," she said.

Claire's optimism and ability to persevere in the face of the most harrowing challenges are a few ingredients she thinks contributed to her long life. She also lists faith, hope, and a Scotch at the end of the day. "We're not promised a bed of roses. You have to learn how to deal with what comes your way," she said.

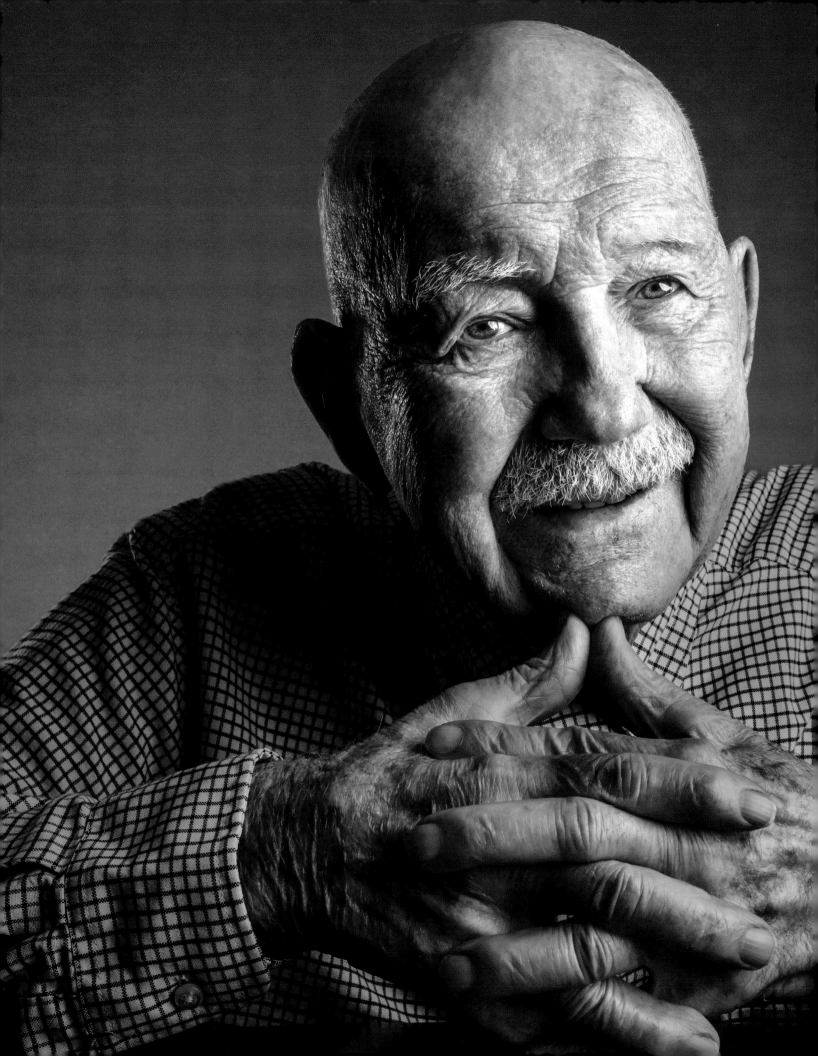

ERNEST BACKUS

Nashville, TENNESSEE
September 15, 1915

ERNEST BACKUS WAS BORN AND RAISED IN NEW Straitsville, Ohio, a former coal-mining town that earned the dubious title "Moonshine Capital of the World." Ernie grew up with two brothers and two sisters; his father was a coal miner and his mother was a strong, feisty woman who canned everything they grew or purchased from the local farms. She was also an excellent cook. Ernie longingly recalled the taste of her squirrel gravy. "If you've never had squirrel gravy, you've missed a lot," he said.

There wasn't a lot to do in their small town, but Ernie and his childhood friends found creative ways to entertain themselves. They played marbles, often inventing their own games, and went to the movies. It only cost a dime. Ernie played American Legion baseball until he was sixteen years old and was a member of his high school baseball team. He also liked to dance. Without cars of their own or public transportation, Ernie and his friends got around by foot. Although he eventually learned to drive, Ernie's mother was the one most often behind the wheel of the family's only car.

Ernie graduated from New Straitsville High School in 1933 and worked for the Civilian Conservation Corps for three years. Then, at the encouragement of a cousin, he moved to Barberton, Ohio, outside Akron. Compared to his hometown, Barberton was a rollicking city. During the height of its industrial age, Barberton attracted a large number of immigrants from Europe and it grew so fast it earned the moniker "Magic City." Ernie enjoyed the diverse cultures, especially the wide range of cuisine available. Being gregarious, it was easy for him to talk to people and he quickly made a lot of friends. He especially liked the dance halls where he could dance to music by great artists such as Louis Armstrong and Cab Calloway.

He also met his wife, Helen, at the First Baptist Church in Barberton. The couple married in 1942 and, two years later,

Ernie enlisted in the Navy. He felt an obligation to serve his country, and he also hoped to see the world. Instead, Ernie was sent to San Diego. "I never sailed the seas," Ernie said. But, like most things, he took it in stride.

After leaving the military, Ernie returned to Barberton to reunite with his family (Helen and their son, Wayne, and daughter, Elaine) and subsequently accepted a position at Babcock & Wilcox as a welder and machinist. The company provided (and still provides) energy and environmental technologies and services for power and industrial markets worldwide. It was an exciting time; there was a lot of innovation and development happening in Ohio and throughout the Midwest. Ernie thrived there and enjoyed being a part of it.

Ernie had a productive and fulfilling career at Babcock & Wilcox for forty years. After retiring in 1977, he looked forward to having more time for doing the things he loved. Yet shortly after transitioning to a life of leisure, he discovered he wasn't truly ready for it after all. So he reentered the workforce, this time as a ticket-booth attendant in a parking garage at Barberton Citizens Hospital. It was a perfect fit. Ernie knew everyone in town, and they knew him. He was glad that he could give back to his community by offering kind words to patients and families visiting the hospital. Ernie remained at his post until he was eighty-six, the oldest employee at the hospital to date.

Ernie and Helen shared a love of gardening, as well as a strong religious faith. While Helen was extremely creative and channeled much of her energy toward the arts, Ernie liked baseball, bowling, golf, and especially fishing. In fact, you could say fishing was a passion. He traveled to Canada in pursuit of the walleye and northern pike—his biggest catch being a fifteen-pound, three-foot pike.

"I may be old, but I can still learn."

But the pinnacle of Ernie's fishing trips was the one he took to Alaska in search of salmon. Ernie was close to retiring, so he took a month off work to drive there with friends. Long stretches of the Alaska Highway weren't paved yet; some days they were only able to cover forty-five to fifty miles. "The pebbles flew," recalled Ernie. They had to cover mirrors and windows and there were frequent breakdowns. "It took two weeks to get there. But I saw everything there was to see."

In 2004, Ernie and Helen moved to Nashville, Tennessee, but shortly after, Helen unexpectedly passed away. Although he'd never had to take care of household duties, he remained in their condominium, at first muddling

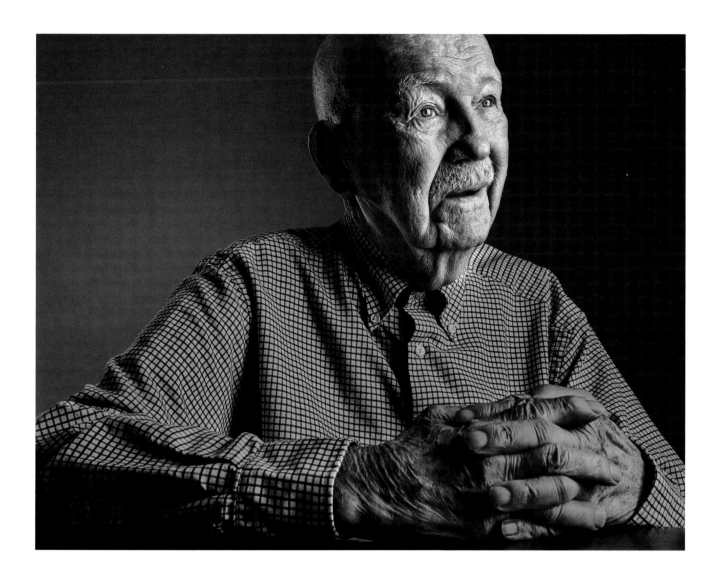

through the daily tasks that Helen had managed for so many years. When his daughter Elaine asked if he'd be OK living on his own, he responded, "I may be old, but I can still learn. Just teach me one new thing a week until I master each." And he did. Elaine said he also won the hearts of his new community, and he did the same when he settled in Belmont Village in 2013.

Although Ernie has slowed down over the past few years, and he uses a walker that he refers to as his "horse," he still retains a lust for life and exudes positivity. His family, which includes eight grandchildren and eight great-grandchildren, has a list of endearing phrases they call "Ernie-isms." One of their favorites is "I'm in pretty good shape for the shape I'm in." Perhaps Elaine summed up her father best in a touching tribute she wrote for his 100th birthday celebration: "A man of simple needs and wants, Daddy has been a crowning example to us all, through his strong religious faith, his passion and love of life, and his unconditional love of those around him."

EDNA PARKER

Shelbyville, INDIANA
April 20, 1893

EDNA PARKER WAS STILL LIVING ON HER farm after she turned 100. She might have remained there if her family hadn't suggested she move in with a relative. She was still climbing ladders to replace lightbulbs and they were concerned for her safety.

Edna spent most of her life on a farm. After marrying her child sweetheart and next-door neighbor Earl, they worked the land together, moving from one farm to another until finally settling in the Blue Ridge area on eighty acres in Shelby County, Indiana. They raised a variety of crops and always kept a few dairy and beef cows, hogs, and chickens. They had two sons, Clifford and Earl Jr., and Edna rose every day at 4:00 a.m. to fix breakfast for the family before heading to the barn.

Edna hadn't always been a farmer's wife, however. She received a teaching certificate from Franklin College in 1911, and taught grades one through four in a two-level schoolhouse before marrying Earl. But Edna enjoyed the outdoors and the hard work of farm life, so she never returned to a classroom.

After Earl died from a heart attack in 1938, Edna kept the farm going with the help of Earl Jr. Clifford married and moved to a farm nearby. Earl Jr. eventually married and moved as well, but Edna stayed put and managed the farm on her own.

Healthy throughout most of her life, Edna enjoyed fresh eggs, homemade sausage, bacon, and fried chicken, but her grandson, Don, said she was always thin. Even in her last years, she took few medications and was relatively free of health problems. Longevity runs in her family (one sister reached her late nineties), but Edna also credited education as the reason for her long life. Perhaps it was also her sense of humor. At her 114th birthday party, she remarked that her age was "several years too long. I probably knew George Washington."

Edna's impressively long life mystified researchers. After she reached the supercentenarian mark (more than 110 years old), researchers from the New England Centenarian Study at Boston University took a blood sample from Edna for the group's DNA database. Her DNA is now preserved with samples of more than 100 other people with the same status. Their genes are being analyzed to help researchers find the key to longevity.

Edna spent her last years at the Heritage House Convalescent Center in Shelbyville, a town outside of Indianapolis, and she received frequent visits from her family; most have remained in the area and several are farmers. In addition to her two sons (now deceased), Edna's legacy includes five grandchildren, thirteen great-grandchildren, and thirteen great-great-grandchildren.

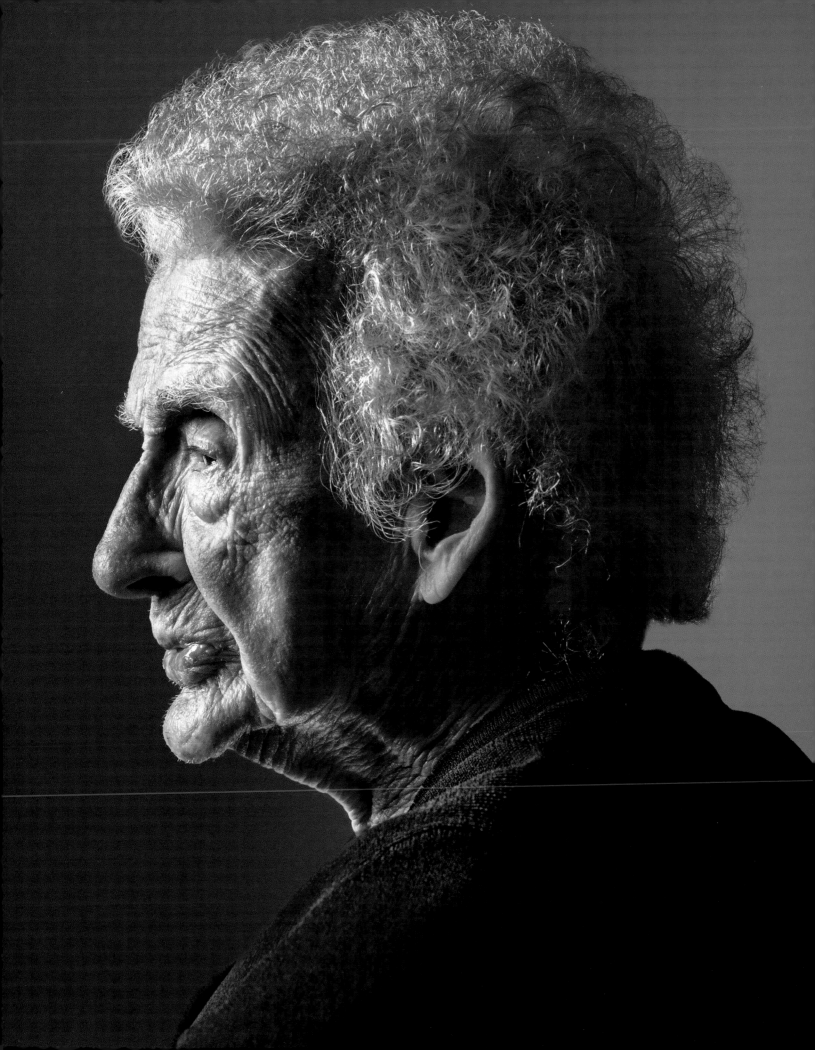

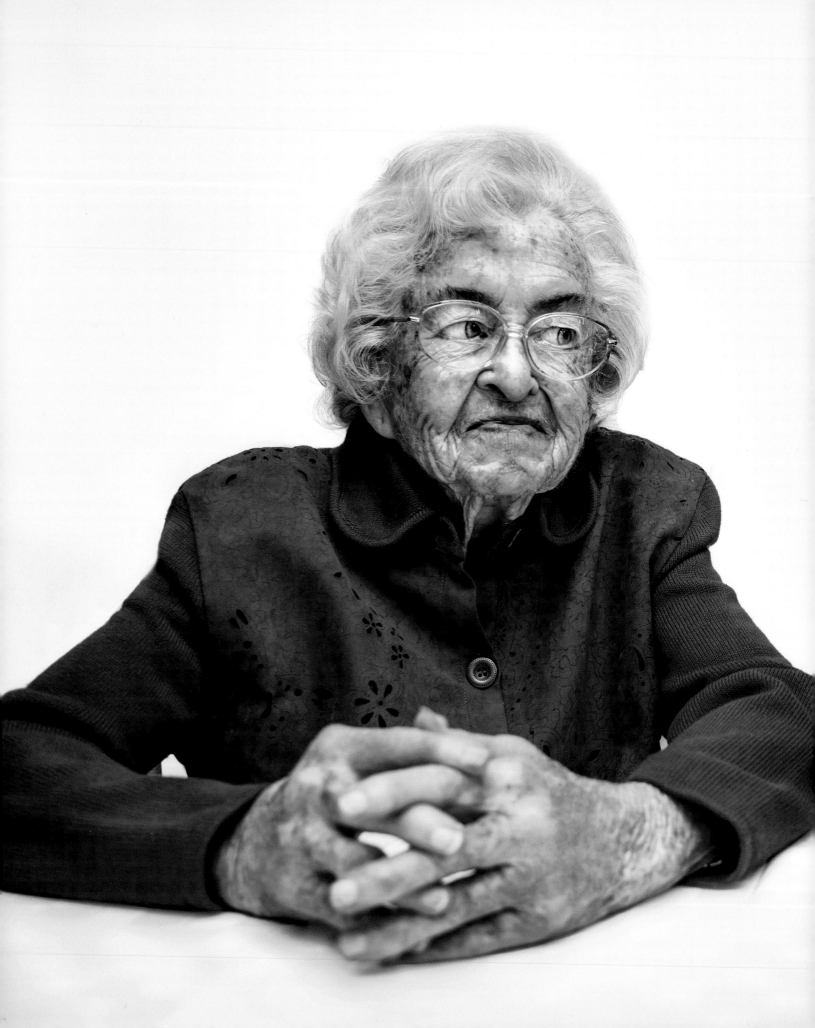

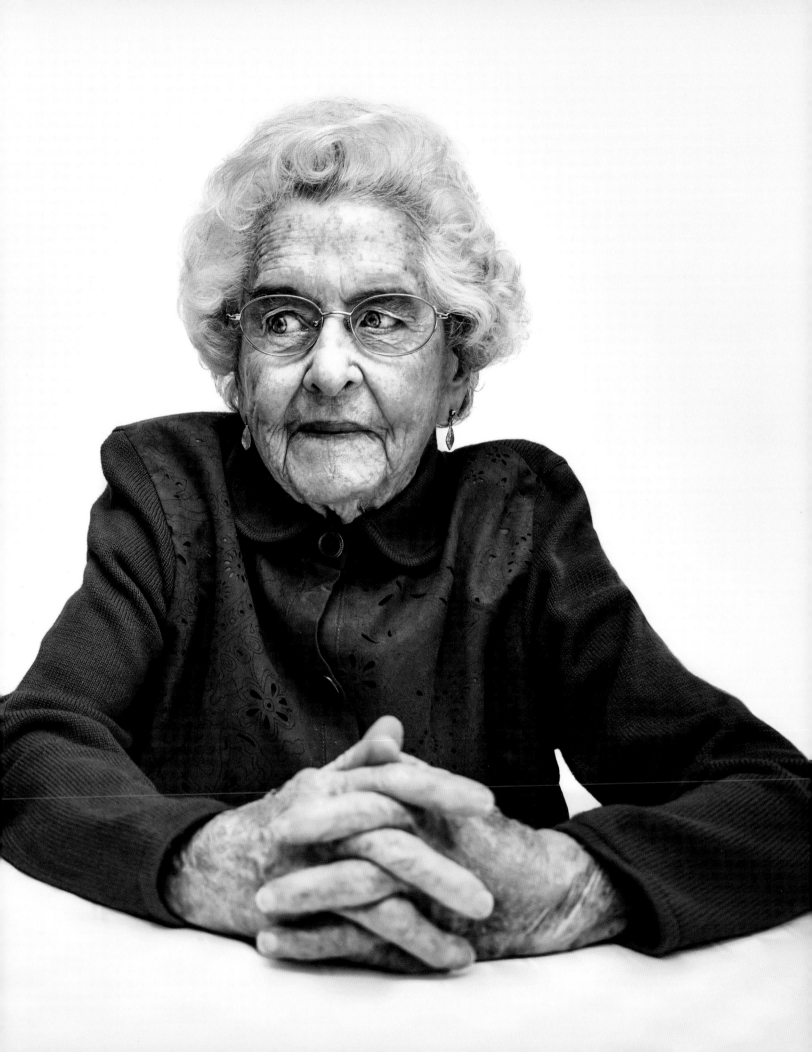

INEZ HARRIES & VENICE SHAW

Sylmar, CALIFORNIA / Newbury Park, CALIFORNIA
January 15, 1911

WHEN IDENTICAL TWINS INEZ Harries and Venice Shaw turned 100 years old, they were invited to appear on *The Tonight Show with Jay Leno* as special guests. Sitting next to actor Ben Affleck, they took turns calmly answering questions about their childhood, as if being on national television was old hat. Jay asked Venice about her first car, a 1929 Ford Coupe with a rumble seat, and enticed the twins to sing a song they'd performed on a horse-drawn float in the 1917 Rose Parade, dressed as poinsettias. Then he surprised them by bringing out Carol Burnett. Although gracious and composed, they were clearly thrilled to be sharing the stage with their favorite entertainer.

Inez and Venice were born in 1911 in Pasadena, California, to William and Anna Hesser and grew up in the San Fernando Valley, then a rural area on the outskirts of Los Angeles. Their home was modern, with amenities such as running water, electricity, and an indoor bathroom. In 1918, the family moved to a citrus ranch in San Fernando, when the roads were still dirt and the landscape barren, save for the groves of lemon, orange, and grapefruit being irrigated by the newly completed Los Angeles Aqueduct.

Inez liked to point out that she was born fifteen minutes before Venice. So Venice always considered herself the baby of the family. Their older brother Edward was nearly twice the size of his petite sisters.

"We'd get mad at him and both be pounding on him. But he'd just stand there and laugh," said Venice.

For much of their childhood, their father managed citrus ranches. With acres of open land to run free, the twins were always outdoors: riding horses, swimming, and taking trips to the beach with Edward and their friends. They were nearly inseparable and usually shared one close friend. Everyone, including their parents, had difficulty telling them apart. The twins got a good laugh out of confusing people, sometimes switching the colored ribbons their mother tied in their hair so the teachers could tell them apart. Their schoolmates called them both "Twinny" to avoid mistaking one for the other.

During the Depression, the sisters and their brother were able to find work together at the Sunkist packing house in San Fernando, where Venice also met her first husband. Venice recalled picking her sister up for work in her car—the Ford Coupe. She'd paid 450 dollars for it, at a time when the minimum wage was a paltry thirty-three cents an hour.

Inez was the first to get married in 1931. Then, two years later, on the same day, Venice and Edward married their respective sweethearts in a double wedding. They even honeymooned together on Catalina Island with Inez and her husband joining to celebrate their two-year anniversary.

Although they lived in different cities in the Los Angeles area, the twins remained close as adults,

"Be honest, give lots of love, and keep a close family." —Inez

offering support and friendship to one another during life's highs and lows. Their close relationship sometimes transcended time and space; on several occasions they sensed something was happening to the other, even though they were miles apart.

Both women lost their first husbands and remarried—Inez twice. Inez has two sons, Richard and Charles; a daughter, Gerry, who passed away in 2000; and two stepchildren, Jeanette and Phillip. Venice has only one daughter, Bonnie. Between them, there are thirteen grandchildren and twenty-five great-grandchildren from their natural offspring.

Both Inez and Venice worked most of their lives, even while raising their families. Among other jobs, Venice was a supervisor for twelve years in a plastics injection plant that made small parts for sprinkler systems. Inez worked for Lockheed Aircraft for twenty-seven years. During World War II, she labored up to ten hours a day, plus weekends, installing control cables in P-38 fighters and later helping build Constellation airliners and helicopters.

Longevity doesn't run in the family, so Inez and Venice haven't put their fingers on the reason they've outlived their peers. They both faced immense challenges during their lives and survived natural events, such as the 1971 earthquake and the flu epidemic of 1918, when thousands of people died. But they suspect their longevity is in part due to their lifelong good health, as well as their close

and loving relationships, their strong faith, and a healthy diet. Their father was diabetic, so from an early age they understood the importance of good nutrition and eating in moderation.

Inez and Venice were also very social and involved in church and clubs that kept them active in their communities. Both were members of the San Fernando Friendship Club from the mid-1940s until it disbanded in 2005. (They were the last remaining members.) They traveled with their husbands and together to Europe, on cruises to Alaska, and on the Mississippi and Ohio Rivers aboard the *Mississippi Queen*.

Venice said some of her happiest times were going to Yosemite National Park with Inez and their families, and the camping trips she took with her husbands and the camper clubs they belonged to. When asked if she thought a good partner was the key to a long life, she said yes. "Choose a good partner, someone who shares the same interests," she said, adding, "and be happy and eat well." Inez also placed importance on family and living with integrity. "Be honest, give lots of love, and keep a close family," she told her loved ones.

The twins celebrated their 103rd birthday together about one month before Inez passed away with Venice at her side. Venice continues to live with her daughter, and at 105 still enjoys regularly attending church and Bible study as well as spending time with family and friends.

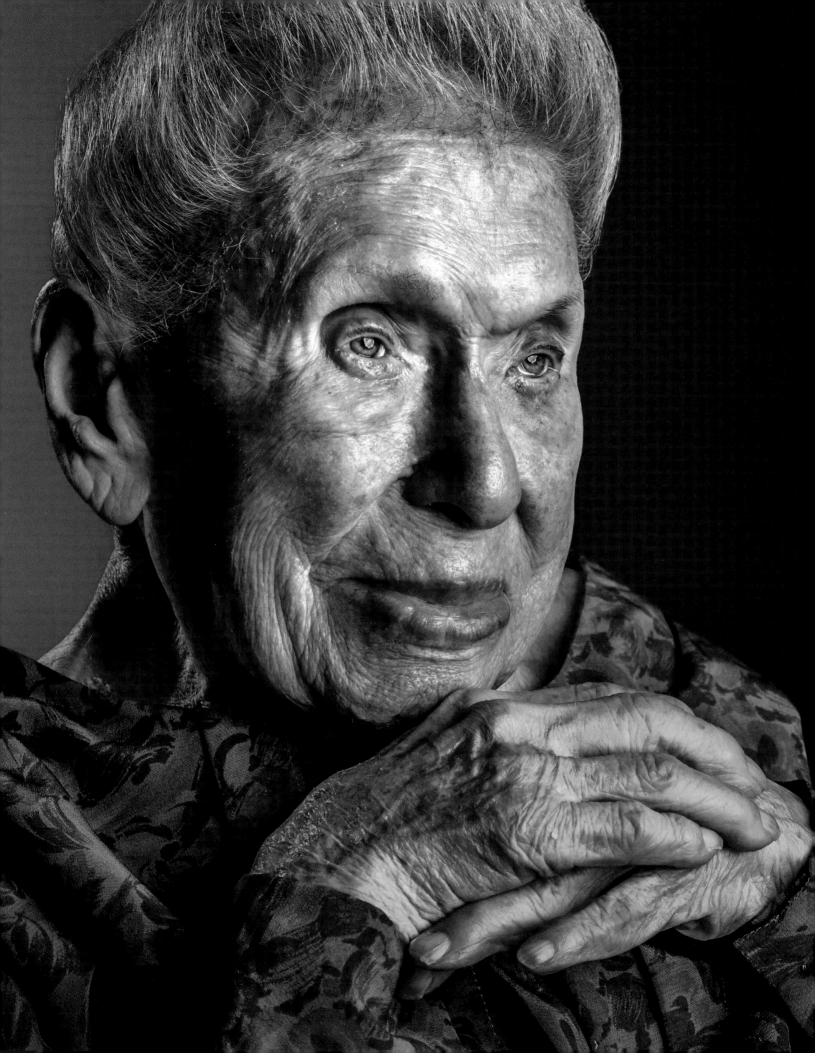

GOLDIE STEINBERG

New York, NEW YORK
October 30, 1900

GOLDIE STEINBERG'S GREATEST TREAsure was her family. She often said that the secret to her longevity was having great children. Equally adored by family, friends, acquaintances, and the media, Goldie left a lasting impression. "I've never met anyone so positive," said her granddaughter Ellen. "I don't think she ever had a negative thought."

Goldie was born in the city of Kishinev, in what was then part of the Tsarist Russian Empire, today the capital of Moldova. Life was not easy and her family had little, but Goldie's father gave generously to charity and was known as being an honest and kind man. Goldie held onto this memory with pride throughout her life and she lived by her father's example. She looked on the bright side of every situation and believed there was no challenge that couldn't be overcome.

Although she was too young to remember the pogrom of 1903 (during which forty-seven Jews were killed and hundreds wounded), her family was forced into hiding at a Russian neighbor's house during the massacre. Goldie was later told by her family that they were saved by the neighbor who told attackers they weren't Jewish.

In 1923, Goldie and two sisters, Raizel and Sura, moved to the United States, where their uncle had a clothing factory. Immigrating to the United States ensured that the sisters had opportunities they wouldn't have found in their homeland. Although they didn't know it at the time, the move overseas also saved their lives. Several years later, their entire family—parents and five siblings—perished during the Holocaust.

In the United States, Goldie worked as a seamstress making dresses and draperies. She met Phillip Steinberg while a member of a society of Eastern Europeans, and the two were married in 1932. They moved to an apartment in Brooklyn and had two children, Don and Ann. After Phillip passed away in 1967, Goldie remained in the apartment and continued working as a seamstress until she retired at the age of eighty-three. She was very gifted, often making her own clothing, but also sharing her handiwork with family and friends.

Goldie lived alone in her apartment until she was 104, when a fall put her in a rehab center. Goldie's family spoke to her on a daily basis and she had frequent visitors. She kept her hands busy crocheting and knitting, but she also read and rooted for the Yankees during baseball season. She was grateful for her health. "If you have your health, you have it all," she would tell her children. Aside from a pacemaker and a couple of medications, Goldie had been spared from serious disease and illness. Her memory remained sharp too; she was able to recall details from her life, which she liked to share with her family.

On the day she passed away, Goldie said goodbye to her children, four grandchildren, and seven great-grandchildren. Several family members were gathered around her and others spoke to her by phone and FaceTime. After saying her last farewell, Goldie quietly passed. Her family believes it was just as she wanted. "She was one of a kind," said her grandson Peter.

"I've had a pretty good life."

ORLANDO RICCI

Johnston, RHODE ISLAND
April 8, 1915

O RLANDO RICCI IS READY FOR ANOTHER 100 YEARS. IF GIVEN the chance, he'd spend more time relaxing. He'd also get back to golfing. He played the game for more than sixty years on courses throughout Rhode Island. On his best day ever, he shot a hole in one—twice.

Orlando still gets around by car and lives in the house he and his wife, Marie, bought in 1964 for 15,500 dollars. The sprawling 5,000-square-foot lawn gets mowed regularly, and he keeps a nice row of tomato plants. He doesn't complain. "I've had a pretty good life," Orlando said.

Born in 1915 to Italian immigrants, Orlando grew up with eleven siblings on a farm in Rhode Island. Life wasn't easy but they were happy, and they never went hungry. Orlando still remembers the long table at his childhood home,

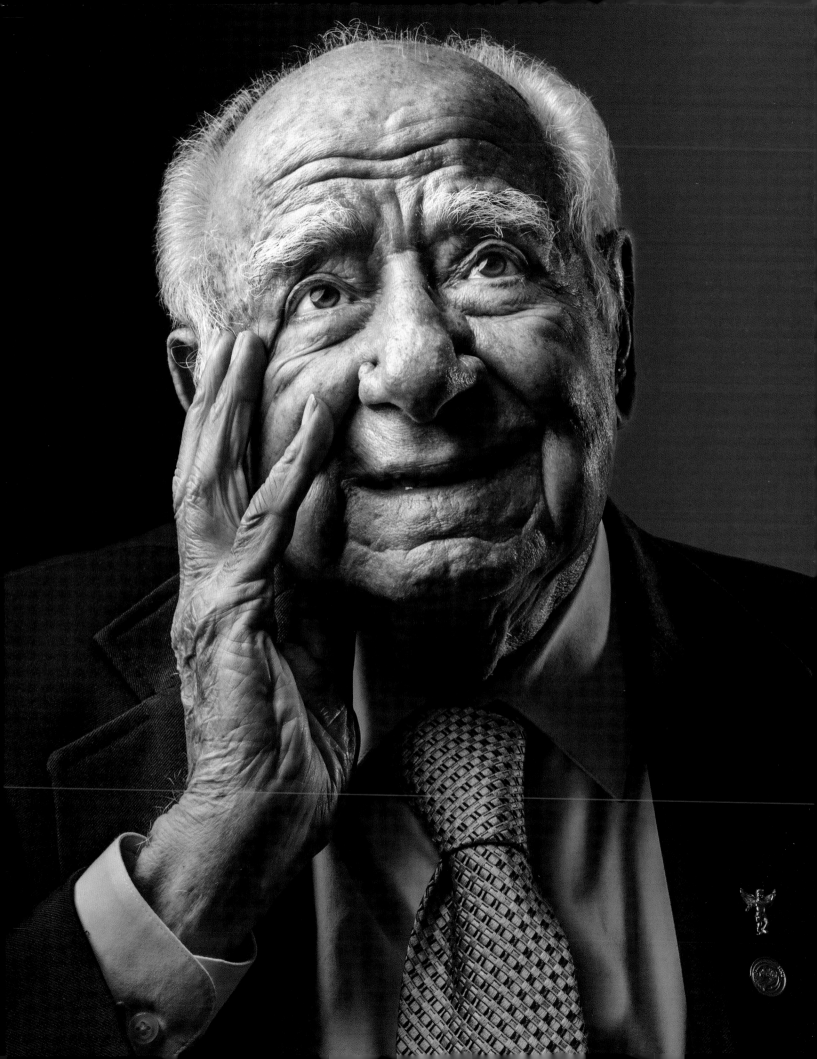

with a bench on one side and chairs lined along the other. Each family member returned to the same spot at the table for every meal. His older brothers made wine during the winters, when the main course usually consisted of cabbage and homemade pork sausage. Orlando's mother always kept a twenty-five-pound bag of flour on hand for baking bread, and the milk delivered to their home by horse-and-buggy had two inches of cream on top.

After finishing the eighth grade, Orlando went to work. Jobs were hard to come by during the Great Depression, so Orlando signed up to work in the Civilian Conservation Corps (CCC). The CCC was part of President Franklin Roosevelt's New Deal and was designed to provide jobs in natural resource conservation for unemployed young men. From the money he saved, Orlando bought his first car—a 1927 Maxwell Roadster. With wheels of his own, he could go anywhere and do anything.

By 1935, Orlando had left the CCC and moved back home, where he got a job as a jewelry press operator. He remembers meeting Marie shortly thereafter. "She looked pretty nice," he said. They went to the movies every Saturday night. Orlando's favorite movie star was Cary Grant; Marie liked Clark Gable. After courting for three years, Orlando proposed. "When she said she wanted to marry me I said, 'All right then, let's go.'" They were married in 1939.

Then came World War II. Orlando joined the US Army and was in the 67th Battalion, where he did signal calling on the front line. He fought in England, France, and Belgium for nearly three years. So did four of his brothers. Only one of the four didn't return, for which their mother became a member of the American Gold Star Mothers.

After returning from Europe, Orlando and Marie settled back in Rhode Island. They raised two children—Elizabeth and Dennis—while Orlando worked as a machinist at Ostby Barton, a jewelry company, and later at Speidel, where he made watchbands.

After retiring from the workforce in 1983, Orlando and Marie took road trips and enjoyed their leisure time with family and friends. Orlando played golf every week, when the weather allowed. He was a member of Triggs Memorial Golf Course and for several years he was part of a foursome called the "walking wounded." Orlando was the only one who walked the course. The other three rode in one cart. "Now they're all gone and Dad's still walking," said Dennis.

Orlando was still playing golf at ninety-three. The only reason he stopped was to take care of his beloved Marie before she passed away in 2011. They had been married for seventy-one and a half years. Now he spends several days a week having lunch and visiting with friends at the Johnston Senior Center. He's also a member of the Church of Saint Rocco Holy Name Society, an organization

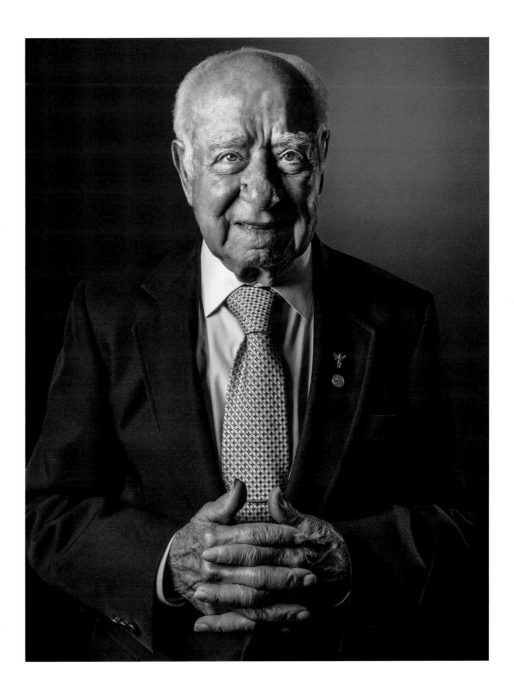

of men of the parish committed to their faith and country. His two children, four grandchildren, four great-grandchildren, and one great-great-grandchild live nearby, as well as his eighty-four-year-old brother Ron, ensuring plenty of family time.

While it appears that Orlando leads a busy social life, he leaves plenty of time in his schedule to tend to his yard and tomato plants during the warmer months, catch up on what's happening in the news, and work on puzzles. Healthy, independent, and content, Orlando is easing his way into the second century of his life, doing what he likes to do and surrounded by the people he loves.

IDA MAE WILSON

Oklahoma City, OKLAHOMA
December 24, 1907

I N 2007, IDA MAE WILSON WAS HONORED FOR ATTENDING EIGHTY consecutive years of Oklahoma University football games. The OU football fan even knew Bennie Owen, for whom the stadium was named, as well as famous OU coaches, such as Bud Wilkinson.

Born in Ardmore, Oklahoma, Ida Mae was raised on a farm nearby, the eldest of three children. After completing high school, Ida Mae studied at the University of Oklahoma and supported herself by working for the telephone company. There she met her future husband Paul Wilson. They married in 1937 and Paul passed away in 1986. The couple didn't have children, but they had plenty of nieces (Sharen and Beverly) and nephews (Paul and Steve) to dote on. Her family still lovingly calls her "Auntie."

Athletic and adventurous, Ida Mae enjoyed travel and was a member of a travel club. She was an avid reader and a walker until she sustained injuries from a fall at the age of 106. Until then, she had enjoyed nearly perfect health. Her great-niece, Allison, a registered nurse, has kept a sharp eye on Auntie for many years. Before Ida Mae had to move to a nursing home, she went on regular outings with her family. In fact, for her ninety-ninth, 100th, and 101st birthdays, her nephew Paul and his wife Linda took her to Las Vegas. Ida Mae hadn't been to Vegas since 1944, when she'd taken a train to San Francisco to see her husband while he was on leave during the war. Ida Mae liked to gamble but she was very conservative, carefully putting in one quarter at a time.

Paul said Ida Mae has always had a positive outlook on life. "She spent more than 100 years being happy and nice to others," said Paul. "You would not find a better person anywhere."

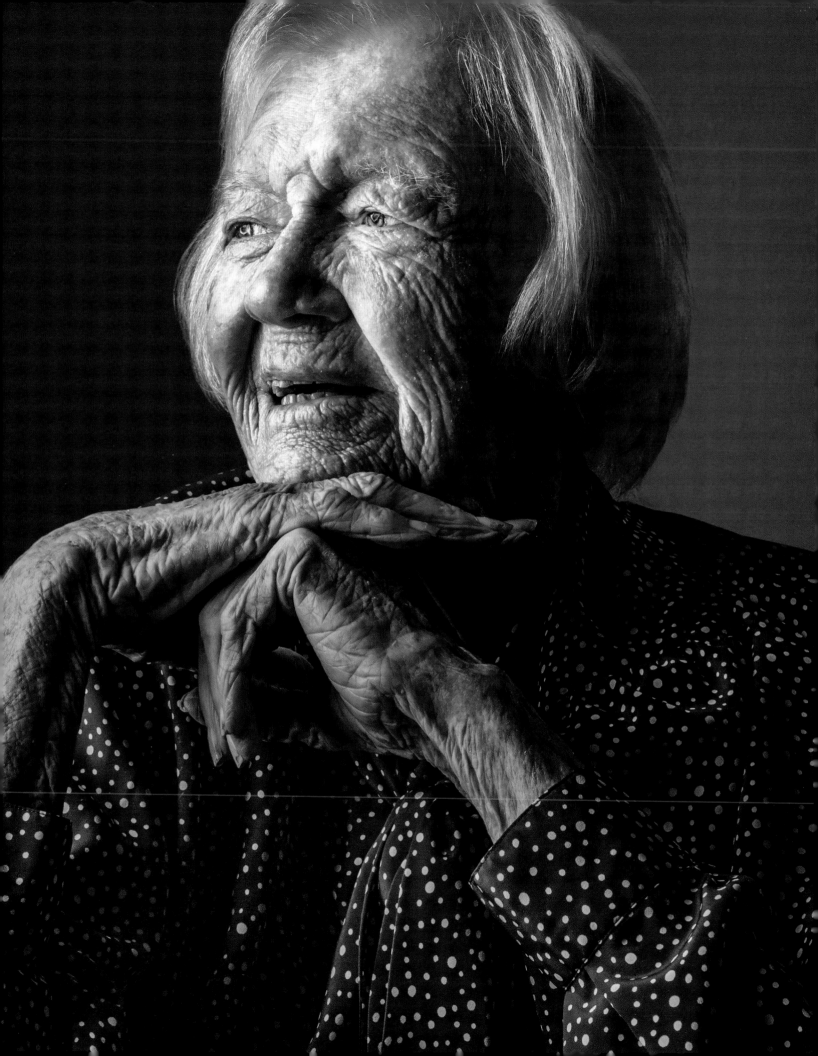

ALVIN SEXTEN

Washington Court House, OHIO
July 3, 1908

WHEN ALVIN SEXTEN WAS A teenager, he decided to start a livestock-hauling business. First, he needed a truck. He socked away money until he had enough to buy a new one and then went to the dealership in town to pick it out. Alvin flipped through a catalog until he found what he wanted. (Back then, vehicles didn't sit on dealership lots.) He placed the order and then waited.

When it was ready, Alvin took a train to Detroit, arriving at the factory just as they were putting the final touches on his rig. Much to his surprise, it wasn't a wood body, as he'd ordered, but a steel body. Even better. Alvin took the truck home and, according to his son, Bill, thought he was quite the "big man in town" driving around in the latest truck technology.

That was the start of Alvin's business, which spanned a couple of decades and burned through a number of trucks, including a semi—the first of its kind in Ohio. Alvin also owned and drove a wood-sided school bus. He met his wife, Francis, in that bus; she was one of his passengers.

At the same time Alvin was hauling livestock for pay, he also was working on the family farm. He'd been born there and didn't plan to leave. He was a third-generation Sexten working the land in Fayette County. The family grew a number of crops and raised beef cattle, but also kept chickens and dairy cows.

During the Great Depression, Alvin and his family held the farm together with very little. Alvin's family managed to ride out the era without losing the farm, but it was not without difficulty and deprivation.

After several years of courting, Alvin married Francis in 1938. They remained on the farm and raised three children: Kay, Rita, and Bill. Alvin sold the hauling business so he could dedicate his time to the farm, but he never lost his entrepreneurial spirit.

In 1955, after considerable research, Alvin built a pole barn to replace an existing one. It was the second pole barn built in Ohio and, at the time, a completely new design approach. Bill said the barn is still standing and has weathered the years well.

As the only son, Bill worked alongside his father every day of his life. Alvin liked to tell stories and Bill heard a lot of them. Sometimes they talked about the changes Alvin had seen over the course of his life. As a young man, he'd farmed with a team of horses. By the end of his farming days, he owned self-driving tractors. Alvin rolled with the changes of the times; he embraced new technology or anything that improved his efficiency.

Alvin also liked to work. "There was no idle time," said Bill. In fact, the only vacation he can recall his parents taking—aside from weekend trips to see relatives—was in 1976. Alvin, Francis, and some friends took a weeklong vacation to drive to Georgia, where they toured former President Jimmy Carter's farm.

Hard work was Alvin's modus operandi and he attributed his longevity to it. He was still hauling grain to the elevator at ninety-eight, and Bill said he was active until the last couple of years of his life. "Never stop to think about dying," Alvin liked to say. "There's no time for that."

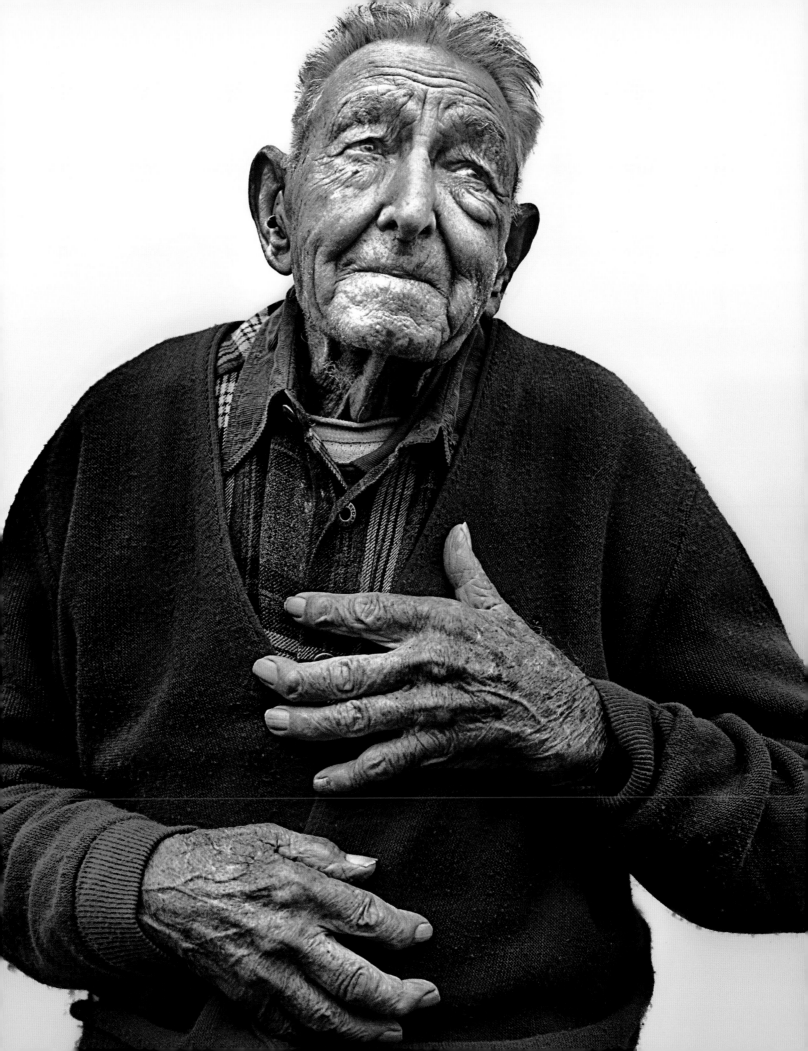

THELMA DAVIS

Belle Fourche, SOUTH DAKOTA
January 11, 1913

HEN THELMA DAVIS WAS A young girl, she helped her father tend their flock of sheep. Spending several days at a time on the South Dakota prairie, sleeping in the sheep wagon at night, Thelma would often be left alone to bravely herd the flock. Her father always kept a pistol in the wagon in case a coyote wandered too close. "When you hear them howl, shoot the pistol in the air," he told her. "That will scare them off."

Thelma's fearlessness is one of her many admirable traits. Her daughter, Sherry, said her mother has never been afraid to try anything, whether it was tuna fishing in Alaska, flying in an open-cockpit plane, or training a young horse. "She's a remarkable person," said Sherry.

Thelma grew up on a farm with her parents, Luther and Kate Hill, and three siblings. During haying season, she drove the team that raked up the hay in the field. An enormous pile would gather on the trailer, and then Thelma would guide the team back to the barn, where her brothers unloaded it with pitchforks. She milked the cows and fondly recalled how she would squirt milk to the cats sitting patiently nearby. She also helped her mother in the vegetable garden, fed the chickens, and gathered eggs. There was a lot of work to be done, but there was also time to enjoy life. Thelma recalled walking to church together as a family, and she and her siblings rode four miles each way to school—on one horse.

After completing high school, Thelma earned a two-year teaching certificate. Her first job was at a country school outside of White River, South Dakota, that combined all grades in one classroom. Thelma met her first husband, Ora, in White River, and they married in 1936. During the first few years of their marriage Thelma didn't teach, but eventually she returned to the classroom. During the summers, she would take classes at Black Hills State University to advance her education. Although it took a number of years to complete, eventually Thelma received her bachelor's degree in education.

Thelma and Ora had four children: Sherry, Michael, Linda, and Leo. Ora changed jobs frequently. One of his ventures was owning and operating a café in Rapid City, South Dakota. On Saturdays, Thelma would bake twenty pies to sell to people leaving the dance clubs at night. There wasn't a morsel left by closing time. Her reputation as a pie maker—especially for her apple pie—was known far and wide.

Sherry described her mother as the kind of person who could do anything and always had answers to her questions. Growing up, Thelma encouraged her children to explore creative solutions to their problems. She took her own advice when her marriage ended in 1960. Moving to Spearfish, where incomes were higher, Thelma continued teaching, took in college students as boarders for extra money, and found industrious ways to save.

Three years after retiring at the age of seventy, Thelma was introduced to Chuck Davis, the true love of her life. Sherry fondly recalled the evening Chuck came to her house to ask if she and her siblings would object if he asked their mother to marry him. "We all knew they were headed toward

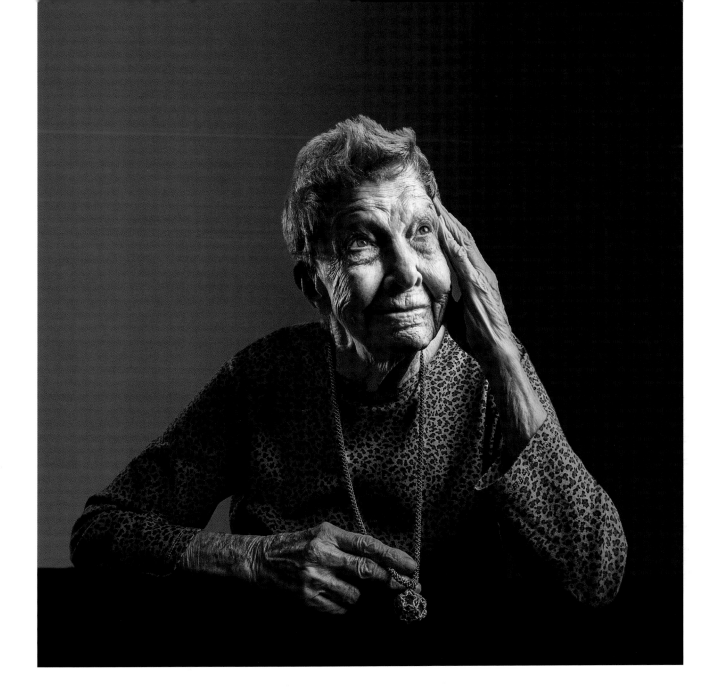

marriage," Sherry said. The couple married in 1988, and for ten years, until he passed away in 1998, they enjoyed life to the hilt. Traveling abroad and across the United States, the pair also enjoyed taking walks together, using their metal detectors to find hidden treasures, playing cards, and fishing.

Thelma has macular degeneration; she is now legally blind. Although she's no longer able to read, she listens to books on tape, but mostly she fills her time making toothbrush rugs, a skill she picked up when she turned 100. The proceeds from the sales of the rugs, made from old sheets and other recycled materials, go to the Methodist church.

Thelma's doctor told her she acts more like a seventy-seven-year-old than a centenarian. She considers that a compliment, and is appreciative that she has lived such a long and fulfilling life. "Living a long life is a gift from God," she said. "But to help him along, you need to work hard, play and laugh often, eat healthy (most of the time), keep busy, and be kind to others." Clearly, Thelma has been very helpful.

HAROLD LAMBERTY

Faribault, MINNESOTA
July 9, 1915

HAROLD LAMBERTY WAS JUST A schoolboy when he got a job delivering milk by horse-and-buggy. He still remembers the horses' names—Maud and Pony—and he can picture the containers his customers filled with buttermilk. Back then milk cost only ten cents. Harold got up well ahead of the sun to get the rig ready and deliver the milk before school. He suspects that's why he didn't do too well as a student. He was always falling asleep in class.

After his father became ill, Harold helped support the family while his three sisters took care of the house. He held a lot of jobs as a young man, so many that he lost track. Then he joined the National Guard. On one memorable occasion, Harold was sent to Minneapolis during a truck driver's strike. His unit was responsible for keeping the area safe from the "hoodlums causing the trouble." It was an exciting event to witness, but Harold wasn't particularly comfortable with his role. "The only part I didn't like about it was having to carry a loaded gun and given orders to shoot," he said.

Harold was working in a Faribault, Minnesota, grocery store when he was drafted in 1942. He was immediately deployed overseas and stationed in New Delhi, India. He spent two years there and in Burma as part of the 164th Signal Corps Photo Company, supplying the military with cameras, film, and chemicals. Harold's memories of India are of incredible heat and humidity. But he also remembers the Taj Mahal and its remarkable beauty. After the war, Harold returned to his hometown.

He took a job on a tobacco and candy route. Later, he worked at a cleaners, tended bar for a number of years, and then landed a position in the post office. Eventually, after six decades of hard work, Harold was able to retire and enjoy a life of leisure.

Harold and his wife Jane have been married for more than seventy years and have four children (Patricia, David, Dale, and Kathy) and nine grandchildren. For years they escaped the Minnesota winters by going to Texas in their motor home, car in tow so they could take short road trips throughout the Southwest and Mexico.

"I've taken pretty good care of myself," Harold said of his health. He also still drives his car. He needs the mobility to help care for Jane. She requires help around the house, and Harold takes her to appointments.

But he still reserves time to get out for a daily walk. He used to walk three miles a day but has scaled back a bit. He also likes his daily dose of beer. Loves it, in fact. Just one or two bottles a day, and not any brand in particular. For his 100th birthday, he was given cases of beer. There are so many cases that Harold suspects he'll have enough to last the rest of his life. But there's no guarantee; Harold is still going strong.

In 2010, Harold was invited to go on an Honor Flight to Washington, DC, to visit the National World War II Memorial. Harold was honored to attend with his peers, many of whom were in wheelchairs. It reminded him of his good fortune and health. "I felt pretty lucky to still be walking around," he said. "Yes, I am fortunate. I feel pretty good."

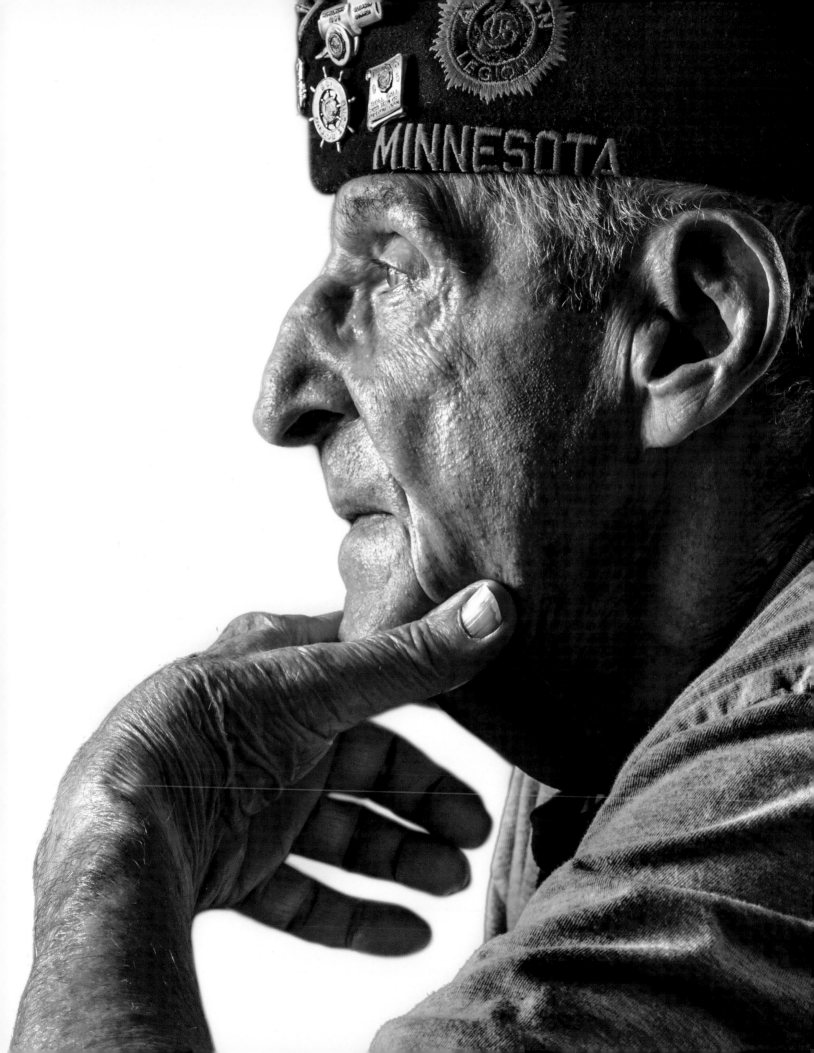

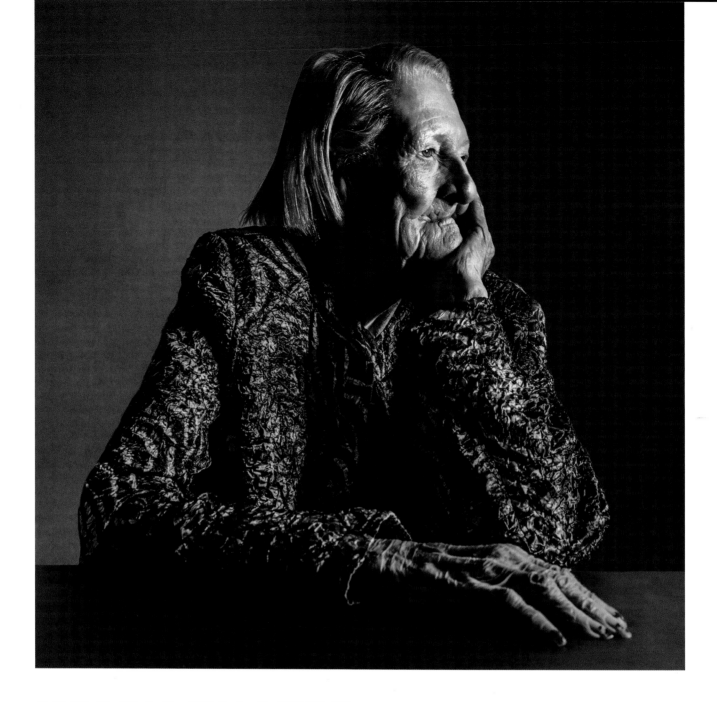

HELEN WALTER

Las Cruces, NEW MEXICO
November 13, 1909

WHEN HELEN HOLT WALTER WAS a young girl growing up in Tennessee, she was stricken with scarlet fever and spent two years at home. During her long, slow recovery, an aunt provided tutoring so she wouldn't fall behind in her studies. The one-on-one attention gave Helen an academic edge, and when she returned to school she discovered that she'd outpaced her classmates.

After graduating from public school at the age of sixteen, Helen attended a local college for two years and then transferred to Vanderbilt University to

study journalism. To her misfortune, Helen graduated in 1929, the same year the country fell into the Great Depression. It had been difficult for women to land professional jobs before the Depression, but during that era it was nearly impossible.

By then, Helen's parents had moved to Jacksonville, Florida, where her father was the minister at the First Presbyterian Church. His connections proved to be helpful. She was able to get a job as a bank teller in spite of the depressed job market. Pretty and sociable, Helen soon met her first husband. He was in the Army Corps of Engineers, so the young couple moved frequently before settling in Washington, DC.

When the marriage ended in the 1930s, divorce was uncommon and especially difficult for young women. But Helen was smart, practical, and strong willed. She landed on her feet, securing a good job at the Pentagon—and a new love interest. She also owned and sailed her own boat, which she moored at the Capital Yacht Club in Washington, DC. In 1944, Helen married Lawrence (Larry) Walter, a lieutenant commander of the Seabees, a position that took him all over the Pacific during World War II. Meanwhile, Helen remained at her job as a statistician tracking American warships lost during battles at sea.

After the war, Helen left her job at the Pentagon and the couple moved to Potomac, Maryland, to raise a family. They had two children, Anne and Karolyne. (Karolyne passed away in 2004.) Anne described her mother as being very Victorian and proper, a reflection of her religious upbringing. She recalled a scene from her teen years when she, Karolyne, and their mother were watching a television movie. In one of the scenes, a man and woman were kissing on a beach, the waves washing over them. "Don't ever let a man get you in that position," Helen told her daughters. "We just looked at each other and laughed," said Anne.

After retiring from their respective careers, Helen and Larry resettled in Holly Hill, Florida, enjoying twenty golden years of leisure until Larry was moved to a care facility for Alzheimer's patients. Helen and Larry moved in 1988 to Clearwater Beach, Florida, to be close to Karolyne and their two grandchildren. Larry died shortly thereafter.

The decade following Larry's death was especially difficult for Helen. She stopped doing the things she'd enjoyed and had a limited social life. But she did continue to travel, taking Karolyne to Australia and Scandinavia and Anne and her husband Michael to Italy.

Anne said her mother had never been one to sit idle. She'd always been active in her church, kept a garden, sewed, and was even involved in Daytona Beach city politics. "Even if she was watching television, she never sat down. She would find chores to do at the same time," said Anne.

After Karolyne died, Helen moved to North Carolina to be with Anne and Michael. In 2012, they all relocated to Las Cruces, New Mexico. Helen moved to a care facility two years later, a place where she could get around easier in her wheelchair. Although she has no major physical ailments, she does have poor vision due to macular degeneration and is hard of hearing. Still, she doesn't take any medication, except for an occasional Tylenol.

Longevity doesn't run in the family; only one of Helen's siblings lived more than ninety years. Helen doesn't know how she has lived this long, and she doesn't think about it too much either. She just takes it one day at a time. "Don't we all?" she said. In November 2015, Helen celebrated her 106th birthday at the Aristocrat Assisted Living Community with Anne, Michael, and a gathering of admirers and local press. When she was asked what she wanted for her birthday, she said wryly, "A boyfriend and tequila."

MAUDE WANGBERG

Omaha, NEBRASKA
May 16, 1905

B Y THE TIME MAUDE WANGBERG RETIRED FROM THE VAUDEVILLE circuit in 1930, she had traveled the country and throughout Canada several times and had more adventures than most people have in their lifetimes. She was only twenty-five, but five years on the road as a dancer with the Whirl of Splendor was plenty for Maude. She was ready to go home to Omaha, Nebraska.

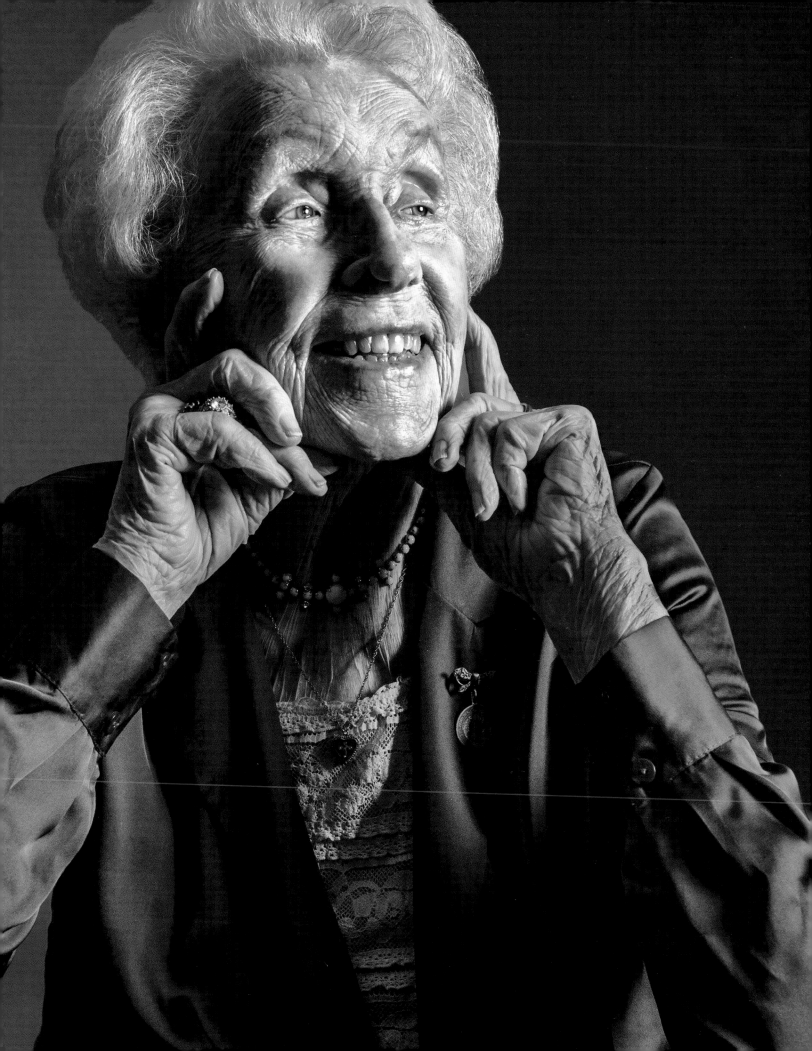

Maude discovered dance as a teen and was devoted to the art. She studied at the premier dance studio in Omaha and practiced at every opportunity. After high school, Maude attended Duchesne College, but dance beckoned. Shunning the conventions for young women at the time—and defying her father, who was against her career choice (though her mother supported her)—Maude went east with her dance instructor to be part of a new dance troupe. She settled in an apartment in New York City with three other dancers from Omaha—all of whom returned home after a short stint on the vaudeville stage.

The Whirl shared the bill with some of the great vaudeville performers, such as Sophie Tucker and Milton Berle. Dance acts and singers filled the show, with performers entering and exiting on a revolving stage. Maude was part of an all-girl dance finale. Because of her skill, training in an array of dance styles, and pizzazz, Maude was the featured dancer in many of the shows. Slight of build and wearing her dark hair in a bob—the style at the time—Maude was the quintessential flapper.

The Whirl traveled by train, making the Orpheum vaudeville circuit in and around New York and Canada, as well as appearing in major theatres along the East and West Coasts and in the Midwest. The group performed nearly every day of the week, sometimes doing several shows a day. It was thrilling to travel the country in such a provocative era, but the pace was exhausting and the lifestyle difficult.

During her vaudeville years, Maude had been given two chances at stardom. Early in her career, she'd been offered an opportunity to lead a Paris revue, but she turned it down. Later, she was asked to headline a vaudeville show in New York. By then she was tired of the demanding pace—for which she was paid fifty-five dollars a week. She declined the offer and instead returned to Omaha, and to John Wangberg, the boy she'd dated as a teenager and corresponded with while on tour.

Maude was born in Grand Island, Nebraska, the youngest of three girls. Her parents moved briefly to Chicago, and then resettled in Omaha, where her father worked as a reporter with the *Omaha Bee*, and then as advertising sales manager for the Iten Biscuit Company. Her parents were devout Catholics; Maude used to say that she might have ended up a nun if she hadn't discovered dance.

After Maude returned to Omaha, she and John picked up where they left off. They married in 1933. Maude wore a white suit and gloves. It was a modest wedding, as Maude's father had lost a lot of his money in the Great Depression, and John returned to work the next day. Times were tough, but the newlyweds

were remarkably lucky. John had a good job as a salesman for RKO Pictures, a film production and distribution company. (Coincidentally, RKO was formed from a merger in 1929 that included the Keith-Albee-Orpheum vaudeville theater company.) Maude opened a dance studio.

They settled in Kansas City, where John had been transferred, and started their new life together. A few years later, John was transferred again, this time to the South. As a salesman, John had to go from one city to the next. Maude joined him and together they traveled from city to city, mostly living in hotels. Maude enjoyed the travel and exploring the South—especially the food. She amassed an impressive collection of Southern cookbooks during that time.

After many years, however, Maude grew tired of the transient lifestyle and spending her days "sitting around." They returned to Kansas City, purchased a house, and, in 1946, adopted a daughter, Lorraine. Maude happily settled into domestic life. She was very involved in Lorraine's schools and several Catholic organizations. "Mother was a professional volunteer," said Lorraine. She had an affinity for nuns, and Lorraine recalled the time her mother and father took several nuns to a Braves baseball game. They enjoyed watching the nuns having a good time.

John died in 1991. By then, they had moved to Omaha to be close to Lorraine and her husband, Thom, and extended family. Maude lived on her own until she was 100 and remained active as a volunteer well into her eighties. She tried to attend Mass every day, read a lot, and watched Kansas City Chiefs football and Kansas City Royals baseball on television. When she finally gave up driving, Lorraine was relieved. Maude had a reputation in her family for driving too fast. "We called her leadfoot," said Lorraine.

Although her hearing declined and her mobility was limited, Maude kept all of her teeth and remained in good health, in spite of her lifelong aversion to vegetables and fruits and her sweet tooth. Lorraine said her mother always had a sweet roll for breakfast, and dinner was primarily meat and potatoes followed by dessert. But Maude never snacked between meals and always maintained her weight—her secret to longevity.

Or perhaps it was the fact that longevity ran in the family. Maude's mother lived to be 103, a sister reached 102, and all of her aunts lived into their nineties. At the age of 107, Maude was honored by the County Board for being the oldest living resident in the county as part of its 100-year celebration of the Douglas County Courthouse. When she passed away at the age of 109, three months shy of 110, Maude still reigned; she was also the oldest woman in the state of Nebraska.

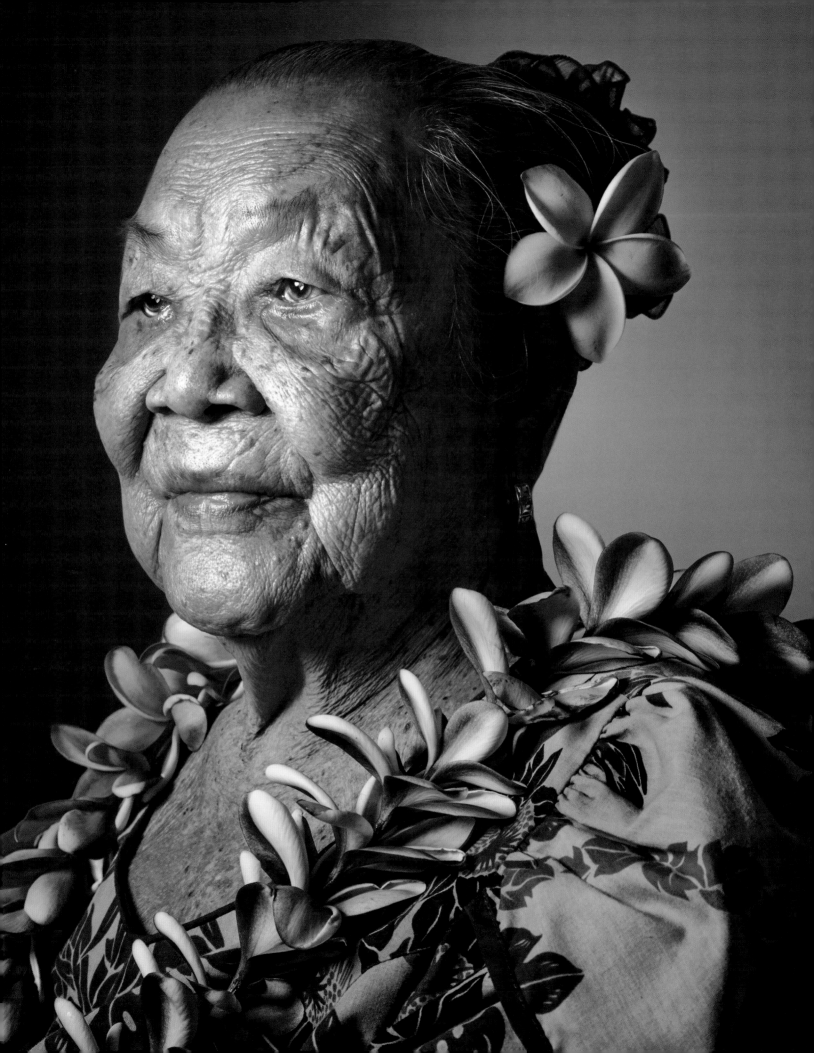

JOSEFINA SADAMA

Lahaina, HAWAII
August 31, 1915

SEVERAL TIMES A DAY, JOSEFINA SADAMA likes to sit in the opening of the garage at her daughter's home in Lahaina, Hawaii, and smoke hand-rolled tobacco from her native Philippines. She tears small pieces from the dark brown leaf and neatly rolls them into a larger piece. Next, she trims one end, and then ties the other end with a string and trims it too. Finally, it's ready to smoke. She enjoys the warmth of the sun and the relaxation that comes from a habit she has had since she was a young girl. Throughout her life doctors have told her to quit, but she brushes off their warnings. At the age of ninety-nine, she told a concerned respiratory therapist that if she quit smoking she would die.

But Josefina likes to do more than smoke tobacco. She's a gifted seamstress and quilter, and she also likes to crochet. Josefina still uses an antique Singer treadle sewing machine. Although her eyesight makes most work difficult to do now, many of her family and friends have something she has made over the years as a keepsake.

For many years, after retiring from the Del Monte cannery in Honolulu at the age of sixty-two, Josefina kept a garden and babysat her grandchildren. She often traveled to the Philippines, always bringing with her balikbayan boxes filled with gifts for her relatives. Balikbayan boxes are usually sent by freight or delivered by family members traveling by plane. They might contain nonperishable food, but also clothing, toys, or other items that are difficult to find in the Philippines.

Although Josefina's five children (Benny, Mabel, Linda, Tony, and Rose), eighteen grandchildren, and eighteen great-grandchildren live in the United States, many relatives still reside in the Philippines. Some live near the area where Josefina was born and raised: Sanchez-Mira, in the province of Cagayan. During World War II, the province suffered significant destruction from bombing and later invasion by the Japanese. Josefina still remembers the terror she felt during the invasion. She described fleeing to the forest to hide from Japanese soldiers, staying there for days until she knew it was safe to return to her home. Her husband, Aurelio Sadama, faked malaria to keep the Japanese soldiers away.

In 1946, Aurelio and their eldest son, Benny, moved to Hawaii, where they had relatives. Two more children joined them in 1961, but it was 1966 before Josefina and the rest of her children were together in their adopted home. Although she speaks English, Josefina prefers to use Ilocano, her native tongue.

Josefina's granddaughter, Judy, said her grandmother doesn't like to receive help or be the center of attention. She has always been a very independent woman. But now that she has reached a stage in life that requires a little more help, Josefina is graciously accepting it. For her 100th birthday, her family took her to Las Vegas for five days of gambling and entertainment. It's her favorite place in the world and she enjoyed herself immensely. So much so, in fact, that she has been asking when they can return.

"[Ruth] was the best bingo prize I ever won."

IRVING OLSON

Tucson, ARIZONA
November 26, 1913

IRVING OLSON'S THREE-PART FORMULA FOR A LONG LIFE: HAVE A great spouse, enjoy everything in moderation, and don't under any circumstances take any crap from anybody—ever. There might be something to that advice considering Irving has remained healthy, active, and sharp as a tack for more than a century. He's still creating and experimenting, too. In his kitchen-turned-photography laboratory, Irving has been working on his latest project, which involves photographing the precise moment when two water drops collide. He became interested in the subject after seeing a similar black-and-white image in a technical photography magazine. After figuring out how to get the shot, Irving added color.

In 2012, *Smithsonian Magazine* featured Irving's colorized water drops on its blog; the Hearst Foundation has two of his images in its permanent collection in New York; and he's regularly featured in the press. He posts his best work on his Facebook page and keeps his website up to date.

"I never took any classes; it's always been a hobby for me," said Irving. Although he considers himself an amateur photographer because he has never earned his living by taking photographs, Irving has been handling a camera for ninety-two years. His first one was a Kodak Brownie that he picked up for a dollar. He's pretty confident he has taken more photographs in his lifetime than anyone else in the world.

Irving thinks he has done well in life, considering he flunked kindergarten. (Apparently, the teacher didn't like that he couldn't memorize the rhyme, "Jack be nimble, Jack be quick, Jack jump over the candlestick.") He made it through grade school and high school "with much trouble" before attending the University of Akron in Ohio—the first person in his family to go to college. He paid the forty-dollar tuition with money he'd earned repairing radios.

But shortly after starting college, Irving announced to the engineering dean that he was dropping out. He marched out of the office, leaving his pencils, paper, and a good ballpoint pen on the dean's desk. "I took off and I was happy. I was free!" he said.

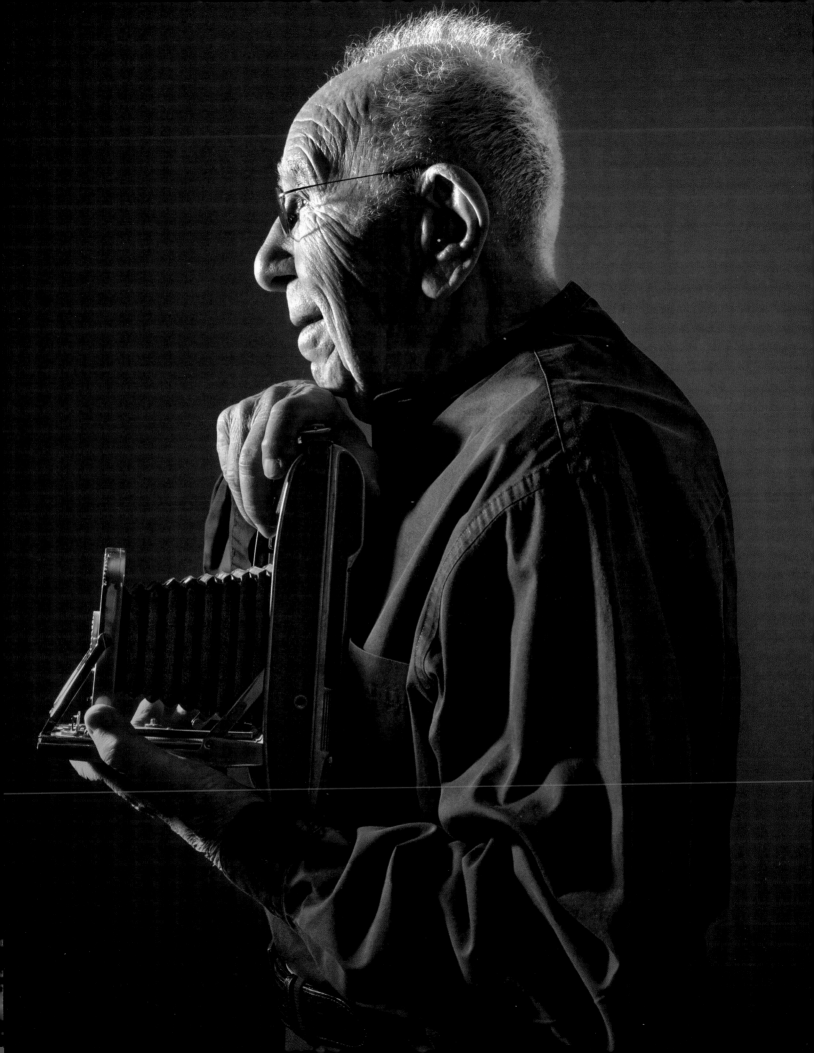

Needing to earn a living and not the least bit interested in being a barber like his father, Irving opened up a radio repair shop in his parents' basement. A neighbor with a broken radio was his first customer. Although he'd never seen the inside of a radio, Irving figured out what wasn't working by testing each part. It was a faulty capacitor. He went to Woolworth's and bought a new one for fifteen cents, repaired the radio, and collected two dollars for three days' work. That was the beginning of Irving's career in electronics. From a modest start in the family basement, Irving and his younger brothers,

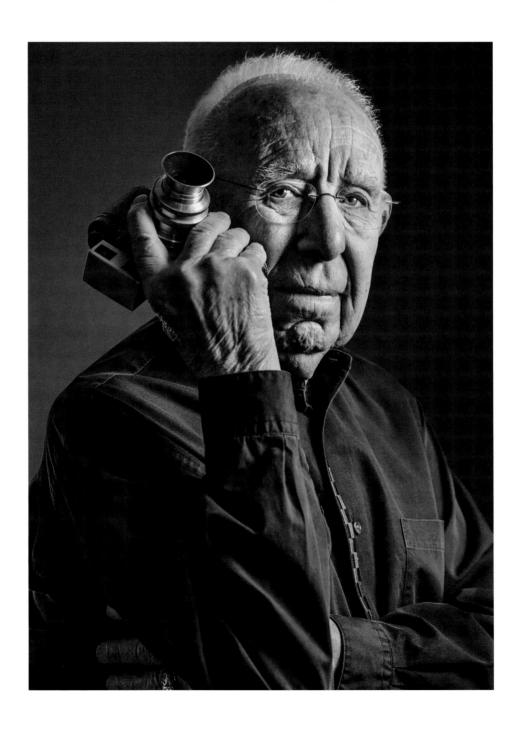

Sidney and Philip, built an immensely successful radio repair and parts retail chain and mail-order business. At the height of its success, Olson Radio Warehouse, which became Olson Electronics, had grown to more than 100 stores nationwide and did mail-order business in almost every town in the United States.

In 1963, the Olsons sold their business to Teledyne Industries for a handsome sum and, shortly after, Irving retired on his fiftieth birthday. "At five o'clock, I put my pencil down and walked out. The next day they delivered my personal items from the office. That was it," he said. Financially secure and with many interests to pursue, including a passion for photography and travel, Irving and his wife, Ruth, began a new chapter in their lives.

Irving met Ruth, his "redheaded damsel," at a dinner party in 1940. His friends had put him in charge of calling the numbers in a bingo game and when a pretty young woman sat down next to him, he devised a way to impress her. Since he could see the numbers on her cards, he made sure she won every game.

Irving invited Ruth out on a first date by sending her a letter that read: *I'd like your company next Saturday night. Please accompany me for dinner.* "I wanted to woo her so I took her out for a nice dinner. Her other boyfriends were only taking her out for a Coke," Irving said. That first date was the beginning of a relationship and marriage that lasted nearly seventy-one years and produced two children (Stephen and Carolyn), six grandchildren, and six great-grandchildren. "She was the best bingo prize I ever won," he said wistfully.

After Irving retired, the couple spent more than forty years traveling the globe, photographing places, people, and landscapes. They shared a love of photography and developed their craft together. Their photographs have won dozens of awards and are in collections throughout the United States.

In 1999, Irving and Ruth made Tucson their permanent home. They got involved in the community, just as they'd done in Akron, and set up several scholarships to help students of the arts in Arizona. Then, in 2011, after a long illness, Irving's beloved Ruth passed away at the age of ninety-one. Irving said her passing was the greatest tragedy of his life.

In spite of his loss, Irving soldiers on, staying engaged in his community and friendships, and responding to the many e-mails he receives from strangers who admire his work and tenacious spirit. He ends his day with one Scotch (he has never been drunk) and gets four hours of sleep every night. He assumed he might live to be 100, but hadn't considered what would happen beyond that. "I got to 100 and I guess I forgot to die," he said wryly. On most days, he's just happy to create in his photography lab, energized by the possibilities presented when two water drops collide.

LILLIAN MILLER

Chicago, ILLINOIS
February 5, 1915

LILLIAN MILLER HAD A GOOD LIFE. SHE had a lot of friends, a family that adored her, and she was happily independent. "She was a real character," said her nephew Julian. Lillian liked to travel, read, and create. For several years, she and her best friends Molly and Bess went to a movie and dinner every weekend. When they were younger, they rode to Lake Michigan to sit on the beach with their books. Friends for at least fifty years, they were more like sisters.

Lillian was born in Joliet, Illinois, outside of Chicago, where she grew up in poverty with her six siblings. The family didn't have electricity or indoor plumbing; they used gas mantles for light and heat. Their mother cooked in a potbellied stove in the dining room and a large cook stove in the kitchen. Everyone bathed in a round tub in the kitchen. After their outhouse burned down, a pantry in the house was converted to accommodate an indoor toilet. The family was thrilled.

Lillian wanted to be a teacher, but her family did not have the means to pay for college, so she jumped right into the workforce after finishing high school. Her brother Elmer had become a pharmacist and started his own company. Lillian worked for him for several years, selling vitamins and injectable solutions to physicians, helping in the office, and filling orders. Eventually, Lillian landed a coveted position at the Saks Fifth Avenue department store on Michigan Avenue. Lillian started in sales but within a short time was promoted to manager in the lingerie department. Her clients were Chicago's elite. She wore smart outfits in Saks-designated beige, brown, black, or navy with heels, and always a piece of jewelry. Her hair was coiffed and her nails polished. Lillian's career at Saks spanned more than three decades. Her friend Molly worked there as well, and for a few years Lillian's sister Florence worked in the shoe department.

When she was a young woman Lillian was courted by several gentlemen, but she never married. She liked her independence and the ability to earn her own money. Also, she wasn't interested in moving away from her family and friends. Lillian devoted many years to caring for her ailing mother and a sister. Her family was the most important thing to her and she remained close to her siblings throughout their lives. She doted on her nieces and nephews as well; rarely a birthday or graduation went by without Lillian there.

As creative as she was intellectually curious, Lillian took art classes for many years at the

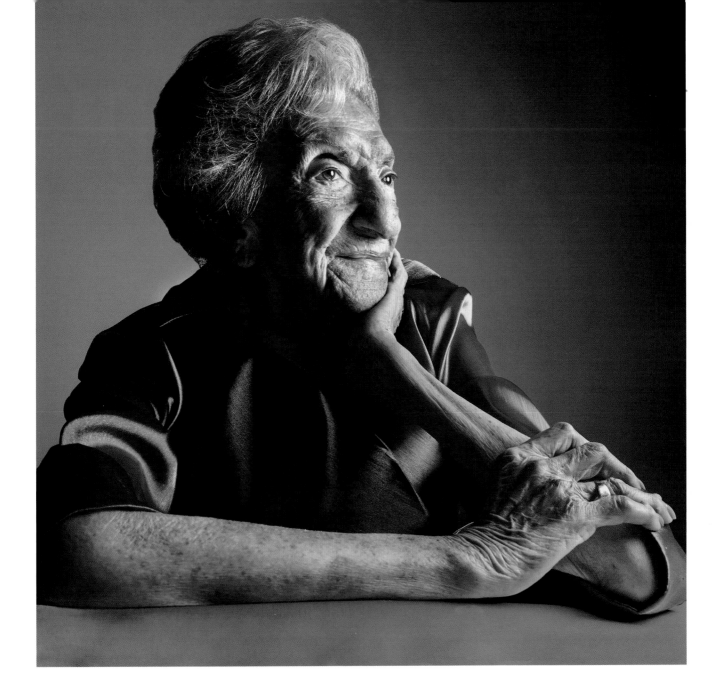

Art Institute of Chicago and other studios. She studied painting, sculpture, and metal welding, and continued to create artwork into her nineties. She equally enjoyed viewing art in Chicago's many galleries and museums, and listening to music, especially classical.

Lillian stopped driving in her nineties, but it didn't slow her down. She always found a way to get where she needed to go. Finally, it was failing eyesight that restricted her freedom. Lillian had macular degeneration and by the time she reached the century mark it was difficult for her to see well enough to get around without help.

Although all her friends and siblings had passed, as Lillian neared the end of her life she regretted that she would not be able to see what her great-nieces and great-nephews would accomplish. Ruthy Rabyne, Molly's niece and Lillian's caretaker at the end of her life, considered her family. "Aunt Lil was a very warm, loving, and caring person who was very interested in the lives of those she loved, and was most generous," said Ruthy.

LUCY HAMM

St. Louis, MISSOURI
January 30, 1908

J ANUARY 30 IS LUCY HAMM DAY IN ST. Louis, Missouri. Mayor Francis Slay proclaimed it would always be Lucy's day. After all, she's one of the oldest living residents of St. Louis and deserves to be recognized as an elder of the city. Lucy is pleased. After decades of hard work and raising two children, she is now enjoying the well-deserved spotlight. "I like to be the center of attention," said Lucy. "If not, I get ornery!"

Born in 1908 in Cairo, Illinois, one of fifteen children, Lucy was the first person in her family to attend high school but had to quit at age fifteen to help raise her younger siblings following the death of their mother. After marrying Joseph Hamm in 1927, the couple—with their two children, Herman and Anna—moved to St. Louis. However, in 1940 Lucy left Joseph and raised her children alone. She supported her family by working a string of jobs. It was difficult for women to get good full-time positions at that time, so Lucy had mostly part-time jobs, such as housekeeping. When World War II broke out, she helped the war effort by working at a small arms plant. Eventually, she moved on to the Brown Shoe Company, and then to Walk Easy, where she learned all aspects of the business, from administrative work to manufacturing. Lucy was the happiest when she was busy and as a result did not retire until she was seventy-two years old.

In fact, Lucy attributes her longevity to hard work. Her very first job as a child was helping her mother carry buckets of hominy to sell to local hotels. "I've learned that it doesn't hurt you to work," she once told a reporter. Lucy has also evaded disease (her only stay in the hospital was for a hysterectomy in 1952), and she shunned bad habits like smoking.

In 2001, Lucy left her apartment for Tower Grove Manor, where she enjoys an active social life. She has earned the title of "sheriff" because she knows what's going on most of the time. She still enjoys a beer or cocktail during the weekly cocktail hour and says it's the key to long life. "Drink a beer every day," she said. "Then follow it with an apple." It's also still important to her to look nice. She loves to get dressed up for meals—especially in pink—and always accessorizes her outfits.

Lucy is also in remarkable health, refusing to give up her walker for a wheelchair. "She said she's not going in a wheelchair because once you do you can't walk anymore," said Janice Hamm, Lucy's daughter-in-law. "She said, 'I want to keep walking.' So as long as her legs will carry her, she's going to stay on that walker. She's a very determined person."

Lucy is also a very happy person. She has a lot of friends at the manor and her family—which includes five grandchildren, eleven great-grandchildren, and one great-great-grandchild—lives nearby. "After 108 years, I'm perfect now," she joked. "I'm just trying to straighten everyone else out!" Still, she questions why she has outlived all of her peers. Janice said she has brought it up on several occasions. "I tell her that God isn't finished with her yet," said Janice. "And she always replies, 'I wish he'd tell me why.'"

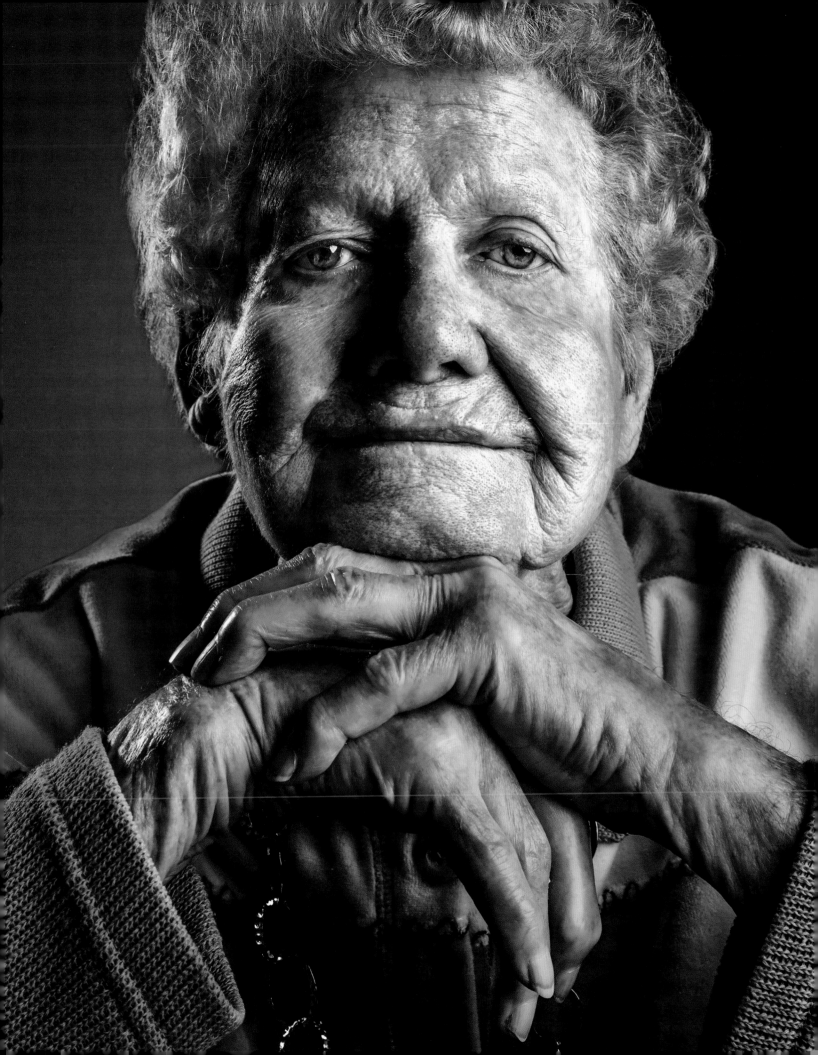

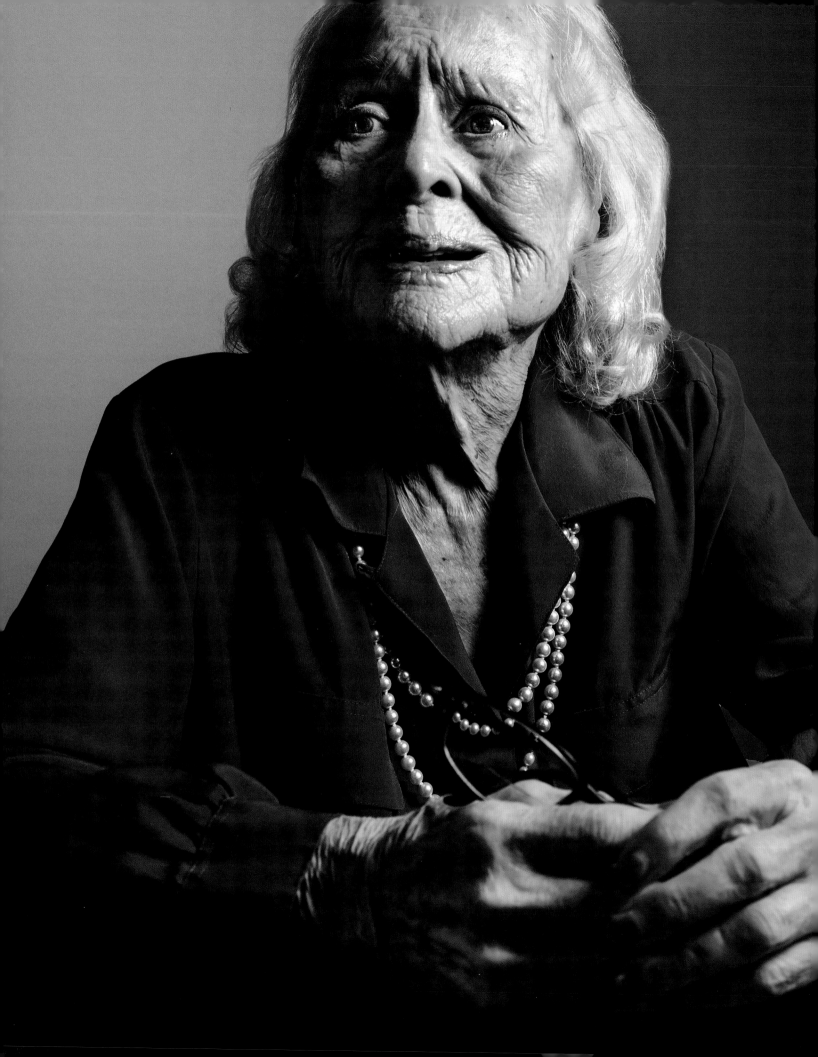

CLARA ANDERSON

Homer, ALASKA
July 2, 1905

SOME PEOPLE ACCUMULATE THINGS. CLARA ANDERSON ACCUMULATES knowledge. She has been doing it her whole life. She listens, watches, reads, and studies—always curious and interested in her surroundings. She forms opinions about the things she reads only after giving the matter considerable thought. "Keep your eyes open and your mouth shut and you'll learn a lot," she said. If asked, she'll gladly share her opinions at the appropriate moment. She calls this "speaking her truth." Her granddaughter, Kellie Blue, said it's probably one of the things that lends to her longevity. Rather than bottling up her feelings and thoughts, she expresses them— mindfully. "Wait for a teachable moment," Clara said.

There are other traits and behaviors that may also explain how Clara has lived such a long and productive life: fearlessness, resilience to adversity, service to others, faith, and creative expression.

Clara's father instilled in her the importance of education and charity. He was a pastor in the church in Winigan, Missouri, where Clara grew up and also taught school. He gave generously to his community. Clara recalled the time her father spent days caring for a neighboring family during the Spanish flu epidemic of 1918, when millions of people died. She was proud of his self-lessness. She still speaks of him with reverence. "I'm pretty lucky to have the dad I did," she said.

Like her father, Clara had an aptitude for math. In high school she was introduced to calculus and later became the first girl to take a calculus test in the state. She was also a gifted musician and studied piano throughout her childhood. After graduating from the Springfield Teacher's College of Missouri, Clara and her sister Irene took a long and arduous train ride to the Pacific Northwest, where their aunt and uncle had a farm. Their Aunt Maude had offered to find teaching jobs for them. Along the Oregon coast there were many logging camps with migrant families. Clara easily found work in the camps, teaching the children English grammar, art, math, and music.

"Keep your eyes open and your mouth shut and you'll learn a lot."

Her family proudly tells the story of the time Clara marched into a camp and went head to head with a logging mill owner who wouldn't supply study materials for the children in his camp. Her mantra has always been, "Don't go borrowing trouble when you don't need to," but in that case, Clara felt it was essential to speak up on behalf of the children and their parents. She told the mill owner that it was not Christian-like to deny children the opportunity to learn. Clearly her words made an impression on the mill owner because shortly after the confrontation the children in his camps received books and learning materials.

Clara met her first husband while teaching in Oregon. Victor Samuel O'Herliney was a native of the Pacific Northwest and worked as an engineer on the Oregon jetty program. The couple had one child, Marylee (Mary), before Victor had a serious accident. His injuries were so extensive that he required around-the-clock assistance and hospitalization for the rest of his life. After his

death, Clara raised Marylee on her own as she continued teaching and advanced her education at the University of Oregon, where she earned a master's degree.

When Clara met Einar Paul Anderson, a widower and an engineer for a Portland electrical company, Marylee had already married Ken Oldham and moved to Alaska, where they ran a successful fishing and hunting lodge. Clara and Paul married in 1963 and for the next six years enjoyed a life of international travel and adventure. Clara worked at Meier & Frank, a Portland-based department store, and kept a lush yard and garden. After Paul passed away, Clara helped take care of her grandchildren (Jean, Kellie, Ken, and Kris) while Mary and Ken were operating their hunting and fishing lodge for weeks at a time in the Alaskan wilderness. Kellie said she loved staying with her grandmother and appreciated the clothes she made for her. "I had the best outfits and homecoming dresses," she recalled.

In 1991, Clara moved to the Clackamas Town Center Village on the outskirts of Portland, where she devoted most of her time to volunteerism. She and her best friend, Alma Steinhauer, provided missionary outreach for the elderly. Alma counseled and held services while Clara played the organ or piano. During this period, Clara also used her tailoring knowledge to do a lot of sewing for neighbors and family. Then one day Clara decided it was time to join her family in Alaska. She was ninety-three years old.

It wasn't long after moving in with her daughter Mary in Homer that Clara was fully immersed in the community. She volunteered at the Pratt Museum and Haven House of Homer, and spent a lot of time with her family. She also helped them with their various businesses. Clara was working along-side Kellie as a volunteer in her health club until she was well into her 100s. "Everyone adores her," said Kellie. "She's such a people person."

Aside from hearing and eyesight loss, and some memory loss following a fall in 2014, Clara remains in good health and her mind is sharp as ever. She pays attention to world and local news and continues to speak her truth. Since moving into the care facility in 2014, Clara has advocated for several improvements to procedures on behalf of her peers. She regularly plays the piano for residents, easily recalling music from her childhood, and she maintains an active social life. Kellie even suggested that she get a social secretary.

In her 110 years, Clara has seen the dramatic effects of war, technological advancements, and social and environmental changes. When asked to describe how she felt about various events as they were happening, Clara took her time to respond. "A lot of times I think one way, then I collect data and change my mind," she said. "So I'm consistently learning. It pays to observe your surroundings."

THELMA ARNOLD

Norfolk, VIRGINIA
June 24, 1915

THELMA ARNOLD WAS BORN AND raised in Norfolk, Virginia. Her father, Harvey Nash, was a blacksmith, shoeing horses and making wagons. Thelma's mother, Elizabeth Jones Nash, worked hard in their home raising six children, even in the midst of tragedy. One of Thelma's younger brothers was only a toddler when he drowned in a well. Thelma remembers waving good-bye to her brother as she left for school one morning, somehow knowing that she'd never see him alive again.

Thelma dropped out of Oceana High School before she graduated and got a job working curbside service at Doumar's, a popular diner in Norfolk. She worked several other waitressing jobs, including a stint at the posh Monticello Hotel, before she took a cashier position at Colonial Stores. She retired from there at the age of sixty-five, and all but five of those years she walked to and from work.

Thelma had always managed to get around without driving, but at the age of sixty her granddaughter persuaded her to change that. She studied hard for several weeks before taking the driving test. She still remembers the ride: "I was riding along nice when the man said make a right turn, and I made the prettiest left turn you'd ever seen," she said. "I pleaded poverty, and he passed me."

Her first husband Jimmy drove his grandfather's milk truck and sometimes gave Thelma a lift home from school. She married him in 1931, and they had a son who they called Little Jimmy. The marriage lasted fewer than ten years. Thelma dated a few men after her divorce, and then met and married Aubrey Arnold. They remained together until he died in 1975. After that, she was done with marriage.

Thelma cared for her mother in the house she and Aubrey had purchased for 14,000 dollars—the down payment was made with coins she collected in a coffee can. A vivacious and social person, Thelma enjoyed going out with friends. "Three drinks is my max, because I don't want to mess up my lipstick and hair—or stumble and fall!" she said. Now she enjoys spending time with her growing family, which includes five grandchildren, five great-grandchildren, and five great-great-grandchildren. (Little Jimmy, her only son, passed away in 2011.) She has a terrific sense of humor and is still a bit mischievous: every time she goes to IHOP for chicken-fried steak she tells them it's her birthday so she gets a free ice cream sundae.

Until 2013, Thelma was able to get around with ease. But after a fall that broke her pelvis, walking became difficult. Now she spends more time at home. Her memory is as sharp as ever. Her granddaughter Natasha said when people comment on things in Thelma's house, such as a vase, she can recite when and where she got it, if it was a gift, or how much she paid for it.

"When I look back on my long life," Thelma said, "I didn't do anything I'm sorry for." She doesn't know why she's made it to the age of 100 but she wonders if it was the water she once tasted from a wishing well in Fort Lauderdale, Florida. "I didn't think it did anything, but here I am," she said. "For some reason, I'm still here."

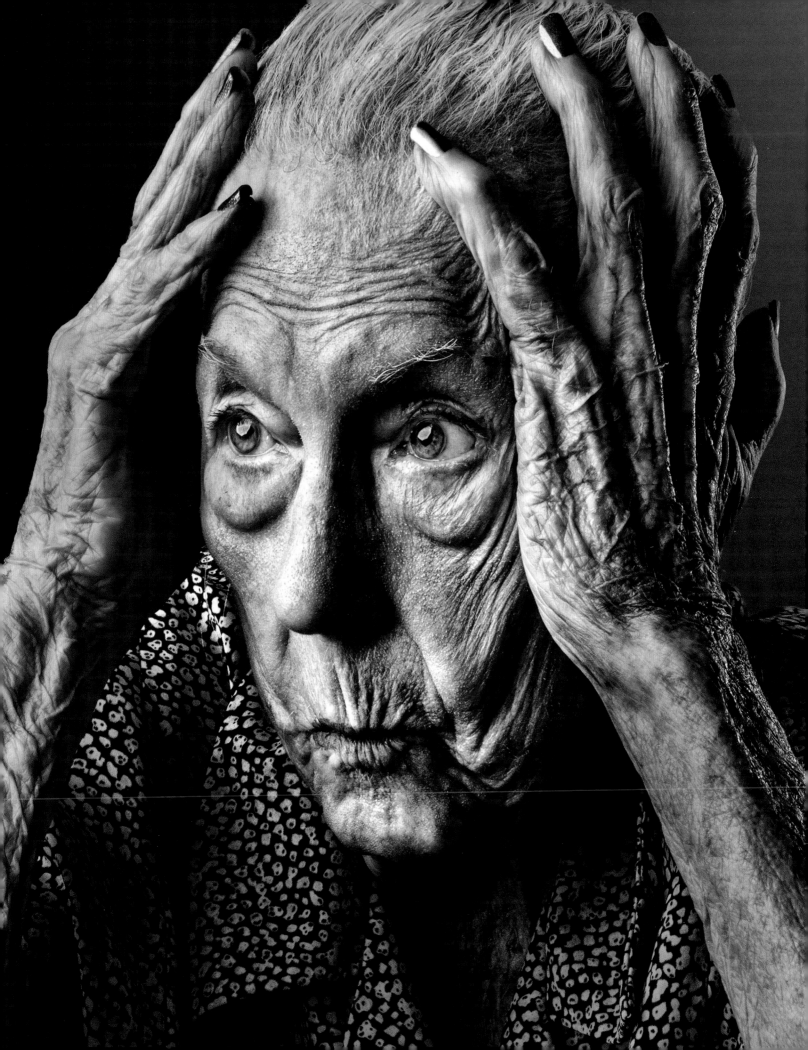

ALFREDO AGRON

Anchorage, ALASKA
December 24, 1910

ALFREDO AGRON WAS BORN IN CLAVERIA, CAGAYAN, PHILIPPINES. On June 1, 1931, Alfredo boarded the SS *Empress of Asia*; his destination was the United States, where he would endure the hardships of finding odd jobs and living day to day during the Depression.

A decade later, he enlisted in the US Army at Camp Beale, California, as part of the First Filipino Regiment during World War II. Alfredo was assigned to provide reconnaissance and intelligence in the Philippines, reporting directly to General Douglas MacArthur's headquarters. He was known for his tactical information, which provided strategic options within the Philippine Islands. Highly intelligent and a skilled engineer, Alfredo excelled at his responsibilities and received numerous honors to prove it, including the Bronze Star.

After the war he went to Anchorage, Alaska, to work for the US Army Corps of Engineers and later became a Department of the Army Civilian Service employee at Fort Richardson until he retired in 1978. He and his wife, Pacita Ann Pacis, also a native of the Philippines, cofounded the Filipino Community of Anchorage, Alaska, in 1965. Alfredo's legacy includes three sons (Gary, Robert, and Charles), eight grandchildren, and a community that has benefited from his advocacy, kindness, and humanity. Alfredo was known for his desire to "humbly be better." He was grateful for everything in his life. Until his passing in 2015, he was recognized as the oldest living Alaskan World War II veteran.

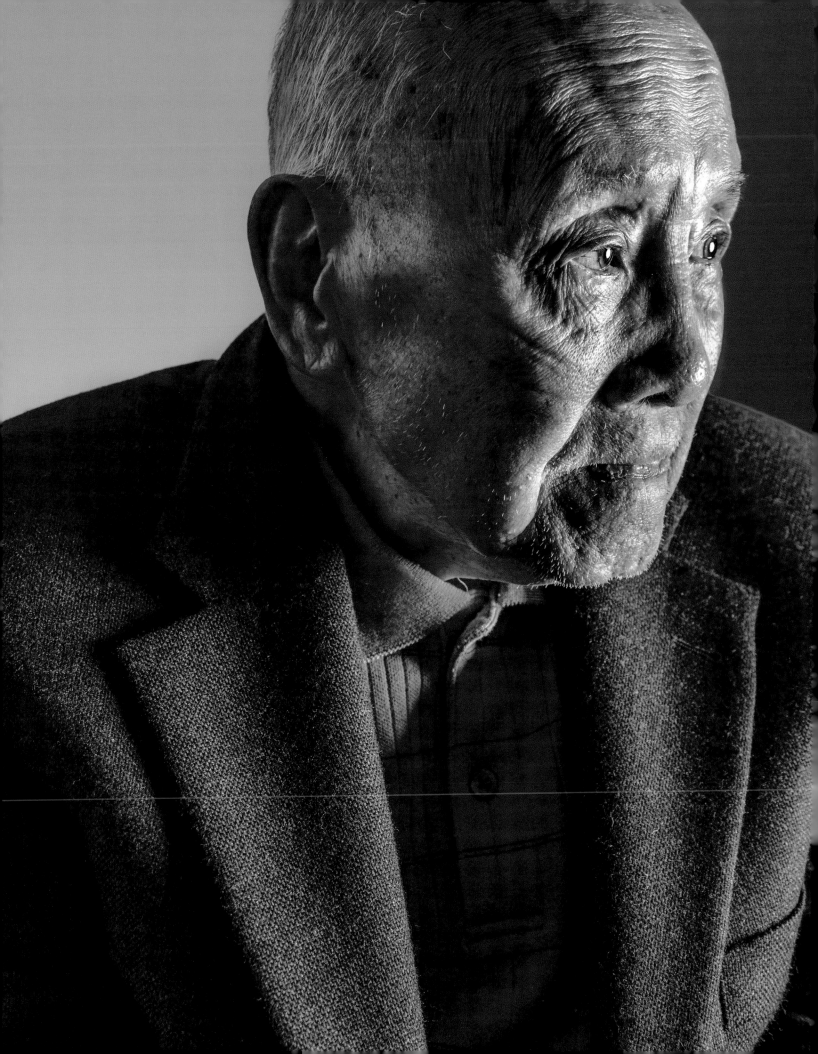

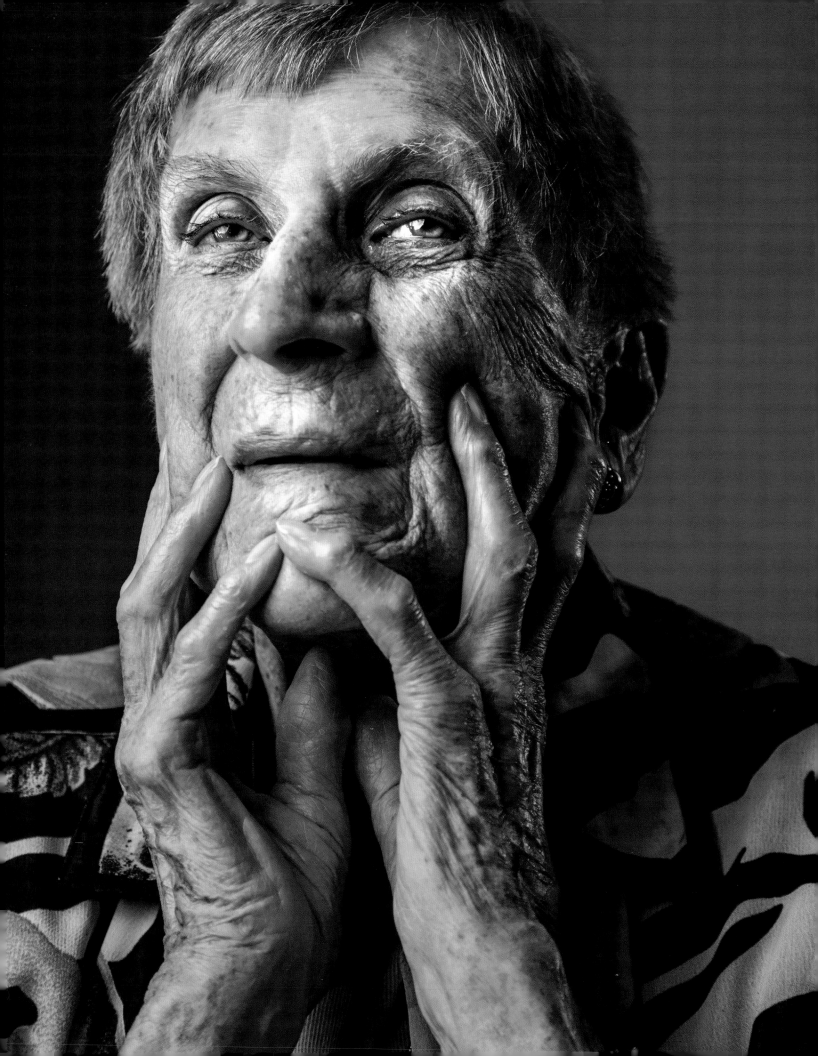

MARGARET WACHS

Stratford, CONNECTICUT
September 20, 1913

Margaret Wachs marked her 100th birthday in the most unusual way: she swam ten laps to help raise money for her church. That's the equivalent of five football fields—more than a quarter mile. It took fifty-five minutes, sixteen seconds. Four generations of Margaret's family were poolside to support her effort and celebrate their impressive matriarch. Before the swim, as she lowered herself into the pool, she told a reporter covering the event for the local paper that she "felt pretty good." After she finished, she felt even better—she had already raised 2,000 dollars for Stratford United Methodist Church.

As a child, Margaret swam in the lakes of Vermont where she grew up. Her parents had a farm in North Thetford and she helped out by taking the cows to pasture in the morning and bringing them back to the barn by nightfall. After Margaret's father died, her mother, not having the interest or experience to continue, sold the farm and moved the family to town.

Margaret was only sixteen when she received a scholarship to the University of Vermont. After graduating, she taught eight grades in a one-room schoolhouse for two years, but left the profession when she married Miller Wachs. She'd met Miller at the Methodist church when she was a young girl. Miller was a brilliant engineer and part of the team that worked on the research and development of the first helicopter. The couple raised five daughters: Greta, Ann Marie, Martha, Elaine, and Bonnie.

Miller passed away in 2012, and Margaret still lives in the house they purchased together in 1951.

The Wachs traveled extensively, to twenty-nine countries in total, which means a lot of stories and memories—some better than others. For example, the second time they visited China, Margaret broke her leg on the Great Wall and had to be taken to a hospital in the back of a Red Army transport truck. Still, she found China interesting and would return if she could. The couple also traveled to Russia when it was still the Soviet Union, and toured several countries in Africa.

Although Margaret has suffered with foot problems most of her life and has poor eyesight (she's nearly blind from glaucoma now), she has remained active and vital, unencumbered by the challenges of age. "I don't think about being old at all. In fact, I took the word 'old' out of my vocabulary," she said. If her eyesight were better, she'd return to the bowling alley. She belonged to a senior bowling league in her seventies, averaging 149 a game. Later, in her eighties, she became interested in computers. After taking a class on the subject, she built her own.

As for swimming, Margaret said she didn't swim much at all for most of her adult life. She was ninety when she took it up again. At first she couldn't complete one lap without stopping several times to catch her breath. Her perseverance paid off, however; after fifteen trips to the pool she'd built up her stamina. Now, on her good days, she swims twenty laps. "I don't say, 'Ah, I'm getting old!'" she said. "I don't ever think that way."

INGER KOEDT

Jackson Hole, WYOMING
January 16, 1915

NATURE HAS ALWAYS BEEN A SOURCE OF JOY AND COMFORT TO Inger Koedt. As a child in Copenhagen, Denmark, she spent a great deal of time in the forest and sailing on the Baltic Sea with her friends. At the family's summer house, Inger loved to garden with her father. Even now, far from her childhood home, Inger enjoys walking near her home in Wyoming to listen to the wind in the trees and take in the earthy scents.

Inger's only brother was six years older and studied at a boarding school, so she rarely saw him during her childhood. Her parents decided to keep Inger in public school, and that suited her. She adored her father and the time they spent together outdoors. Sometimes Inger accompanied him on his hunting trips, even though she loved animals and didn't like to see them killed.

When Inger was fifteen, her father was shot by a burglar in the family home and died. In the difficult weeks that followed, Inger drew on the inner strength her parents had nurtured, choosing to go on and embrace life rather than close off from the world. "I missed him so much," she said. "But I found something inside and it helped me move forward and accept changes in life." Little did she know at the time that she would have to summon that strength many more times during her life.

Inger met her husband Bobs through his sister, Elli, a good friend from school. The two would talk when Inger visited Elli at the family home. Inger and Bobs's casual friendship quickly grew into a romance, and in 1935, they were married. It was a big wedding, well attended by family on both sides as well as their many friends. Inger still remembers the day fondly.

Bobs studied architecture, and Inger worked as a ceramic artist—a highly respected skill in Denmark at that time. They had their first child, Bonnie,

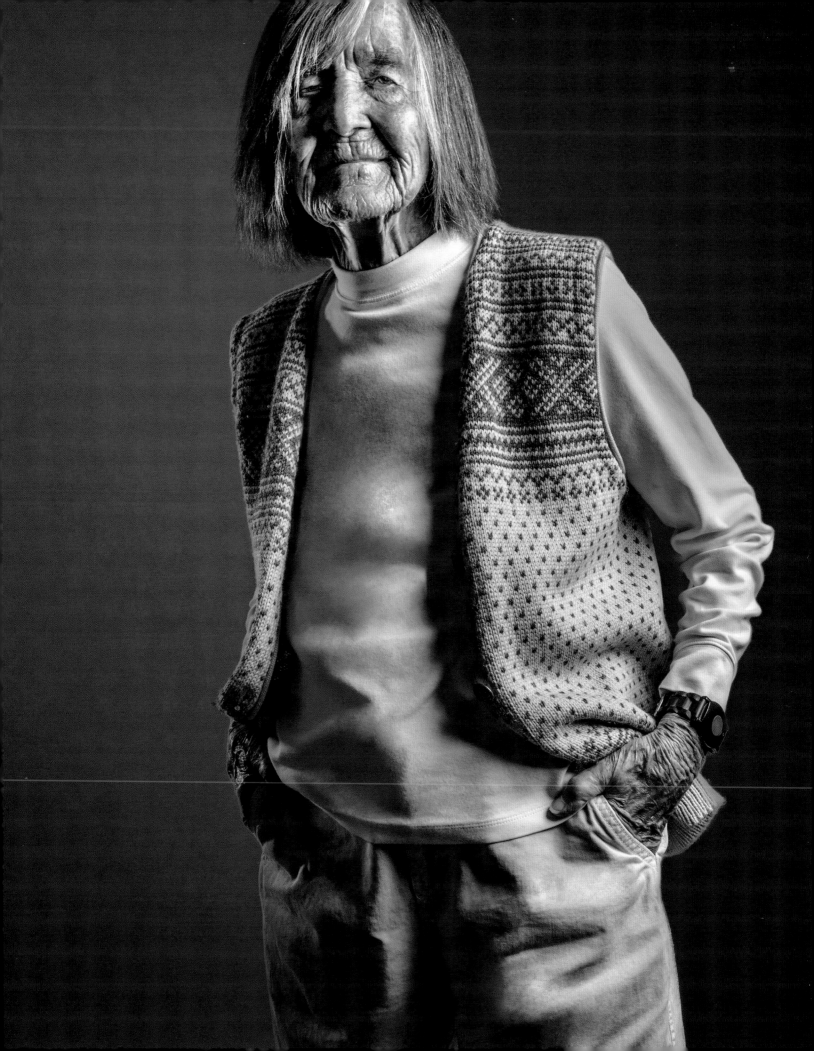

in 1937. Anne was born two years later. But within a year after her birth, their lives took a dramatic turn when Nazi Germany invaded Denmark.

In response to the occupation, many people joined the Danish resistance, an underground insurgency made up of ordinary citizens. Bobs became a member of the resistance early on, and by 1943 Inger was a part of the movement as well. The Danish resistance movement coordinated the transport of approximately 7,200 Jews to safety during the occupation. According to the United States Holocaust Memorial Museum, because of this mass rescue effort, at the war's end Denmark had one of the highest Jewish survival rates for any European country. The Koedts' most important role in the movement was helping Jewish families leave Copenhagen for Sweden. The families hid at the Koedts' home for a day or more until it was safe to go to the docks, where fishing boats waited to take them to safety.

At the time of their involvement in the resistance, Inger and Bobs didn't question what they were doing. "No doubt, we had to help them [Jews leaving Denmark]. It was a terrible thing and they had to get to Sweden," she said. One night Nazi soldiers searched their house, leading Inger and Bobs to believe their phone had been tapped. When it became too dangerous to stay, Inger took Bonnie, Anne, and Peter (born in 1944) to the summer house while Bobs moved from one house to the next until the war ended.

In 1951, the Koedt family made another bold decision—to move to Palo Alto, California. Bobs had been born in the United States and because he had an American passport, they were able to emigrate without trouble. Inger fondly remembers the thirty-day trip across the Atlantic Ocean on a passenger freighter, and passing through the Panama Canal.

"Hang on to the good things; don't hang on to the bad things."

The family settled in Palo Alto, where Bobs found a job, and friends helped them settle in. They loved the sunny climate, a welcome change from Denmark. With the ocean and forests close by, Inger started hiking and skiing, and the family took regular trips to the beach.

Five years later, the Koedts made another big move. Bobs was hired to oversee construction of Colter Bay Village in Grand Teton National Park, a career opportunity he couldn't pass up. Although it meant leaving the West Coast for landlocked Wyoming, they agreed to go. Bobs moved first, and Inger and Peter followed several months later. (Anne and Bonnie were attending university by this time.) Any reservations Inger had about being away from the

ocean dissolved after she got a glimpse of the Grand Tetons. She knew at that moment she would never want to leave Wyoming.

Inger and Bobs spent forty years in a cabin on the Murie Ranch, a former dude ranch inside Grand Teton National Park. Olaus and Margaret (Mardy) Murie were renowned conservationists, and Olaus and his brother Adolph were distinguished biologists. The remote property, which includes an assemblage of cabins, studios, and a lodge, was a popular gathering place for conservationists, biologists, and environmentalists, as well as artists, musicians, and adventure seekers. It's now listed on the National Register of Historic Places as a historic landmark.

The Koedts enjoyed a stimulating social life and an equally wonderful outdoor life at the ranch. Inger especially liked interacting with the abundant wildlife that wandered up to their cabin on a daily basis. One particularly fond memory is of a young porcupine that paid her regular visits. Climbing up to the windowsill, she'd peer inside, curious and a little hungry. Inger affectionately called her Porkie. She loved boiled potatoes and Inger's homemade bread. When she saw Inger, Bobs, or the kids, she would come up to have her soft face rubbed. "She was a lovely animal," Inger said.

Since arriving in Jackson Hole in the summer of 1956, Inger hasn't stopped enjoying the mountains and high country. She was in her sixties when she climbed the highest peak of the Grand Tetons with Peter, and she was still doing some cross-country skiing and hiking when she was ninety. In 1967, Inger became the first chef for the popular Mangy Moose Restaurant in Teton Village. She and Bobs were also active in the Jackson Hole community: Inger helped established a student exchange program, was on the Science School board, and worked for affordable housing in Jackson Hole. She also helped bring the Anne Frank exhibit to Jackson Hole. Bobs designed houses throughout the valley. Their daughters, Bonnie and Anne, were both active in the women's rights movement and have authored books. Peter (who passed away in 2010) was a pioneering climber, outdoorsman, and backcountry guide.

Bobs died in 1992. Eight years later, in 2000, Inger moved to another historic cabin in East Jackson, where she still lives today. Walking still helps her body and mind. She has also remained involved in the community and has stayed up to date on world events. Not a day passes without her reading the newspaper. Inger attributes her long life to many things: a close family, nature, and a healthy diet, to name a few. Resilience also comes to mind, as well as the ability to focus on the positive even in the darkest days. "Yes, hang on to the good things; don't hang on to the bad things," she said.

WILSON PIERPONT

Mount Pleasant, SOUTH CAROLINA
October 20, 1913

THERE'S A MAP OF EUROPE ON THE wall at Colonel Wilson Pierpont's home that is covered with red lines, so many that the continent is hardly recognizable. Each line represents a route he and his wife Suzanne took during their travels. By car, train, and plane, the Pierponts explored every country in Europe, as well as Japan, Russia, and many Middle Eastern countries. They loved to travel, especially by automobile—one of Wilson's passions. In France, they drove a Peugeot; in Germany, a Mercedes-Benz. In postwar Japan, where Wilson was stationed as part of the occupation forces, he and Suzanne toured the rough country roads in an old army jeep. They carried packs of cigarettes to use as barter in exchange for car repairs.

Wilson grew up in New England, the son of a dairy farmer turned paper mill worker. His mother's family members were peasants from England, and his father's side could trace their lineage back to William the Conqueror. He spent his formative years in a small Massachusetts town, working a series of jobs during adolescence and into his early twenties. He easily recalled a list of jobs he did before attending Lehigh University in Pennsylvania: office boy, carpenter's assistant, truck driver, ice cream factory worker, magazine salesman, and so on. He even had a job watching a water wheel at the local mill. "I was a jack of all trades, master of none," he said. Yet each job offered him a chance to gain new and useful skills that he used throughout his life.

Wilson was attending seminary in New York City when World War II broke out. He knew it was only a matter of time before he was called up for the draft so he took initiative, leaving seminary to sign up at a nearby reserve headquarters. He married Suzanne on February 4, 1942, received papers for active duty on the 10th, and reported on the 16th.

The military suited Wilson and he rose through the ranks of the US Army, eventually becoming a lieutenant colonel. Then, after twenty-one years of active service that spanned World War II to the Korean War, he transitioned to civil service. Suzanne had joined him overseas when he was stationed in Japan, and later took a civil service position as well. Their complementary positions allowed them to live and work abroad and at military bases in the United States while raising their three sons: Wilson, Joe, and Roderick, who passed away in 2004. Wilson said their favorite place in the world was Switzerland.

When they were ready to put their roots back in US soil, the Pierponts retired to South Carolina in 1977, where Suzanne had grown up and still had family. Although they settled into a comfortable life of retirement, they continued to travel, exploring many states by car and most often in the company of friends or family.

Wilson's health has always been good, but he's not impervious to illness and injury. In his eighties, he suffered a heart attack and required two stents. He broke his hip at the age of ninety-six. He has never followed health trends and he smoked for two decades. But Wilson has also walked almost every day for years. He's unsteady now, so he uses a walker to navigate his favorite walks—the boardwalk at Palmetto Islands County Park in Mount Pleasant or

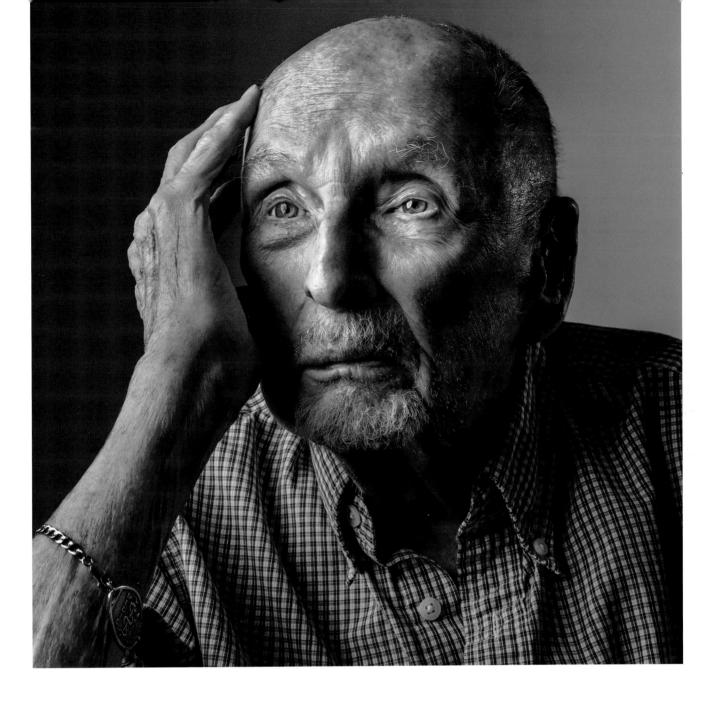

around Colonial Lake in downtown Charleston—and he still enjoys the sight of beautiful women on the beach. He hasn't put his finger on the secret to his longevity, but having a good sense of humor hasn't hurt him. He loves a good joke and can still crack up his son Joe.

Suzanne passed away in 2008, and Wilson mostly fills his days with books and walks now. He has always been a voracious reader, sometimes finishing two or three books a week. His daughter-in-law is a former library employee, so she keeps him well stocked. He also likes watching sports, especially the Tour de France; it reminds him of the times he and Suzanne spent in France. Mostly, he looks forward to the days he can take his BMW out for a spin. He bought the sports car as a 100th birthday present to himself. It has all the bells and whistles one could hope for in a sports car. "It practically talks to us," Wilson said. He doesn't drive anymore, but he still enjoys a nice ride, a little speed, and beautiful scenery. Sitting shotgun with his son Joe in the driver's seat, Wilson is content feeling the road beneath his wheels once again.

ELLA BELL

Anchorage, ALASKA
March 2, 1914

ELLA BELL HAD BEEN TEACHING SCHOOL IN SOUTH DAKOTA FOR sixteen years when she packed up and moved to Washington, DC, to work for the Civil Aeronautics Administration. She remained at her job through World War II, then the office decentralized and Ella once again traveled cross-country, this time to Seattle, Washington. She took a job at Boeing in the purchasing department, but during a trip to Alaska she met Ronald (Rex) Bell. Two years later, they were married and living in Anchorage. The Bells had two children (Greg and Diane) and homesteaded for nearly two years on a remote property without electricity or running water. Rex passed away in 1972, so Ella returned to the workforce to support her family. She took a job as an area manager for World Book Encyclopedia Company and did so well she was featured in *Forbes* magazine as a top salesperson. Her son Greg remembers his hardworking mom with fondness and has the utmost respect for her ability to adapt. "She was a great mom," he said. Ella also has five grandchildren, and seven great-grandchildren.

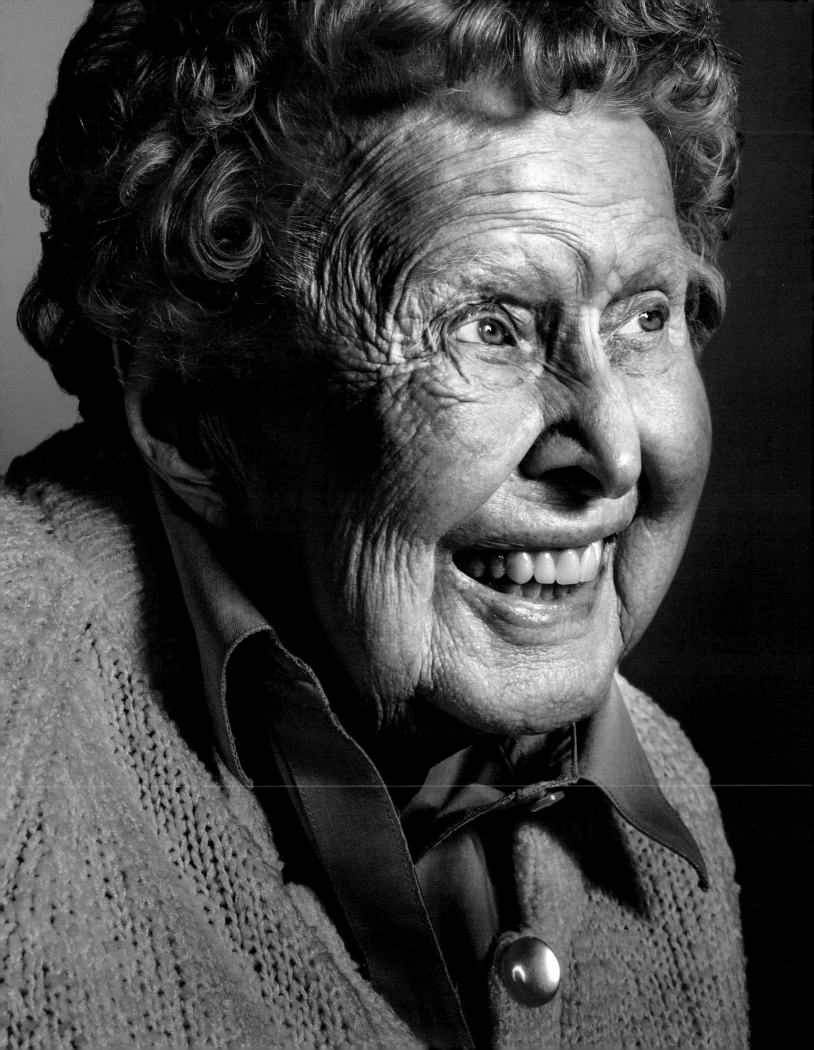

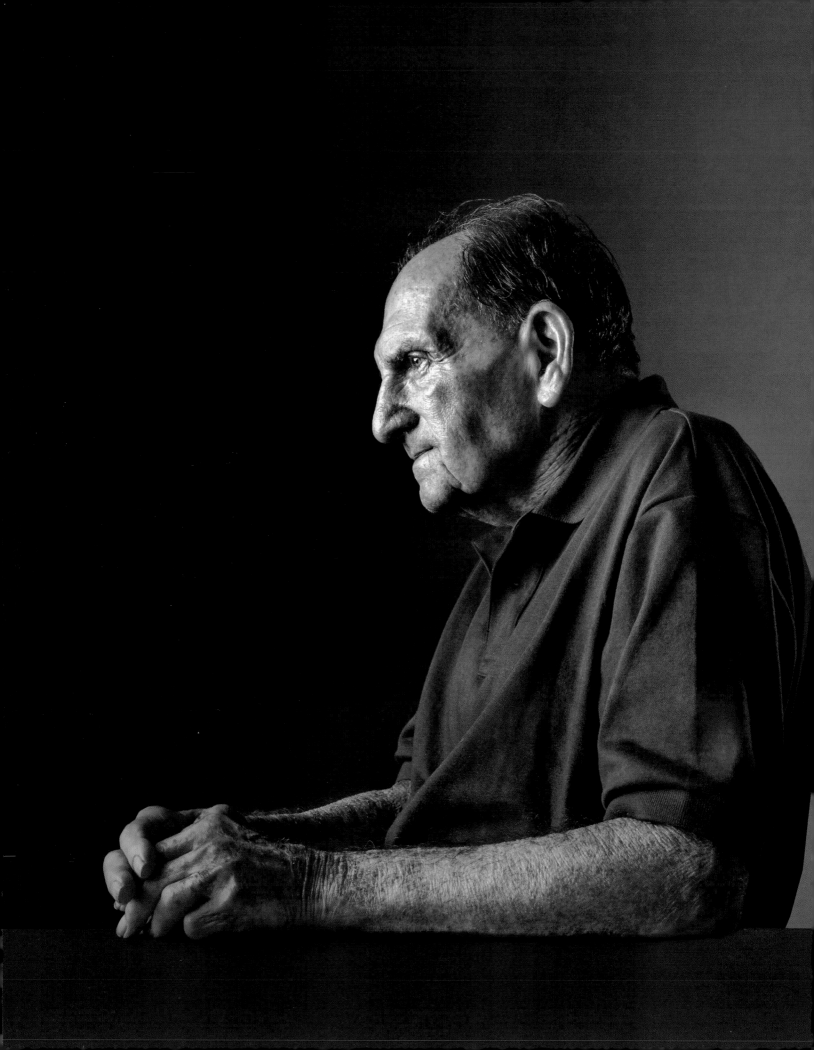

SEYMOUR COHN

Selma, ALABAMA
December 16, 1914

IN 1993, SEYMOUR COHN TRAVELED TO MONTGOMERY FROM SELMA to receive an award of great distinction: Volunteer of the Year for the state of Alabama. Accompanied by his wife, June, and their son, Rick, who flew in from Boston, Seymour was recognized by the state for his contributions to the community. Everyone was proud but not entirely surprised by the decoration. "He is a very honorable man," Rick said of his father.

The walls of the Cohns' home in Selma are lined with plaques recognizing Seymour's volunteerism. He was named Citizen of the Year by the Rotary Club of Selma in 2005; he received the Golden Deeds Award from the Selma Exchange Club in 1997; the Alabama Hospital Association gave him an award for exceptional volunteer service in 1998; and the Salvation Army gave him a Certificate of Life Membership in 1989. "From a very young age, he was a go-to guy. People could count on him," Rick said.

Seymour and June met at Temple Mishkan Israel one Friday night in September 1941. Seymour was an officer stationed at Craig Air Force Base in Selma, and June, seventeen years old at the time, remembers seeing a "darling young man" come in. "I offered to take him back to the Air Force base because I had a car. That's how we met," June said. But then she left for college.

Before enlisting in the military, Seymour had also been a student. But during his sophomore year at Emory University, he was forced to drop out. The Great Depression had financially devastated his family, making it impossible for them to afford his tuition. He immediately went to work for an Atlanta-based

stationery store but enlisted in the military shortly thereafter. That's how he ended up in Selma the first time.

While June was in college the two continued to write, even after Seymour moved to Miami, Florida, to attend officer training. They wrote when he was sent to North Africa during World War II, and continued to exchange letters after he went to Italy, where he was a ranking officer in a squadron that helped liberate Rome.

After the war, Seymour returned to Atlanta and his family. Ten days later, however, he headed back to Selma—this time for June. It had been several years since she had given him a lift to the barracks, but they had never stopped writing. (June still has all the letters in a box.) The two were married in 1946 at June's uncle's house. She descended a grand staircase in her bridal gown, just as she had always dreamed. They honeymooned in New Orleans, staying at the Roosevelt Hotel. June recalled their first breakfast there as newlyweds. "We were dressed up so nice," she said. "No else was, so they knew we were newlyweds."

The couple lived in Atlanta the first year of their marriage, but moved back to settle permanently in Selma a year later. Seymour's father-in-law offered him a job in the family business, and while retail management wasn't his dream, Seymour accepted. For more than forty years he managed S. Eagle & Sons, one of Selma's more popular retailers for nearly a century. He made many friends in the community and, through the front window, Seymour and June witnessed the civil rights movement firsthand. "We watched everything," said June. "It defined life there for a while." They saw Martin Luther King Jr. several times and observed the marches that went by their store on a regular basis.

Eventually, Seymour tired of retail management and he and June decided to get out of the business and start a new one. They kept S. Eagle & Sons open during the day and at night learned what they could about the travel business. In 1972, having properly prepared, Seymour and June officially opened Eagle World Travel—and closed the department store. The Cohns never looked back. For fifteen years, they operated a successful travel business; Seymour enjoyed making his rounds to local businesses to pitch their services, and he often spoke at various events. They were also able to take a lot of vacations: thirteen cruises, plus multiple trips to Europe, Israel, and Mexico, to name a few. It was a good era.

When they closed Eagle World Travel in 1993, June and Seymour were ready to retire from work—sort of. Both were in good health and had hobbies, but Seymour wasn't ready to settle into a life of complete leisure. "Selma has been good to me and I'd like to do something to repay," he told June. And he did.

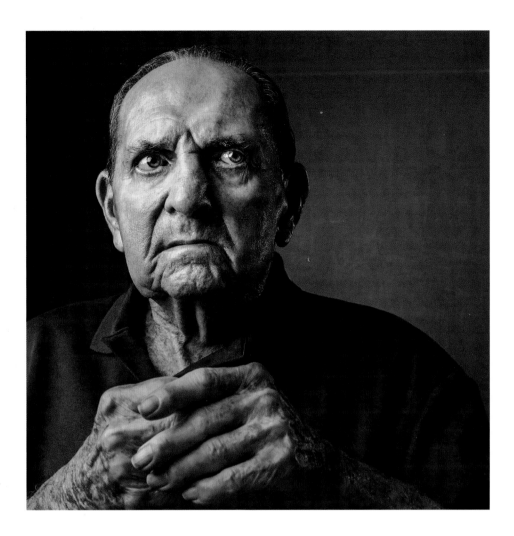

From that moment on, Seymour gave back to his community. He spent many years tutoring children in the public schools, and volunteered for Meals on Wheels and at the hospital. As an avid, lifelong reader, Seymour especially enjoyed the fifteen years he spent volunteering at the Selma-Dallas County Library. The only part he didn't like about volunteering at the library was learning how to use the computers.

At ninety-nine, while helping someone who had fallen in a parking lot, Seymour fell himself, hitting his head on the ground. The concussion he suffered in the fall triggered dementia. Although his health is good otherwise, he can no longer hold a conversation, and, worse, he's no longer able to read. Still, Seymour remains a beloved member of the community. Often when June is running errands, people she doesn't know ask how he's doing. When she returns home she always tells him that a friend inquired about him. "He has always been very friendly and had a lot of friends," she said. "There's not a mean bone in his body."

CELESTE FROEHLICH

Louisville, KENTUCKY
February 20, 1915

CELESTE FROEHLICH DOESN'T THINK of herself as being old. Sure, some things are a little harder to do, but she's not complaining. She is in good health and doesn't feel her age. She said getting older doesn't bother her the way it does some people.

Celeste admits she never liked to exercise, even though she did play tennis and bowled on occasion. She didn't drink much and she has always been careful about what she eats. Still, she has never shied away from rich, buttery dishes. She grew up eating like that. It couldn't be helped—her father owned a French restaurant and she and her mother ate dinner at the restaurant every Sunday.

Celeste was born and raised in Chicago. She had an older brother who she adored and was close to in spite of the eleven years between them. Celeste remembers horse-drawn carriages rambling through the city, and lamplighters illuminating the streets by igniting open burners. Her parents bought a car, which was a modern convenience then, except during the rains when deep puddles formed in the streets. City workers would drop boards from the curbs so pedestrians could cross the streets without immersing their shoes and hems in the muddy water.

"I never did make up my mind what I wanted to do," said Celeste of her professional pursuits. After her father lost his restaurant during the Great Depression, Celeste was anxious to find work. Her first job was making and selling sandwiches in the Kraft cheese booth at the Chicago World's Fair in 1933.

Celeste attended business school and after graduating landed a job in a law firm, then an insurance company. She also got married, and when her husband Robert was sent to Europe during World War II, Celeste remained in Chicago. She responded to the government's plea for women to join the war effort and went to work in a plant where they dismantled airplanes that had been shot down in the war. The parts were melted in great furnaces and the various metals were reused for other war purposes. It was difficult and unfamiliar work, but Celeste adapted and grew to like it. She felt camaraderie with the other women at the plant as well. The closure of the plant following the end of the war was bittersweet. Celeste would have found another job—she liked to work—but her husband wanted her at home. It was several years before Celeste returned to the workforce.

The couple settled into domestic life. Celeste raised a daughter, Patricia, and traveled to nearly every state and overseas: Mexico, Europe, and the United Kingdom. Not interested in returning to Europe after the war, Robert remained at home, allowing Celeste to explore the world with friends and tour groups. The couple later moved to Louisville, Kentucky, where Robert got a job. Celeste settled in and enjoyed the climate and slower pace.

Robert passed away in 1969 and Celeste remained at their home, working as a clerk for more than thirty years before retiring and moving to Belmont Village in 2011. She sees her daughter, two grandchildren, and two great-grandchildren on a regular basis. Overall, Celeste is content with her life—and her centenarian status. "I feel young for being 100!" she said.

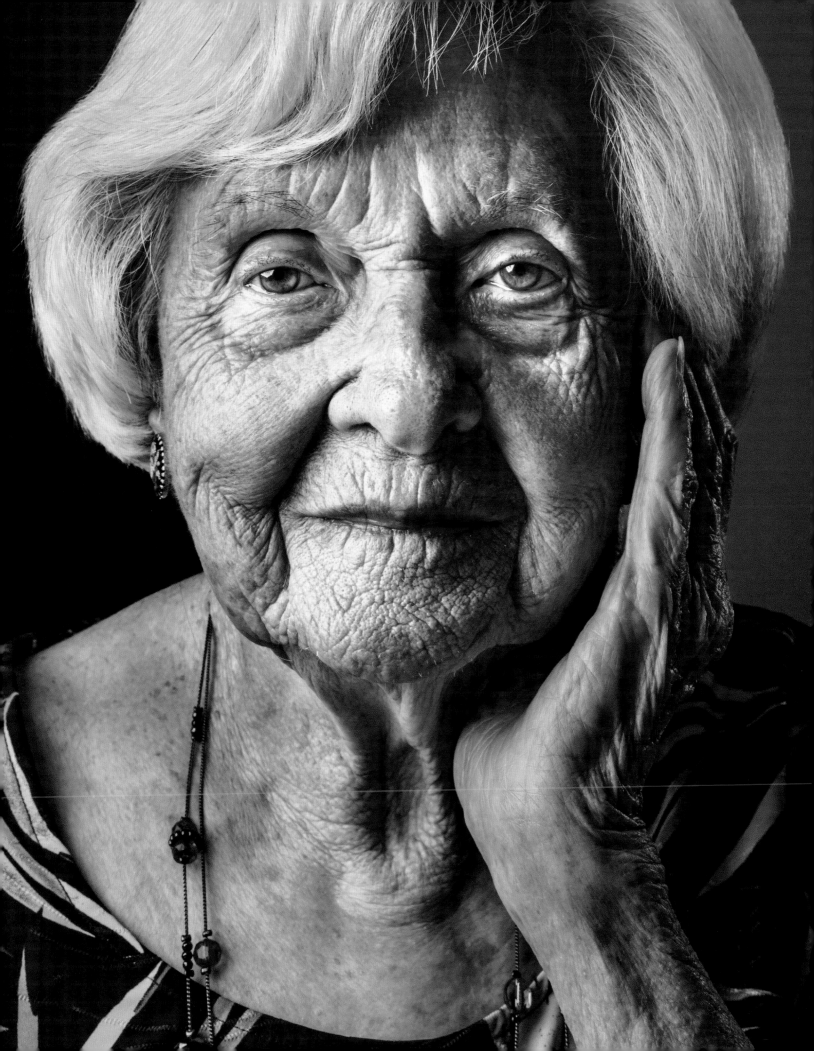

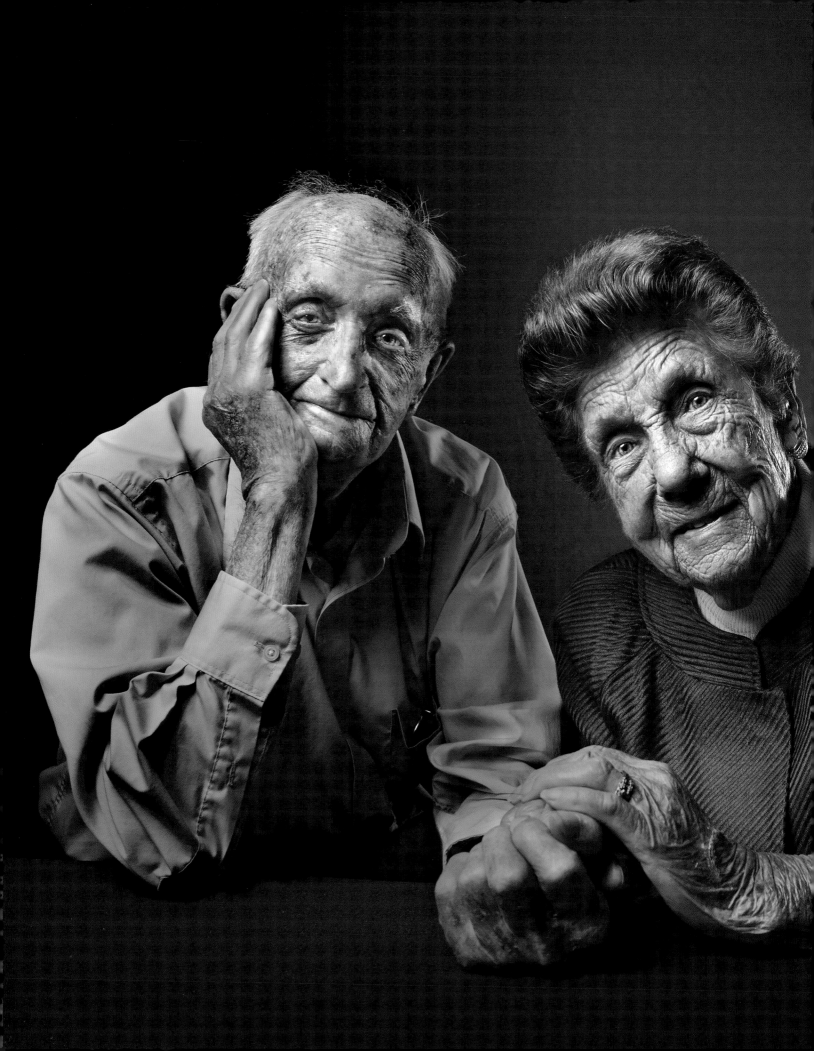

VIRGIL OUVERSON & VIOLA ROBERTS

Fertile, IOWA
November 30, 1913 / May 31, 1914

VIRGIL OUVERSON AND VIOLA ROBERTS KNEW each other in high school and then went their separate ways. Nearly a century passed before they spoke again. After eight decades they became reacquainted in their church, and now the former classmates share a unique status in their small Iowa community: they're both more than 100 years old.

Viola graduated from high school in May 1933 and by December she was married to Forrest Roberts. The young couple moved to a farm in Minnesota inherited from Forrest's grandmother. Three years later, they sold it for about sixty dollars an acre. Viola said it was a pretty good price at that time. She and her husband then bought an eighty-acre farm southeast of Fertile, Iowa. They lived and worked on the land for thirty years before moving in town.

Viola handled the finances but also worked in the fields, for many years driving a team of horses. She was well prepared; as a young girl she'd learned to drive her parents' team in the hills of northern Wisconsin. Even then, Viola preferred to be outdoors helping her brothers (she had eight siblings) collect wood and draw water from the well.

Her love of the outdoors didn't diminish after she became an adult. "I helped my husband with the farm work early on, but later he drove a semi," said Viola. "His mind was on that semi, not the farm, so I did everything. I picked the corn and all of that. But I loved it."

For a number of years, however, Viola spent a great deal of her time indoors raising babies. Like most things, she took it in stride. "They were easy to raise," she said of her three children (Wayne, Donald, and Joanne). Now, Viola has eleven grandchildren and fourteen great-grandchildren.

Rob Perry is the pastor at Fertile Church of Christ, where Virgil and Viola are congregation members. He has noticed that Viola, despite the fact that her eldest son is eighty years old, hasn't relinquished her mothering role. "Her son had an accident, and she wouldn't stop worrying about him. See, you can't take the mother out of someone even when she is 102," he said.

Virgil grew up on a farm outside of Fertile. He still remembers his mother packing him off to school with peanut butter sandwiches. She bought the peanut butter in a wooden pail. "We would all have peanut butter sandwiches for school. I had so many peanut butter sandwiches I can't stand to look at them anymore," he said.

Virgil married his wife, Ruth, on July 4, 1936, and they were together for seventy-five years before Ruth passed away. They stayed in Fertile, raising their children—Larry, Dennis, Roger, and Rosalie (who passed away at the age of fourteen)—and operating a small farm. (A fourth son, Jimmy, was unfortunately stillborn.) Virgil also worked for Winnebago Industries for fourteen years, averaging 80,000 driving miles a year for work.

He and Ruth liked to take road trips together, exploring the countryside in their Winnebago. At home in Fertile, they went to the movies when Saturday night showings were free. The movie was projected on the wall of a building in town. Fertile residents would come with their goods to sell or exchange for goods at the local grocery store: eggs, vegetables, or homemade jams.

Virgil and Ruth were regulars at church, too. Virgil was a deacon for many years and used to fire up the stove before farm work each morning so the congregation members would have heat when they arrived.

Fishing was one of Virgil's favorite pastimes and had been since he was a boy. He frequently went with his father and brothers to fish and trap mink and

"Don't think you are too old to do this or that. Do it!" —Viola

skunks along the Winnebago River while harvesting. Recently, however, Virgil had to give up fishing. Getting out on his favorite piers at Clear Lake became too challenging with a cane in hand and he didn't like feeling unsteady.

In spite of the fact that Virgil prefers to be outdoors, about ten years ago he took up latch hook to keep his hands busy through the winter. Latch hook involves pulling loops of yarn through a pattern. Virgil likes to experiment with the colors of yarn and he has started designing his own quilt-like patterns. He spends a lot of time making rugs—sometimes working two to three hours a day on his creations. "They turn out pretty good," he said.

In addition to age and regular attendance at church, Viola and Virgil share another trait—independence. Both centenarians still live in their own homes and both still drive. Viola gets around in her own car and she recently took an eye test and passed with flying colors. "I don't need glasses so I don't wear them. I put them on for tiny print though," she said.

Virgil's family urged him to stop driving his car after a stroke last year, so now he gets around town in a golf cart. He's not happy about it though. He prides himself on his driving skills. "I drove 75,000 to 80,000 miles each year in the past and in fifteen years never had an accident!" he said. He's also known for his driving abilities in the worst weather conditions. When Ruth was moved to a nursing facility outside of town, Virgil was at her side every day. Not a snowstorm or icy road kept him apart from his lifelong love.

There are a number of things Viola can't do anymore, but wishes she could. "I miss pulling weeds, climbing the ladder, washing windows on the outside. I get somebody else to do it, but I'd rather do it myself," she said. "I just don't like to have to depend on anybody else." Viola still loves to bake but has also modified her cooking, leaving the preparation of big holiday dinners for her family to do.

In spite of the inconveniences and aches and pains, Viola and Virgil are grateful for their long lives and the people in them. "I thank God that he has given me good health," said Viola. When asked what advice she could share on aging, she didn't hesitate: "Don't think you are too old to do this or that. Do it!" Virgil shared her sentiment and also acknowledged his wife, Ruth, and the church as reasons for his long life and health.

Pastor Perry can count on Virgil and Viola attending church service every Sunday. The only reason they wouldn't show up is if they're not feeling well. Even extreme weather does not stop them. "They are both tremendously faithful," he said.

BOB RUPP

Kennewick, WASHINGTON
December 23, 1914

BOB RUPP LIKED TO BAKE ANGEL FOOD CAKE. HIS coleslaw was legendary and the sweet pickles he made with his wife Alice were otherworldly. Although he had a knack for cooking and baking, Bob didn't spend a lot of time in the kitchen. For thirty-four years, he upheld the law as a state trooper, and he spent another twelve years as a sheriff in Benton County, Washington. He also helped raise a family of four; hunted deer, elk, and geese and fished for salmon; rebuilt furniture; and restored old cars. Indeed, Bob was not the kind of man to sit idle; he had as many interests as friends, and enough stories to entertain an audience for hours.

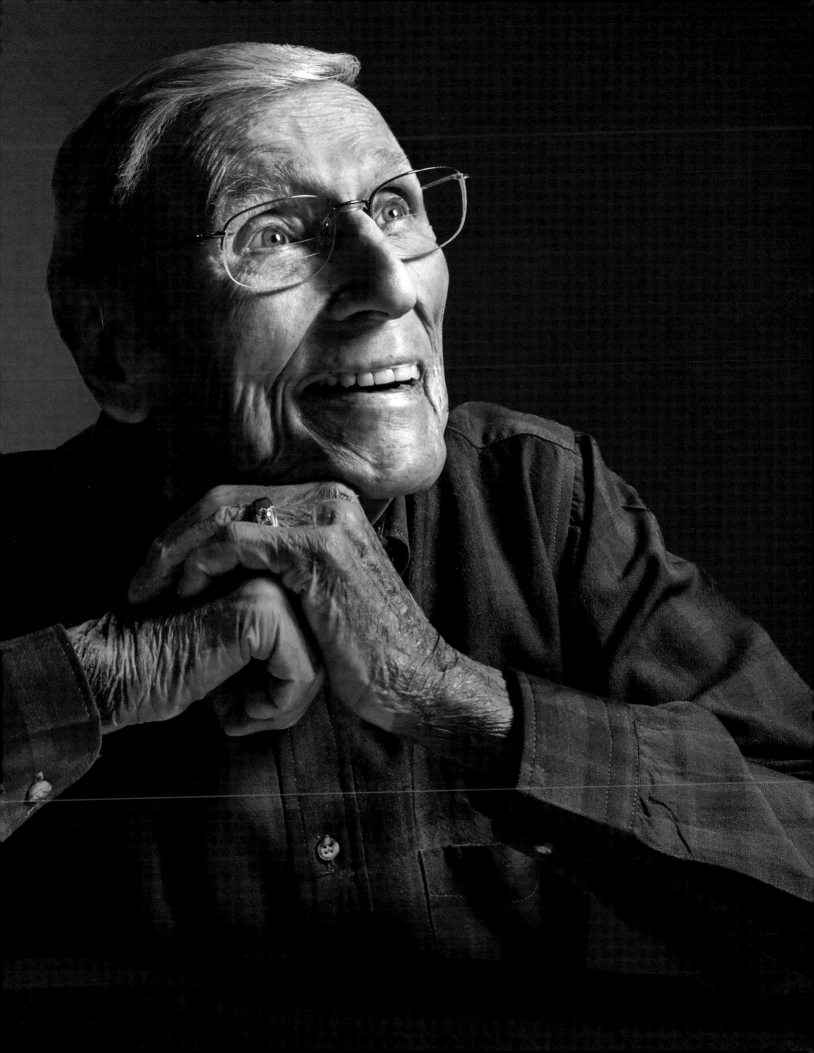

Bob was born to George and Nannie Rupp, pioneers of Kennewick, Washington, the most populous of three cities collectively known as the Tri-Cities. Bob grew up on a farm with a sister and two brothers, and attended Kennewick High School. As a kid, Bob planted a seed in the front yard of the house where he was born and raised—just for the heck of it. The house and the elm tree are still standing.

Although Alice was in the same class, the couple didn't date until several years after graduation. They courted for a short time and then married in 1939 at the Kennewick First United Methodist Church. Within a couple of years, they welcomed their daughter Chris, the first of their four children. They moved across the state, where Bob got a job as a state trooper, and moved again in 1956 to Sumner, where they built a home. They raised Brittany spaniels and Alice returned to work as a beautician. (Alice had graduated from Spokane Beauty School in 1936 and got her first job at Larry's Barber Shop in Kennewick following graduation.) Although they loved their Sumner home, Bob and Alice happily returned to their beloved Kennewick in 1964 when an opportunity presented itself. By then, their family had grown to include two boys, Roger and Bill, and a second daughter, Bobbi.

Bob's chosen profession was often stressful and difficult, and it required long hours away from home. But no matter what happened on his shift, Bob left it behind to return to his family. He didn't let it get in the way of attending the kids' activities or teaching them important lessons, like how to drive. Bobbi remembers the winter Bob took her and a friend out to a field and taught them how to drive in the snow and ice. "He made us go into a spin, then taught us how to counter spin," said Bobbi. "Dad was a very good driver, as you can imagine."

Bob attended as many of the kids' school events as his schedule would allow, took the family on road trips, and liked to make Sunday supper. His specialty was the wild game and fish he caught on his hunting trips, but he was also known to make a tasty meatloaf.

Chris and Bobbi recalled shopping with their dad, who loved to go to stores—whether it was for groceries or clothes. Alice didn't enjoy the activity at all so Bob went instead, even shopping for her clothes. In the mall, Bob would people watch while his daughters perused the stores. No doubt, he always ran into a friend or two while waiting.

When Bob retired from his position as a state trooper at the age of sixty (it was the law), he still had a lot of energy and enthusiasm for his work. So rather than settle into the life of a retiree, Bob pursued a second career as sheriff of Benton County. He held the position for three consecutive terms

before retiring from service for good in 1987. During his career as sheriff, Bob was able to get the Benton County Justice Center built, add a reserve unit and K-9 unit, start marine patrols, and get a new fleet of vehicles. When a new jail was built, Bob hired a color specialist to help choose colors that were appropriate for the different parts of the jail. He also helped secure a plane for the department that was confiscated in a drug bust—a fascinating tale he was fond of sharing.

"I'm happy as a clam at high tide."

After retiring, Bob enjoyed his status as the oldest living retired member of the Washington State Patrol, maintaining close ties with the troopers and Benton County Sheriff's Office. But most of his time was spent pursuing his many hobbies and enjoying the company of his family and friends. He and Alice took cruises to the Caribbean and Alaska and many road trips throughout the United States and Canada. Bob loved the open road and Alice liked to sleep in the car. They drove around the region with other car enthusiasts in whatever car Bob was restoring at the time, and perused yard sales and antique shops together. Their social schedules were so full they kept separate calendars.

Bob maintained his health throughout his life, but he was not immune to health issues. He had two open-heart surgeries, developed type 2 diabetes in his nineties, and broke his hip. But his memory remained sharp. Even after his beloved Alice passed away, Bob retained his enthusiasm for life. He also loved to be around people. His daughters said he truly had the gift of gab. "I never saw dad angry, or heard him say a mean word about anyone," said Chris. Bob's joyful demeanor has left an impression on his family, and his humorous sayings still get a laugh. Their favorite may be the best way to sum up Bob: "I'm happy as a clam at high tide."

NATALIE CHANNELL

NATALIE ROSE CHANNELL DOESN'T leave her house without lipstick. She keeps her nails painted and believes in the power of a good face cream. Beneath her feminine facade, however, is a strong and resilient woman, one capable of navigating a century of ups and downs with grace.

She grew up on her family's fifty-acre farm near Easton, Maryland. Her brother, Dan, was seven years older. Although he liked to tease his younger sister, the two were very close. Natalie's father was a farmer, but later took a job as a deputy sheriff. Her mother was an industrious woman, able to create pinafores out of feed sacks during the Great Depression. In spite of the fact that they were poor, Natalie's family was the only one in the area that didn't lose its farm.

Natalie recalled the day her family sat around the radio in disbelief. It was October 30, 1938, the day Orson Welles aired his famous "War of the Worlds" radio drama. Natalie's mother was frightened for her children because they "still had so much life to live." Although her father appeared to be worried, after the truth was revealed on the radio he told his family he'd known all along it wasn't true.

After graduating from high school, Natalie went to work for the Talbot County Clerk of the Courts office as an administrative assistant. In 1941, she married John Channell and the couple had four children: Sherry, Rozann, Bill, and Jack, who tragically died in an auto accident in 1992. Eventually, Natalie took a job with the Talbot County Health Department as a secretary, but she also took X-rays for the department. At the time, people were still susceptible to tuberculosis and the X-rays were an important part of a patient's health screening. After she and John separated, Natalie moved back to her parents' farm and continued working for the county health department.

Sherry said her mother didn't give much thought to being a single mom—she did what she had to for her four children. "If you want to live to 100, keep the men out of your life! They're too much work," said Natalie. She never needed public assistance, and she was able to put three of her children through private Catholic school. She walked four miles each way to work until she could afford her first car. "She worked hard," said Sherry.

Natalie retired at age sixty-two, and in 1976 moved with her mother to Salisbury, Maryland, to be closer to her sons and care for an elderly aunt. The mother and daughter were very close, enjoying their shared sense of humor and religious faith. After her mother passed away, Natalie continued to care for her great-aunt until she died.

After helping others for most of her life, Natalie was finally able to do something significant for herself when she turned ninety years old: she purchased her first home. She still lives there with her cat, Yoda, enjoying the view of a pond frequented by ducks and deer. Her home is also close to Sherry and her husband Richard, and they stop by several times a day. Once a voracious reader, now Natalie listens to several books on tape each week, even though her hearing isn't great. She has lost most of her eyesight to glaucoma and macular

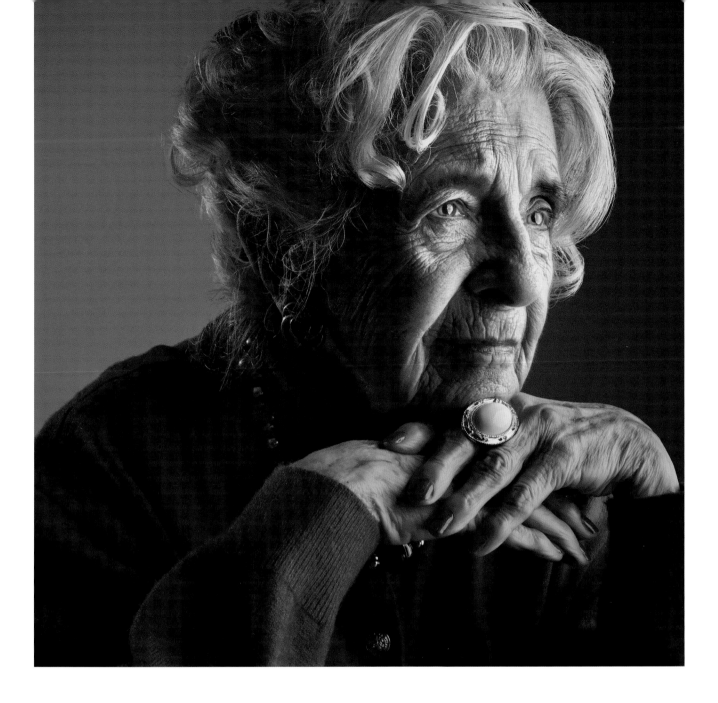

degeneration. She can't needlepoint or knit hats or gloves anymore, but she has adapted: she just knits rows. When the piece she's working on gets too long, she rips it out and starts again. The movement helps keep her hands and mind busy.

Natalie named her children as her greatest accomplishment in life. Her legacy includes twelve grandchildren, thirteen great-grandchildren, and one great-great-grandchild. She is very proud of their successes and how they've blended in with society. In other words, explained Sherry, "We have

so far stayed out of jail and not embarrassed her." Indeed, Natalie has no regrets. Life has not always been easy, however. The death of her son Jack took her breath away. Sherry said it was the worst thing her mother has had to endure. But Natalie is resilient and still thanks God for every day of her life.

Asked to name a favorite memory, Natalie said it was her 100th birthday. She saw relatives and friends that she had not seen for a very long time. She danced with her son Bill. "It was a very happy time," she said.

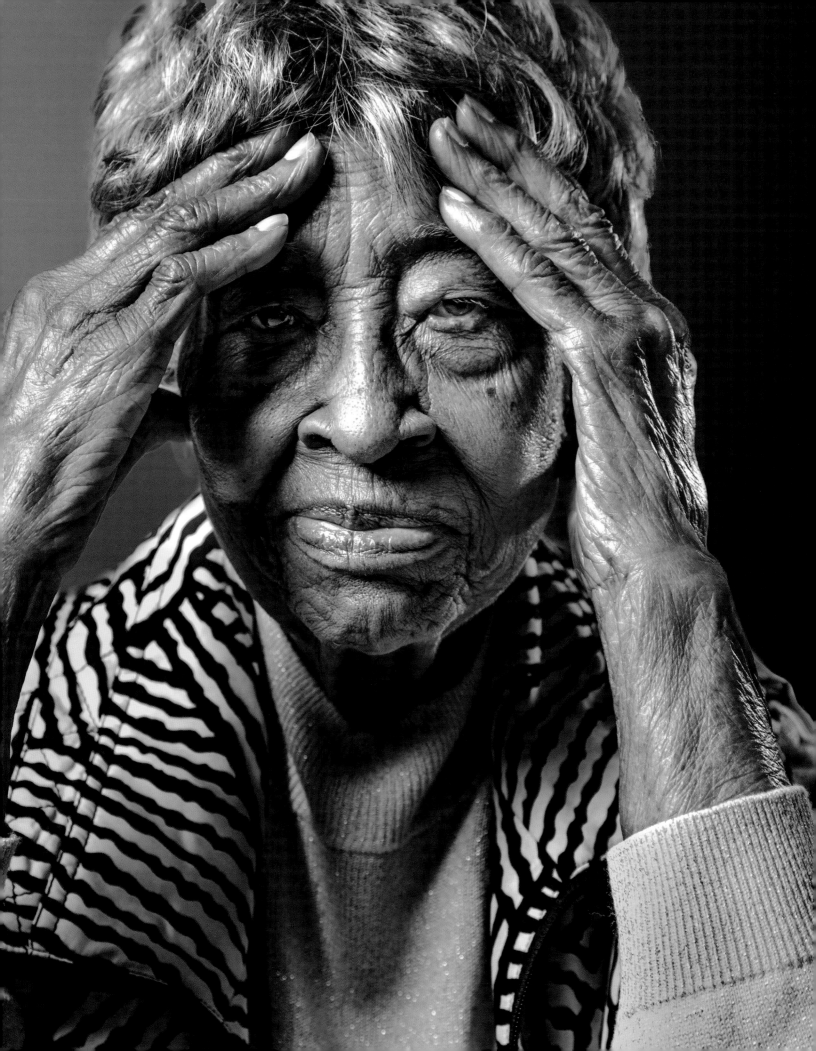

AUDREY JAMES

Las Vegas, NEVADA
July 13, 1914

FIVE DAYS A WEEK, AUDREY JAMES DRIVES TO WORK AT FISH Incorporated to oversee operations. She has been running the food pantry for more than thirty years, but Audrey is ready to step down from her post. Although she needs her walker to get around now, that doesn't diminish her ability to manage a crew of volunteers and efficiently distribute thousands of pounds of food. Audrey is just tired. "I've been doing this for so long," she said.

Audrey has been helping others for most of her life. She has volunteered with an adult literacy program, spearheaded a book drive to benefit children in several African countries, and taught elementary school—for twenty-three years in Las Vegas and, before that, for three years in Mississippi. Her specialty was comprehension; she even created a program called Three-Sense Activity. The lessons were on tape and were designed to help develop students' ability to follow directions. "Seeing and hearing are prerequisites to doing," she explained.

She hadn't planned on becoming a teacher. As a young girl growing up in rural Mississippi, she wasn't sure what she wanted to be, but she knew she wanted to leave the family farm. Audrey was one of eight children; her mother

taught in a one-room schoolhouse and her father was a postman, delivering the mail with a horse-and-buggy. He also worked as a carpenter, blacksmith, and veterinarian. There were few schools for black children in the 1920s, so Audrey was in a classroom only three or four months out of the year. She supplemented her education by sitting in her mother's classes, and when she wasn't in school she worked on the farm. Audrey's family grew cotton, fruits, sweet potatoes, and sugarcane, and raised cattle, pigs, and chickens. She remembers the neighborhood children gathering at their house on cold winter nights. They'd roast peanuts, make taffy, and tell stories. "Those were the good old days, only I did not realize it then," Audrey said.

After high school Audrey moved to Cincinnati, Ohio, where she attended the Cosmopolitan School of Music and Salmon P. Chase College of Commerce—the only one of her seven siblings to go to college. While a student, she also worked part time at a hospital and as a nanny. The experience in the hospital piqued her interest in the medical field so she decided to apply for nursing school. But the school where she applied denied her application because of her race. It was one of many times that racism delayed Audrey's pursuits.

While working as a teacher's aide at Waterman School in Cincinnati, Audrey was told by the director that she was good with children and should go to teachers' college. Also, teaching was the most convenient profession for African Americans at that time. Then, in 1948, while Audrey was home visiting family, her mother suffered a paralytic stroke. Audrey remained in Mississippi to care for her mother, and when September came, the local principal, who had known Audrey since high school, asked her to substitute until he could find a primary teacher. Audrey stayed at the school for three years. At first her salary was ninety-seven dollars a month, then it was raised to 197 dollars a month; a reasonable amount for that time and place, she pointed out.

Audrey met Isaiah James when he was home in Mississippi visiting his brother. Isaiah returned the following year to see Audrey and in 1952 they married. Audrey joined her new husband in Las Vegas, Nevada, where Isaiah got a job in construction and built a six-room shotgun house. For the next several years, Audrey went to school for her teaching degree and worked part time as a teacher. In 1965, she graduated with a bachelor of science in elementary education from the University of Nevada, Las Vegas (UNLV). Six years later, Audrey earned a master of education from UNLV, taking the entire year off from work to focus on her studies.

Audrey finished her teaching career in 1978, just eight years after the Ninth Circuit Court of Appeals ordered Clark County schools to develop a mandatory desegregation plan. Las Vegas had dramatically changed. When

she arrived in 1952, the city was segregated and the west side of town, which was primarily African American, didn't have paved streets, sidewalks, or a sewer system. By 1980, however, Las Vegas was integrating, and growing up and out. African American neighborhoods were merging with white neighborhoods. Luxury hotels lined the Las Vegas Strip, and black entertainers were not only headlining but also allowed to enter through the front doors of hotels, restaurants, and casinos—a courtesy they'd been denied less than a decade earlier.

The Las Vegas clubs and casinos had never interested Audrey though. She attended church (and still does), sometimes playing piano and leading children's choirs, and she was dedicated to her work. She and Isaiah also owned several apartment buildings that he maintained and managed (until his death in 1984). They worked hard, but when they had time to rest, they liked to picnic, sitting on a blanket and listening to the sounds of nature. Even after Audrey retired from teaching she continued to work as a volunteer. She also started to travel in the United States and around the world.

There was one particularly exciting trip she remembers well: in 1972, Audrey traveled to Africa as a participant in a seminar in comparative education. The group of educators visited schools in Egypt, Ethiopia, Uganda, Kenya, and Tanzania over twenty-two days. Troubled by the lack of materials available to students there, Audrey returned to Las Vegas and helped form the Compassion Library. With the help of many volunteers, they shipped more than 1,100 textbooks to schools in Africa.

"Those were the good old days, only I did not realize it then."

In 2012, Audrey was interviewed by Claytee D. White for an oral history project documenting the African American experience in Las Vegas. A collection of transcripts are archived at the Oral History Research Center at UNLV. The interview was conducted at Audrey's home—a house she and Isaiah purchased decades ago. In two separate interviews, Audrey recounted some of the highs and lows of her life, including memories from her teaching career and historic changes in Las Vegas.

Then, in 2014, in honor of her 100th birthday and pioneering role in Las Vegas's history, the Westside School Foundation named its annual scholarship award after Audrey: the Audrey E. James Scholarship. They couldn't have chosen a better way to mark Audrey's remarkable legacy and contribution to her adopted city.

RUBY KETRON

Bozeman, MONTANA
September 24, 1914

WHEN RUBY KETRON WAS A young girl, her father always told her to "Get up and get going—and go fast!" It stuck with her. Ruby has been moving quickly all her life. Born to Danish immigrants on a homestead in Plentywood, Montana, Ruby grew up with seven siblings. There were no doctors in the area to help Ruby's mother give birth, but a neighbor lady was always there to bring the babies into the world. "It seemed like Mom was always pregnant," said Ruby. With her parents working so hard and her mother always with a baby in tow, Ruby said she and her siblings "more or less took care of themselves."

Ruby didn't like the farm life; it was hard work and she wanted something different. So at sixteen she left home to work as a housekeeper for a doctor and his wife in Billings, Montana. She met her husband Chester there and they were married shortly thereafter. Chester wasn't able to join the service during World War II because of foot problems. Instead, he got a job as a police officer at Mare Island Naval Station in Vallejo, California, during the war. The couple lived there for three years and had their first child, Bill (now deceased), before returning to Billings.

Ten years after their second child, Vicky, was born, Ruby and Chester filed for divorce. Ruby took custody of the children and got a job at a small café, then later at a clothing store in town to support the family. "You gotta keep going," said Ruby. "You can't feel sorry for yourself." To earn extra money, she sold fruit pies. Ruby made the pies early in the morning before work and then hand delivered them to the café. She was a very good baker—a skill she'd learned as a child. By the end of the day, every slice of pie would be sold.

At the clothing store, Ruby was required to dress well and she didn't object in the least. "Mom always looked really sharp," said Vicky. She was also a very pretty lady. Although the salary was paltry, Ruby did well on commission.

Ruby's industrious approach to life served her so well that she was able to purchase her own home. She never owned a car, but that was by choice. Ruby didn't drive and wasn't interested in learning either. She was able to get around town just fine, walking both ways to work at the clothing store until she retired at the age of seventy-two.

Ruby not only loved to wear nice clothes, but also liked to sew and quilt. For many years, until Vicky went to Catholic school and started wearing a uniform, Ruby made her clothes. "I was proud of them. She was an excellent seamstress," Vicky said. Ruby liked to give her quilts and kitchen towels as gifts, or donate them to the church during craft bazaars. Vicky said Ruby also didn't mind if people brought her things to work on; she was always glad to help.

Although she no longer takes on sewing projects, and has difficulty getting around, Ruby still finds the bright side of most things. She's content with life, happy to still be alive, and grateful for her family, which includes five grandchildren and seven great-grandchildren. "I don't know why I'm still alive. I guess I just don't know how to die," she said.

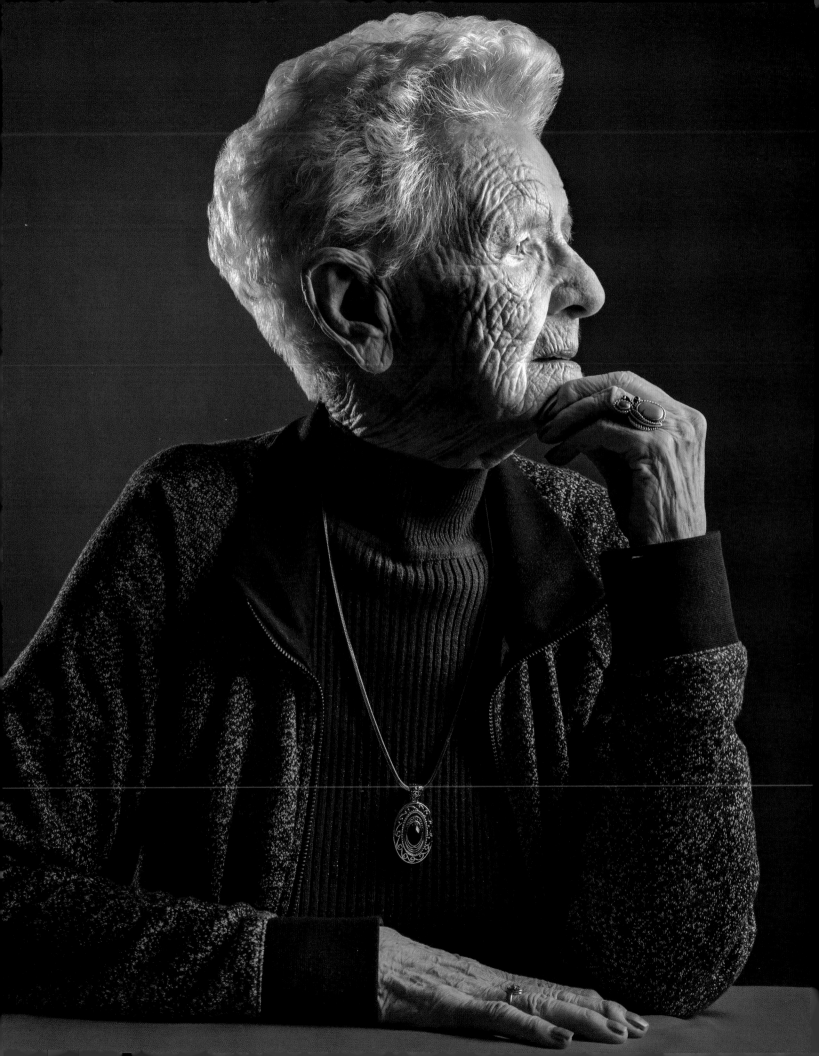

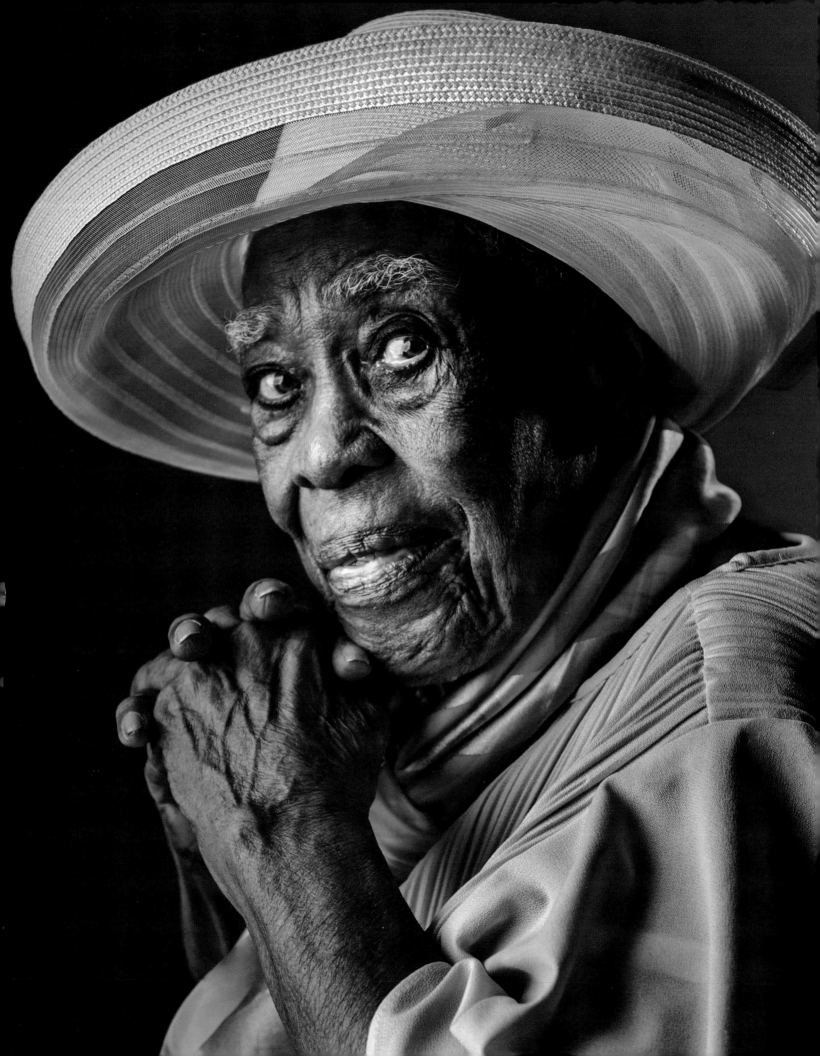

ANNE SCOTT

Pennsauken Township, NEW JERSEY
March 26, 1915

ANNE SCOTT WAS BORN IN JAMAICA, THE SIXTH OF SEVEN CHILdren raised on a farm crossed by two rivers. They raised their own chickens but primarily grew coffee, coconuts, sugarcane, and cocoa. Anne remembered picking coffee and cocoa beans as a child and attending church with her siblings. She can still see her mother standing at the stove stirring a big pot of food. She swam in the rivers, climbed trees, and played soccer and hide-and-seek. "It was a happy life," said Anne. "I'm sorry for children today. They only get to play outdoors when they go to the park."

By age eighteen, Anne was married to Edward and had a son, Selvin. The family moved to England seven years later. Anne received training to be a nurse specializing in ear, nose, and throat care. Edward passed away and eventually Anne accepted an offer to move to the United States to provide in-home nursing care for the mother of a friend. She has lived here since and said it is a beautiful place—imperfect, but she likes it nonetheless.

Longevity is in Anne's genes. She had several relatives that lived more than 100 years, including a grandfather that reached 114. When asked what she thought of her exceptional and long life, Anne responded with a favorite poem, whose author is unknown:

> Life is a book in volumes three
> The past, the present, and the yet-to-be.
> The past is written and laid away,
> The present we're writing every day,
> And the last and best of volumes three
> Is locked from sight—God keeps the key.

DELLA HIGLEY

Springdale, UTAH
April 16, 1914

DELLA CRAWFORD HIGLEY REMEMBERS WHEN THE SIGHT OF A car in her hometown of Springdale, Utah, drew a crowd. The town's remote setting and single dirt road didn't bring many visitors. But that changed after Zion Canyon was designated a national park. By 1926, tourists were driving from as far away as Salt Lake City to explore the spectacular landscape and stay at Wylie Way Camp, one of the national park's first tourist facilities.

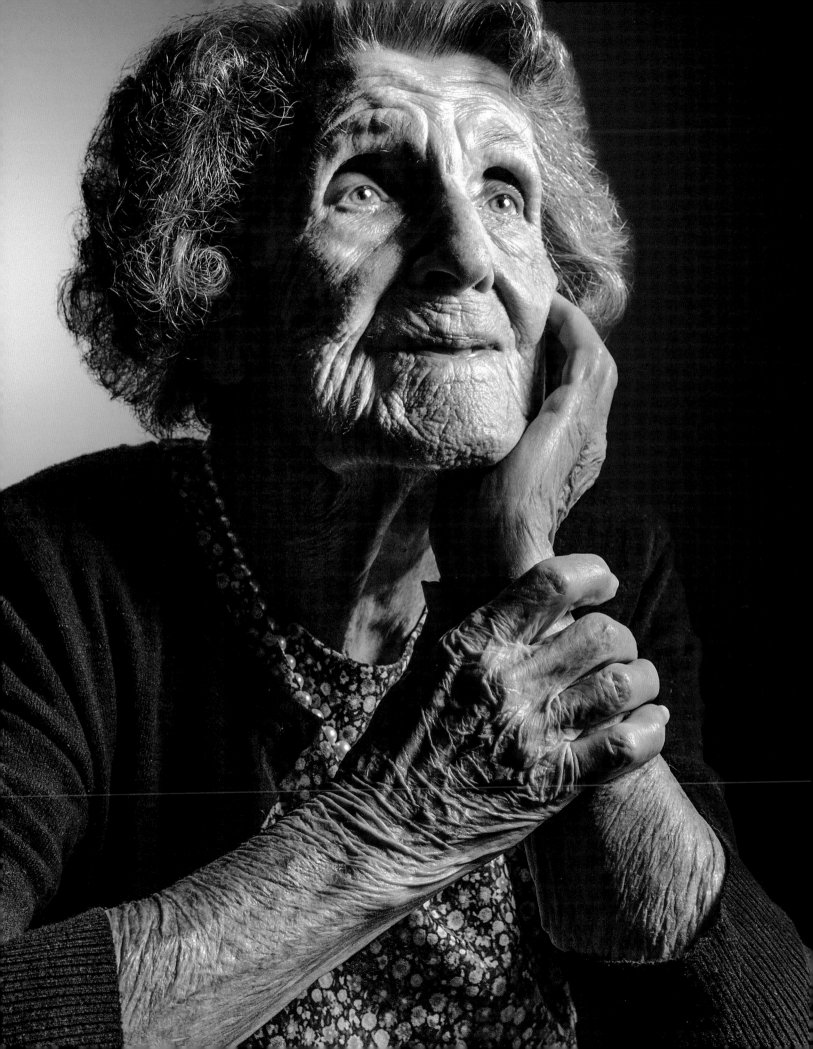

Springdale was a quiet town settled by Mormon pioneers in the 1860s. For nearly fifty years it thrived without electricity, running water, telephones, or a gas station. "Things were very primitive," said Della. "But we just made do without."

Della was born in St. George, Utah, in 1914 and returned to her family home in Oak Creek, a small community close to Springdale. Hers was one of the first Mormon families to arrive in Zion to grow cotton. Brigham Young thought it would be wise to settle and use southern Utah's resources, and to grow enough cotton there to supply church members in the region.

The first homestead that Della's father farmed, where he raised vegetables and turkeys in 1909, was within the park's boundaries. This was an unfortunate setting, as he was required to move after Zion was designated a national park. After resettling outside the park, he replanted his vegetable garden. While her brothers helped on the farm, Della worked in the house, cleaning the stacks of dishes that seemed to appear at all hours of the day. In the morning, she made lunch for herself and her brothers—molasses and butter on bread— then she and her siblings and cousins walked nearly two miles to school, each way. She also did the laundry, scrubbing the family's clothes on a board and boiling them in a cauldron over an open fire.

"Look for the good in people. I've never met an enemy."

The Oak Creek community was resourceful and close-knit. Della had the freedom to play and explore the remarkable canyons and rock formations in her backyard. "We made our own entertainment," she said. There's a large rock at the entrance of the park that Della recalled climbing as a young girl. She figured if her brothers could get up there, she could too, so she climbed up after them. As a joke, they got down and left her up on the rock. Eventually, they returned to help her get down.

Della met her husband, Elmer, at the modest country school in Springdale where three teachers taught grades one through eight. They started dating when Della was fifteen. She was married a year later in October 1930. In March 1931, the couple moved to California. It was the Great Depression; families had to go where work could be found. Elmer and Della and their five children (Geraldine, Marion, Shirley, Jim, and Wil) moved several times, from California to Idaho, back to Utah, and then back again to California. They lived in the Pasadena area, where for fifteen years Della worked as a matron at San Gabriel High School. Della said her happiest years were spent raising her

children. Even during the long days of work and keeping a home, Della found joy in the company of her family.

After retirement in 1977, Della and Elmer returned to their beloved home in southern Utah and settled in Springdale. Some of Della's siblings still lived in the town and she had plenty of friends and cousins in the area.

Elmer passed away in 1996, after sixty-six years of marriage. Della still lives in the house they shared. She cooks her own meals and keeps a tidy home. Until she got her first clothes dryer at the age of ninety—the same year she stopped driving—she still hung her laundry on the clothesline. A son and daughter live nearby and visit with her daily. During her retirement years, Della kept a busy social life, volunteering with a group that visited homebound women. They provided spiritual support and helped in whatever way they could. "We wanted to make sure that no one was left out," said Della. She also helped a group making quilts for charities. Now, she occasionally likes to attend the weekly senior luncheons in Springdale to keep in touch with her friends and family members.

Della has given to others her entire life. In fact, her only regret is that she didn't go on a mission for her church when she was young. But overall, she said she has enjoyed her life. When asked what advice she could share with others on how to achieve the same, she said, "Look for the good in people. I've never met an enemy. I love people."

Zion National Park is a chest of memories for Della. Every bend in the creek, canyon, or rock formation holds a story from her childhood. The wooden house her grandparents built is still standing, and she recognizes the sites where other farmhouses once stood and can name the families that occupied them. But all the people she knew as a child growing up in the canyon are gone. "I didn't sign up to live this long," she said. "I don't like the downside of getting old, like having to depend on others. But, overall, I think I am enjoying it."

WILL CLARK

Tucson, ARIZONA
August 17, 1904

Born in Mitchell, South Dakota, Will Miles Clark graduated from Creighton University Dental School in Omaha, Nebraska, in June 1929, just four months before the Great Depression gripped the United States. Following dental school, Will served in the US Army Dental Corps Reserves for several years, and then transferred to the US Cavalry unit in Des Moines, Iowa. There he rode alongside fellow officer "Dutch" Reagan, known to the world decades later as President Ronald Reagan.

During World War II, Will served three terms of active duty for the US Army Medical Task Force in the South Pacific. The last five-and-a-half months were spent at Iwo Jima, and later he received a Combat Medical Badge for his service there. He also received the Legion of Merit for exemplary service for helping to establish preventative dental programs at several Army posts.

Will married Lois Schafroth in 1933 and they had three children—Terry, Kae, and Max. After the war, Will and his family moved to Colorado, where he opened a dental office. Later, during retirement, Will and Lois moved to Tucson, Arizona. Always active, Will took up golf at age forty-eight, and got serious about it at age seventy. He continued to play until he was 102 years old.

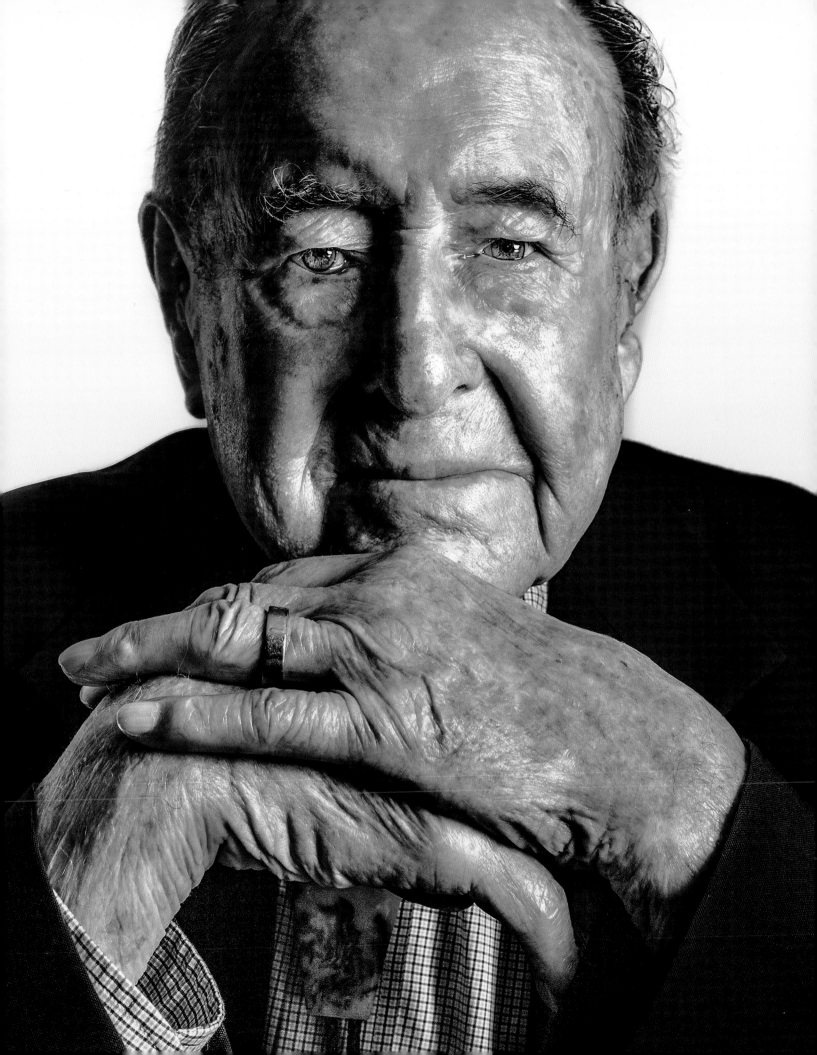

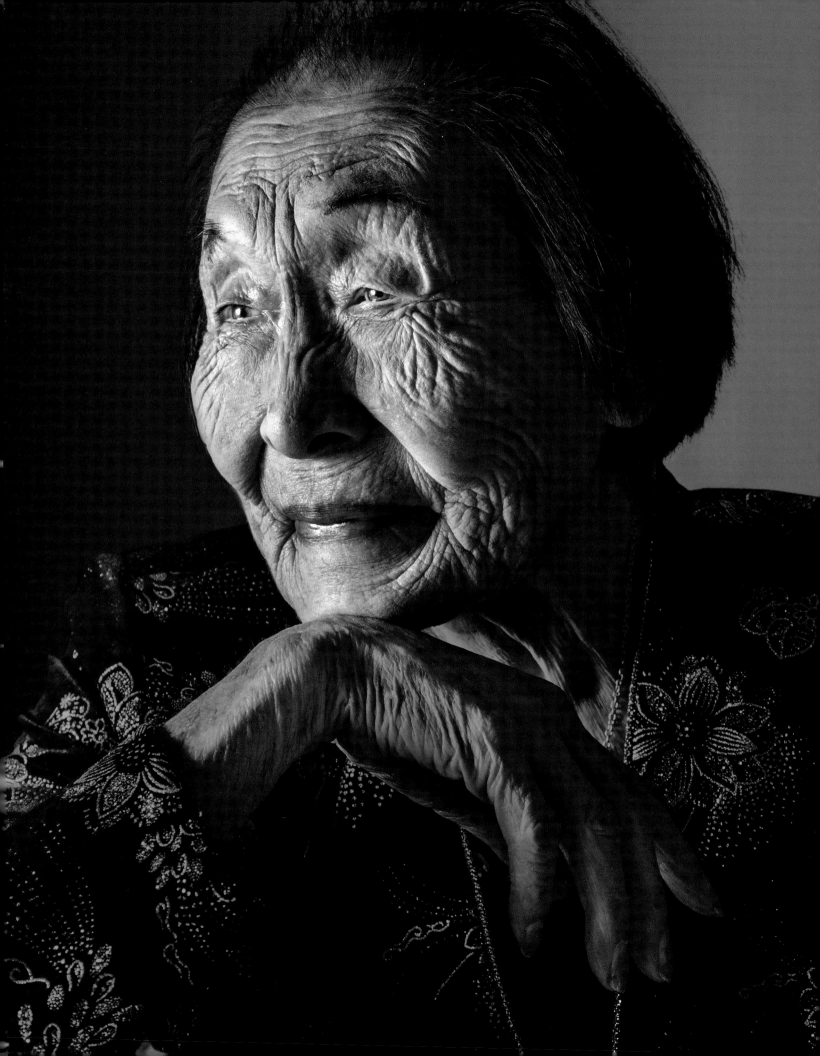

ALICE SUMIDA

Portland, OREGON
July 18, 1914

ALICE SUMIDA IS CONSIDERING TAKING FLYING LESSONS. AFTER meeting a flight instructor at a small airport outside of Portland, Oregon, she was inspired. "Why not?" she said. It wouldn't be out of character for Alice to throw caution to the wind and embrace a new hobby at 100. "Attitude has a lot to do with aging," she said. She was eighty-seven years old when she started ballroom dancing. Within a year, she was waltzing her way around the country and the world, accumulating prizes. In Venice, Italy, she won so many trophies at a dance competition that she had to buy a suitcase to carry them all home. Alice fell in love with dance as a child. She remembers a teacher at Sunnyside School in Los Osos, California, encouraging his students to dance. His wife would play the piano as the kids twirled around the one-room schoolhouse. At home, she danced to music on the radio.

Alice was one of eight children born to Tameji and Take Eto. The couple had emigrated from Japan and settled in the rich agricultural region of California's Central Coast. Alice was the third oldest of seven daughters.

The Eto family was close-knit and happy, and Tameji and Take made their children's education a top priority. Alice and her siblings attended the Children's Home in the Guadalupe Buddhist Temple complex. Their father had helped establish the boarding school for children of Japanese ranchers who lived too far out for daily trips to public schools. Students of Children's Home went to public school but were also ensured a solid education in Buddhism and Japanese language at the temple.

Alice was among the first students to go to Children's Home. She was only six years old when her father drove her by horse-and-buggy to the boarding school, almost a day's ride away from the family farm. To help ease her sadness and fear, Alice's father bought her a lightweight blue wool dress with delicate white flowers appliqued to the hem. She can still remember that little blue dress.

With her sister, Toshiko, Alice attended Mills College in Oakland, California, and then met and married Mark Sumida. "Mark wasn't much of a dancer, but he did know how to fox-trot," said Alice. The newlyweds moved to Seattle to start a new life, but not long after the attack on Pearl Harbor, an FBI agent showed up at their apartment to ask Mark unsettling questions. "I was so scared that he was going to take my husband away," said Alice. Although she was assured that wasn't the case, it wasn't long before they received a letter with orders to be at Portland Assembly Center within two weeks. They were only allowed to take one suitcase each, nothing more.

The center was a converted stockyard that had been minimally altered for its new purpose as the first point of incarceration for roughly 1,200 people of Japanese ancestry. Individual living quarters were modest ten-by-fifteen-foot living cubicles cordoned off with canvas. The smell of livestock manure remained in the air. Soon, the infirmary was filled with sick people. When a farmer came to the center to recruit workers for his sugar beet farm, Alice and Mark leapt at the chance to get out. A few nights later, they boarded a train with eighteen other men (Alice was the only woman from the center), and, once again, the young couple was on their way to an unknown destination and future.

"We arrived [in Eastern Oregon] and were taken to our living quarters—a canvas tent with a wood stove. It was 110 degrees!" exclaimed Alice. The work was difficult and the days were long and hot, but when the crew finished their assignment, the farmer told them they were free to go. He advised them to stay in the country, away from cities where anti-Japanese sentiment still percolated.

When an opportunity to purchase a 200-acre farm along the Snake River became available, Mark and Alice decided to take a chance. Although Mark had

no prior farming experience, he had owned a business selling vegetable seeds to farmers, and prior to the war it had been very successful. It took some effort, but eventually they secured a loan from a banker who believed they could make something of the rocky, barren land; then, they landed a government loan to build twenty houses for employees and their families. Several members of Alice's family who had been incarcerated at Manzanar in Northern California were granted release so they could help on the farm as well.

"Attitude has a lot to do with aging."

The challenges were many, but with help from their family and seasoned employees, the farm thrived. "Our first harvest was stones," said Alice. Rocks were piled in big canvas bags, taken to the edge of the river and dumped, and then hauled away by the truckload. When the land was ready, they planted potatoes and sweet Spanish onions.

But the market was laden with both, making it difficult to sell all their crops, so Mark came up with a new strategy. He sent six bags of their onions to the Florida Chamber of Commerce with a note: "If we can grow beautiful sweet Spanish onions like these, we can surely grow beautiful gladiola bulbs." At the time, Florida was the premier state for growing gladiolas. Within a couple of years the Sumidas' fields were swollen with beautiful flowers in shades of red, yellow, purple, and orange. The Florida bulb growers arrived in droves in their private planes to place their orders. "It took us five years to know how much to plant in order to fill all the [bulb] orders," said Alice.

After twenty years farming the land along the Snake River, the Sumidas sold the property and moved to the Portland area. There, they ran one of the first businesses to import koi fish to America until Mark died in 1981 following a series of strokes. Alice sold the business and their remaining property and moved to a condominium in downtown Portland. She got involved in various clubs and organizations, and then one day a friend suggested they take a dance class together. It had been years since she'd danced. "There hadn't been much time to do anything but work," she said.

In 2004, she met author and artist Allen Say, who turned her story into the children's book *Music for Alice*, recounting her life and passion for dance. Although she still loves to dance, lately Alice's social obligations have consumed most of her time. "I belong to this club and that club. I'm always attending meetings," she said. But Alice is sure she'll return to the dance floor eventually—unless she takes up flying instead.

RHODA LAUGHY

Lewiston, IDAHO
July 25, 1914

RHODA LAUGHY WAS BORN IN NORTH DAKOTA, THE DAUGH-
TER of a horse trader with a wanderer's heart. Rhoda changed
school six times in one year before her mother asked for a divorce
from her father. Later, Rhoda moved to Minnesota and graduated
from high school in Duluth in 1933. As a young woman, she became interested
in handwriting analysis and she credited her involvement in the International
Society of Graphoanalysis with helping her overcome her shyness.

Rhoda met John Laughy while working for the Works Progress
Administration during the Great Depression. John was a highway engineer and
Rhoda was a bookkeeper—her first job after high school. The couple married
in 1936 and began their life together with fifty dollars to their names. Many
years of their long and happy marriage were spent in the Lewiston, Idaho, area,
although they also lived in California for several years.

Their legacy is impressive. Rhoda and John (who passed away in 1979)
have five daughters (two are deceased), seven grandchildren, eighteen great-
grandchildren, and three great-great-grandchildren. Rhoda had several jobs
during her life, and many interests. In addition to being a certified handwriting
analyst, she was a member of Women of the Moose and the National Active
and Retired Federal Employees Association. When Rhoda turned 100,
she was interviewed by Chelsea Embree, a reporter for the *Lewiston Tribune*,
and asked to share her secret to longevity. "Put one foot in front of the other,"
she said.

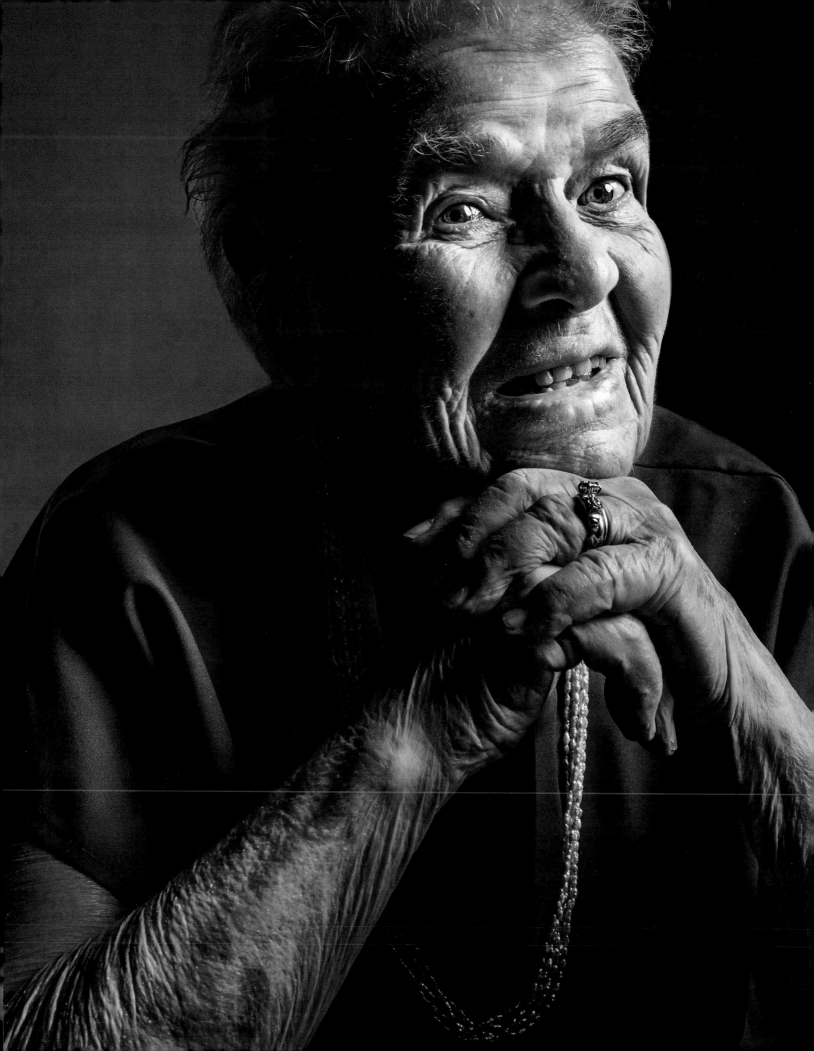

HENRY MILLER

Tulsa, OKLAHOMA
April 22, 1914

"THIS IS GREAT. I WAS BACK HOME," SAID HENRY
Miller as he stepped out of a restored Spartan
C3 biplane at R. L. Jones Jr. Airport in Tulsa,
Oklahoma. Henry had just gone for a ride in
honor of his 100th birthday and the former pilot was thrilled
to be back in the air. "I felt an adrenaline rush I haven't felt in
twenty years," Henry told a reporter covering the event.

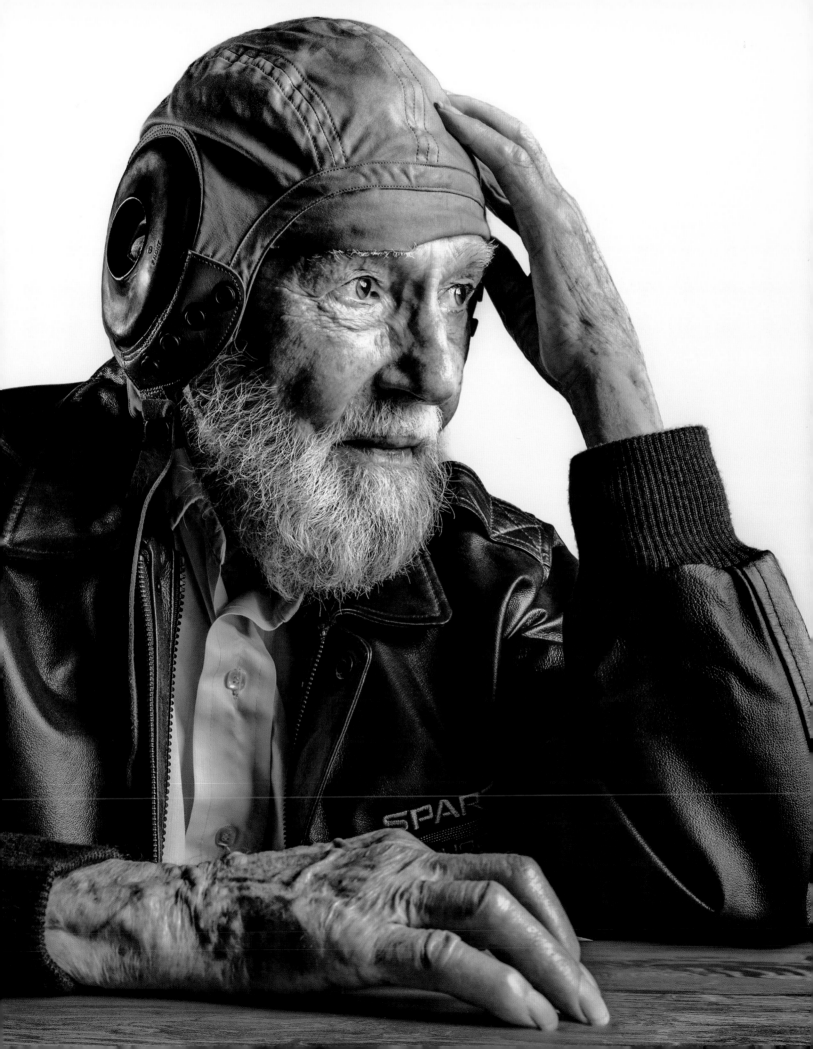

Henry was no stranger to the Spartan C3 biplane; he'd worked on it decades before while employed at the Spartan Aircraft Company in Tulsa. A native of Virginia, Henry moved to Tulsa in 1938 to attend school at the Spartan School of Aeronautics after serving as a radioman second class in the US Navy. Although he would have completed the program, the school lacked the funds to continue. He withdrew and asked for his money back, but was told by the director that they didn't have the money to reimburse him. Instead, he offered Henry the job of night mechanic. (Spartan gave him an honorary degree at his 100th birthday celebration.)

Even before arriving in Tulsa, however, Henry had experienced more in his twenty-four years than many people do in a lifetime. His first flight was in 1934 from Guantanamo Bay, where he was stationed with the US Navy. Then, on February 12, 1935, while serving as a radio operator on the USS *Richmond* off the coast of California, he transcribed an SOS message from the USS *Macon* as it was going down off Point Sur, south of San Francisco. The *Macon* was a rigid-structure, helium-inflated aircraft carrier used for scouting, and it also carried small Curtiss F9C-2 Sparrowhawk biplanes that could be launched and recovered in flight. The day Henry received the distress call, the *Macon* had entered a storm over the ocean. Its structure was severely damaged and it descended quickly. Luckily, the airship was equipped with life jackets and rafts; all but two of the eighty-three men onboard were saved, many of them by the crew of the *Richmond*. The site of the USS *Macon* crash is on the National Register of Historic Places.

"I felt an adrenaline rush I haven't felt in twenty years."

Henry can also say he "met" Charles Lindbergh. While in the radio room of the USS *Memphis* in New York Harbor, he was bumped by a stranger as he was trying to write down an incoming transmission. He asked the stranger to stop, only to find out later that he'd barked at Charles Lindbergh. The famous aviator was visiting the ship for the first time since 1927—the year it brought him and the *Spirit of St. Louis* home from France.

In Tulsa, Henry met his future wife, Ruth. He recalled their first date in a Model A Ford. It was raining and there was a hole in the roof. Although they were soaked by the time Henry got Ruth home, she agreed to go out with him again. It didn't take long for Henry to win her heart. They were married in 1938 and had a baby daughter, Janet, the next year. Henry worked full time at Spartan to provide for his new family, but they still had a hard time making

ends meet. They didn't have a car or telephone, and certainly no means to buy their own home. Then, Henry had a stroke of good luck.

Every Friday, Henry tuned in to *Wings of Destiny*, a national radio program sponsored by Wings Cigarettes that was broadcast locally on KVOO radio. Near the end of each program, listeners were given an incomplete sentence and invited to finish it. The winner of the contest won a Piper Cub airplane. One evening, Henry decided to give it a shot. Four days later, he received a telegram announcing he was one of five finalists, and was instructed to wire the radio station a telephone number where he could be reached during the next broadcast. Henry arranged to use his boss's telephone and radio. That Friday, just as the program was coming to a close, the telephone rang. It was the *Wings of Destiny* staff telling Henry that he was now one of two finalists, and to keep listening. A few minutes later, they called again to tell Henry that he and the other finalist had both won a Piper Cub. Apparently, the judges couldn't decide between the two.

To accept his prize, Henry was told to be at the Tulsa Municipal Airport on Sunday morning at 8:00 a.m. Early that morning, he and his wife bundled up their daughter and made the long walk out to the airport. The perimeter fence was lined with people anxiously waiting to see Henry receive his new airplane. After a lot of publicity photos were taken of the family holding cartons of Wings Cigarettes, Henry was handed the keys to his plane. He enjoyed the Piper Cub, but he eventually sold it and used the money to purchase the couple's first home.

Henry and Ruth had a second child—a boy named Henry Jr.—and then Henry got a job at Douglas Aircraft in California. Later, he worked for Lockheed Missiles in the Los Angeles area as well. But eventually, Tulsa called him back home and he returned with his family to work for North American Aviation, where he stayed until his retirement. He and Ruth returned to Southern California in 1984, but went back to Tulsa again in 2007, the same year Ruth passed away at the age of ninety-seven.

Henry has had his ups and downs in life. He has had plenty of accidents and his share of illness. These days, he walks with a cane. But the ride in the Spartan C3 biplane, and the birthday celebration attended by family and friends, put a new spring in his step. He enjoyed being the center of attention again, but mostly he was happy to return to the skies. "I feel ten years younger," he said.

LOUISE LUCAS

Kahului, HAWAII
March 23, 1910

LOUISE LUCAS HAD NEVER VENTURED outside of New York when she landed in Hawaii at the age of 102. Born and raised in Brooklyn, Louise felt the city offered all she needed. On occasion, she went to Long Island to buy produce when it was still primarily an agricultural area, but that was as far as she would go.

Now Louise is in paradise, thanks to her grandson, Robert Lucas. She'd been living in a care facility in Brooklyn for nearly twenty years when Robert suggested she join him in his adopted state. He assumed his grandmother didn't have long to live and wanted her to experience all the beauty the island had to offer before she passed.

But Louise is still here, and, what's more, she's enjoying herself immensely. For the first two and a half years, Louise lived with Robert in his condominium near the beach. The pair went on beach walks, visited waterfalls, and for Louise's 103rd birthday, Robert took her on a whale-watching trip. When Robert asked her what she thought of the spectacular sight, she responded, "Ah, it's something to look at."

"That's my grandmother," said Robert. Louise has a sharp wit and a biting sense of humor. She keeps Robert's friends in stitches and is a favorite with the caregivers at the facility where she now lives. Robert's neighbors know Louise as well. He said she's a celebrity of sorts, in part because she's the oldest living person on the island, but also because of her feisty spirit and one-liners.

Louise grew up in an Italian American home, one of six Ciccalella children. She was the eldest of four girls. Her family owned a fruit store in Brooklyn and her father worked long hours there. As soon as she was old enough, Louise was tasked with helping her mother care for her three younger sisters, often pushing them through the neighborhood in the baby carriage. She also did the laundry on a washboard and hung it out to dry on the line when she could barely reach the clothespins. But Louise liked the work. "The more I worked, the happier I was," she said. "We worked a lot. That's why I'm so strong."

She remembers taking the trolley car out to Rockaway Beach to buy a live chicken. The kids at the farm would butcher and pluck the bird for a few cents, plus tip. "I'd carry that bird back home on the trolley, then help my mother cook it up for dinner," said Louise. "That would be our weekend meal."

Louise's mother sewed most of her daughters' clothes. Louise said they were extraordinary and she was so proud to show them off at church or wherever she wore them. As a redhead, she was already a striking presence; dressed in her mother's outfits, she was surely a sight to behold. "Everyone thought I looked like a doll. I loved how people admired my pretty clothes," Louise said.

Early on, Louise aspired to be a model and actress. She learned how to tap dance, but also loved to go out on the weekends and dance the Charleston or Lindy Hop. "Those were the days," she said wistfully.

Louise met her husband, George Lucas, when she was a teenager; he was the only man she dated. The couple married in 1934 and they had two children: Bob and Marilyn. George, an employee of the Long

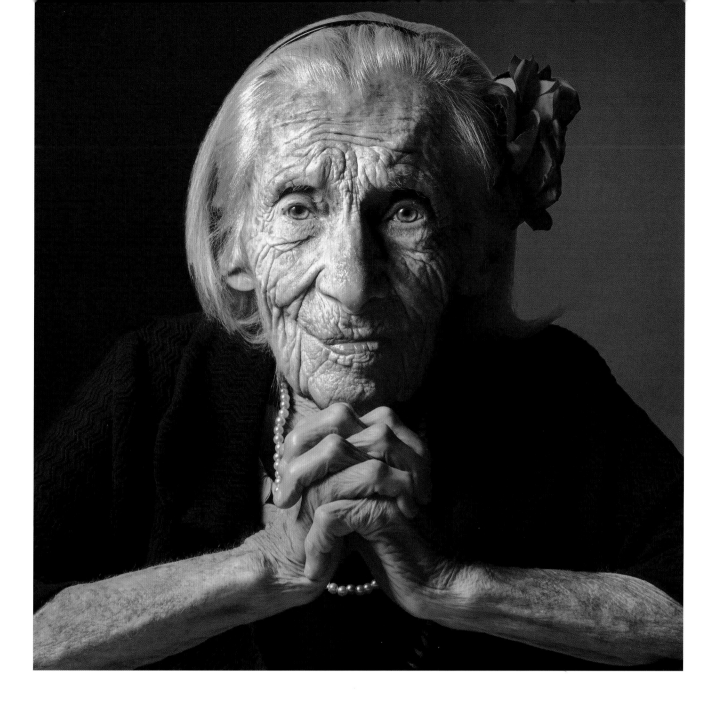

Island Railroad, was only fifty years old when he passed away. Louise did not work while they were married, but after he passed she supported herself by working at department stores. She also taught piano for many years.

Louise never owned a car; she walked everywhere she needed to go. Because of that, Robert suspects she built up a lot of strength and endurance. She still doesn't require a walker. She also doesn't use glasses or need a hearing aid. She doesn't take any medications. Robert said she prays to Jesus every day but isn't in a hurry to meet him. "You gotta keep going as far as you can," she said. "And live it up."

Robert said his time with Louise has been an amazing experience that he wouldn't give up for anything. Although it's not always easy, this special time with his grandmother has had a profound effect on him. She has proven to him that one is never too old to change life for the better, and that attitude is everything. "It's been a beautiful experience," he said. To which Louise responded, with much warmth, "I love my Robbie."

MURIEL DREW

Dover, NEW HAMPSHIRE
December 23, 1910

MURIEL DREW USED TO WALK TO Harvey's Bakery in Dover, New Hampshire, for breakfast with her friends six days a week. Her favorite item was a cinnamon honey bun called a Bull Frog, and she drank lots of coffee. When she turned 100, Harvey's gave her the gift of free coffee for life. She got a big kick out of that. Four nights a week the group also gathered for penny poker. They were known to friends and restaurant staff as the "Golden Girls." Muriel said she'd have walked to Harvey's seven days a week if the restaurant was open on Sundays. She enjoyed being with her friends and neighbors.

Now, Muriel lives at Riverside Rest Home. She moved there to be closer to her ailing sister, Norma Osgood. Muriel helps take care of her. Even at 105, the role of caretaker comes naturally. Muriel was trained as a nurse and worked at Wentworth-Douglass Hospital for many years. She also worked as a clerk at several pharmacies in town.

Muriel is a lifetime Dover resident. As a child, she and her sister and brother moved in with their aunt after being abandoned by their mother. If Muriel was affected by that sad childhood event, she made peace with it years ago. "I made the best of the situation," she said. Did she miss her mother? "You don't miss what you don't have."

When Muriel was a young woman, she met Chesley "Chet" Drew. Chet also was a Dover native. She said it was love at first sight. There wasn't a person Chet didn't like and he gave generously to others. The two eloped—no family or friends by their side. Muriel considers her romantic wedding day the most memorable event of her life, and the days and years that followed with Chet were happy, too.

She fondly recalled the road trips they'd take on weekends. The two would load up the car and off they'd go, destination unknown. "Those were the days," Muriel said. They also liked to bowl and she still has the trophies to prove she was pretty good at the game.

Chet passed away in the 1970s. Muriel sold the house they'd shared for many years and moved into an apartment in downtown Dover, where she lived until 2014. She still misses Chet and although she's not in a hurry to leave this world, she knows she'll "be able to meet him up there."

Strong-willed and outspoken, Muriel had a few words to say about the health advice she'd been given over the years: "If you want to die, go to the doctor. All my doctors are now six feet under. I just walk a lot and try to eat well. That takes care of it." At her 100th birthday party, she danced on the table. Although her birthday parties are a bit tamer now, Muriel has retained her health, eyesight, and a good portion of her hearing. She still doesn't require medications either. She's not sure how she has outlived her peers and doesn't know anyone else in Dover who has lived past 100. But she has a theory: "God's just not ready for me."

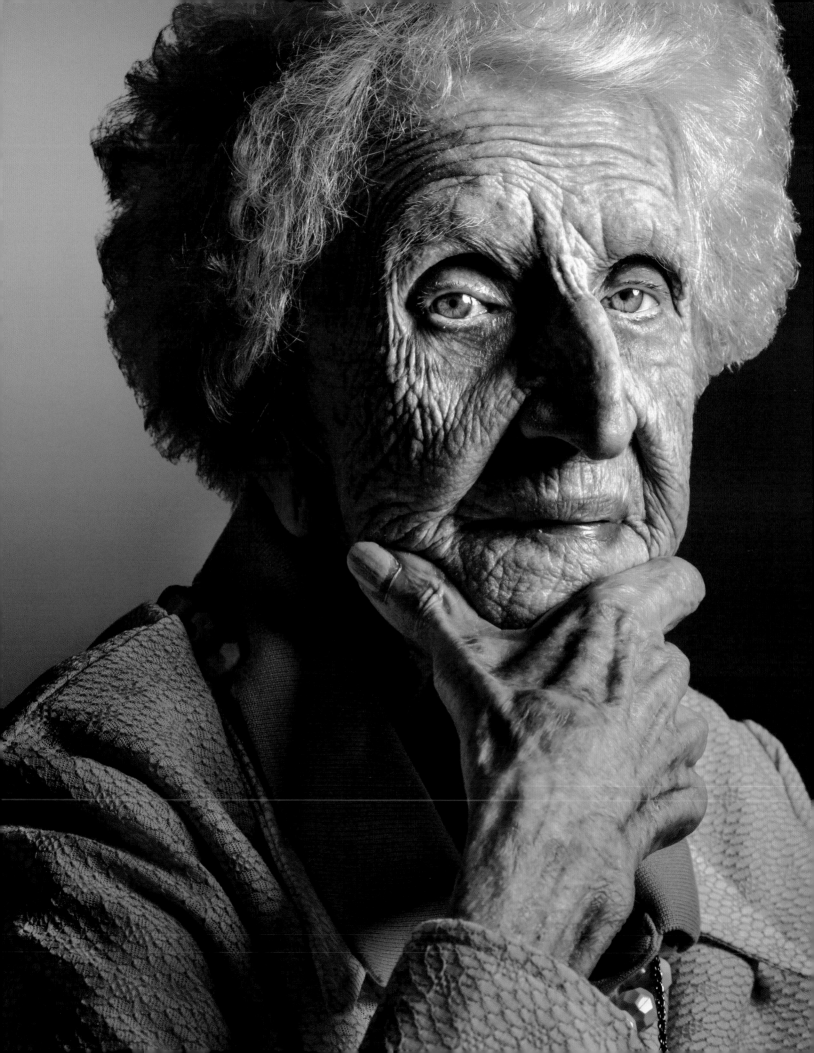

EVERETT PECK

Lewiston, IDAHO
July 24, 1914

WHEN EVERETT PECK RETIRED from his job as a cobbler, he picked up a new skill: the practice of reflexology. He hadn't planned to start a new career; he simply discovered he had a knack for it and enjoyed helping people.

Everett learned about reflexology through a friend who suggested he try it. Five decades bent over his cobbler's table had caused chronic back pain. He'd gone to a chiropractor every month for years, but the relief he felt after a treatment was temporary. It didn't seem to solve the problem.

During Everett's first reflexology treatment, which involved applying pressure to various points on the feet, Everett's back pain disappeared. Curious, he signed up for his first seminar in Spokane, Washington. After his second seminar, he was on his way to developing his own technique. Everett received his certification in 1983 from the International Institute of Reflexology in Rochester, New York. For many years, he treated up to ten people a day at his home office, and he was still treating people in his nineties. He didn't diagnose his clients, but after working on their feet, he could tell where they were having trouble in their bodies. It gave him great pleasure to help people in this way.

Everett had worked with his hands since he was a young boy. His father, also a cobbler, taught Everett how to drive tacks into new heels at the age of nine. After his father died in a terrible car accident (Everett was also in the car and suffered a head injury), he took over the family business in Grace, Idaho. He repaired shoes as well as saddles and harnesses. He was only fourteen and had just completed eighth grade.

Born in Bancroft, Idaho, about seventeen miles from Grace, Everett was the third of thirteen children. He once told a reporter that he weighed in at thirteen pounds when he was born. Everett also liked to tell the story of his mother, Olive, who outlived five husbands. Each husband (after her first) came with a large brood of children. During some periods of her life, there were up to thirty people sitting down to dinner. When Olive passed away at the age of eighty, she had thirty-four stepchildren in addition to her thirteen birth children.

Everett married Lucille in 1933 and the couple had four children: Althea, Eugene, Duane, and Shirley. After moving several times, the family eventually settled in Moscow, Idaho, where Everett worked at Peck Shoe Repair for his son, Duane. Although he spent most of his working life as a cobbler, Everett had a lot of other jobs as well. He sold vacuums door to door, and managed a cemetery and a mobile home park. In the 1940s, he worked for Kraft Cheese in Pocatello, Idaho.

After Lucille passed away in 1990, Everett married Lydia Hall and they remained together until she died in 2013. An active member of the Church of Jesus Christ of Latter-day Saints throughout his life, Everett was involved in a lot of church activities. He liked to read about the church and was interested in genealogy. Shirley said he was always busy and involved in lots of activities. "The grass didn't grow under his feet," she added, "and no matter what, he always provided for his family."

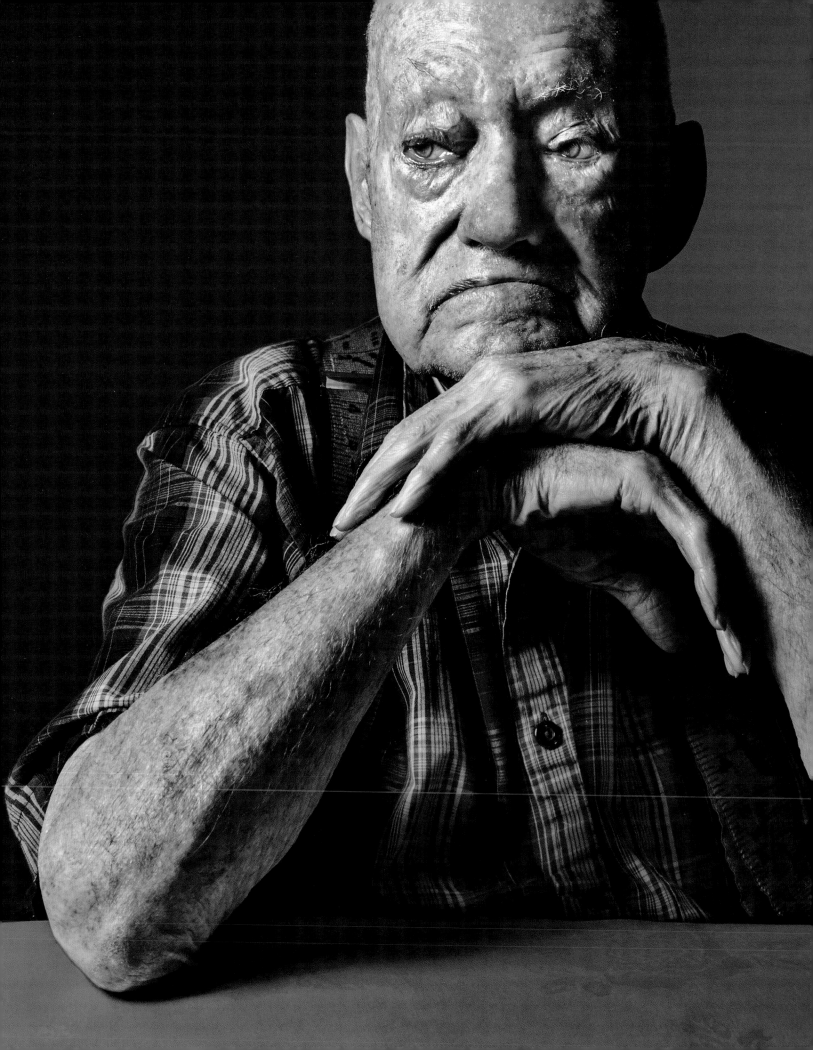

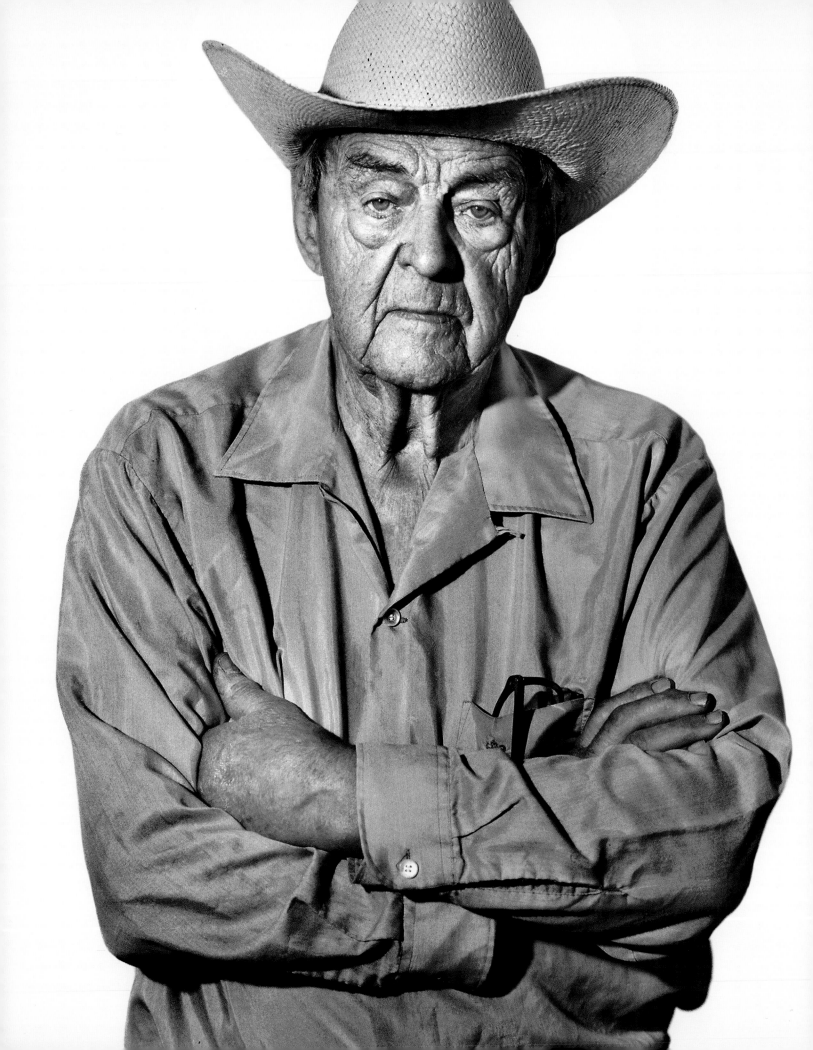

FRED BIRDSEY

Traverse City, MICHIGAN
December 26, 1899

AFTER BEING THROWN OFF A HORSE AND BREAKING HIS PELVIS in his eighties, a doctor told Fred Birdsey that he needed to stop breaking horses. Fred took his doctor's advice, but he didn't give up his favorite pastime, trail riding.

Fred also worked as a barber until he was 100; some of his customers had been going to him for eight decades. For many years, Fred also offered spaying services for dogs and cats (before veterinarians did the surgery), and during World War II, he was the largest gun dealer in the city, selling and repairing weapons out of his barbershop. In addition to being industrious, Fred was also very generous. He helped friends, relatives, and neighbors in need, often without them even knowing.

Fred's first wife Bernice died during childbirth, leaving him to raise their son Dwight on his own. Two years later, he married Gertrude. They had a daughter, Dorothy, but the couple divorced in the late 1940s. Fred was in his seventies when he decided to give matrimony another shot. The marriage lasted only one year, but it didn't diminish Fred's admiration for women. "He always loved horses and blondes," said his grandson, Doug.

PARTHENIA EDMONDS

Beckley, WEST VIRGINIA
December 23, 1914

P ARTHENIA EDMONDS REMEMBERS SITTING ON THE BANK OF A creek near the Tugger's Plantation in Martinsville, Virginia, thinking that she would like to have an education. Her mother, Polly Ann Hairston Fountain, and father, Jessie James Fountain Sr., were sharecroppers, and her grandparents had been slaves. Polly had only gone to the fourth grade, but she strongly believed that her children should get a good education. She taught Parthenia how to read, write, and spell before she started school. A few years later, the family moved to Tams, West Virginia, where her father could get work as a coal miner. Parthenia spent her formative years there.

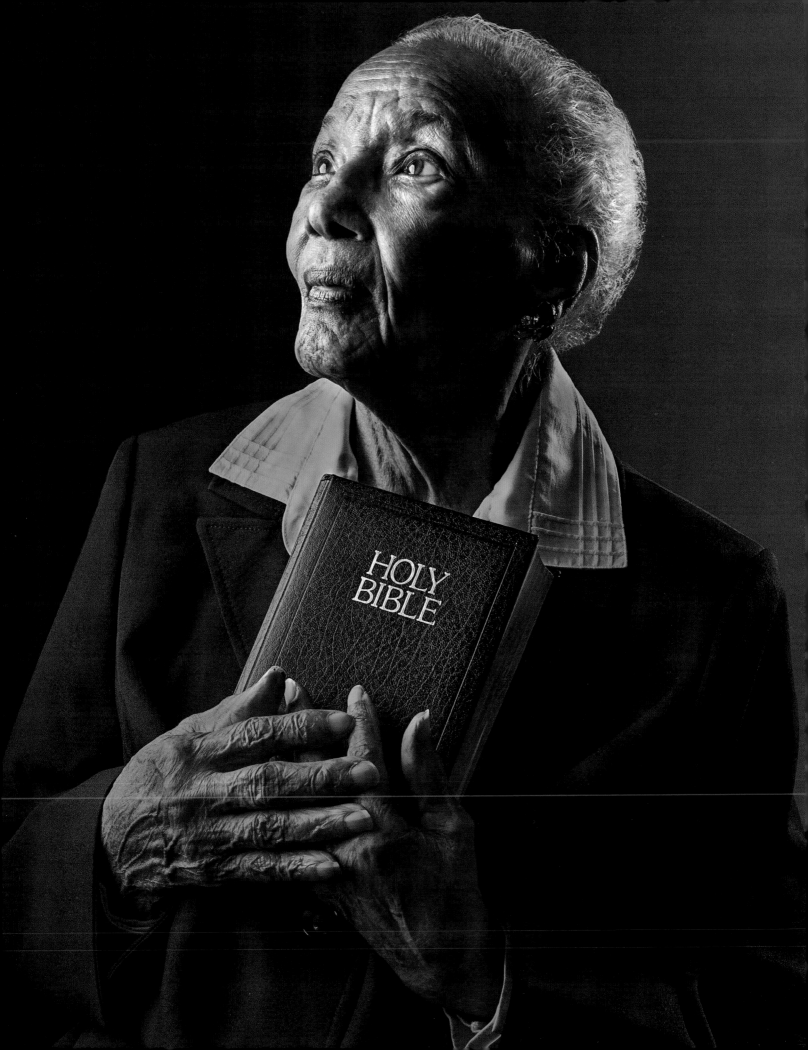

When Parthenia was in high school, she and her classmates were on their way to school one morning when a truck hit their bus. Parthenia's injuries were extensive. A passing coal camp doctor applied a tourniquet and then rushed her to a hospital. Damage to her arm was so severe the emergency doctors at first considered amputation. Luckily, they opted for surgery and her arm was spared.

After graduating as valedictorian from Byrd Prillerman High School, Parthenia entered West Virginia State University (formerly known as West Virginia State College)—a portion of the settlement from the accident paying her tuition. Without the money from the settlement, Parthenia would not have been able to afford a college education; she attributes this turn of events to "divine intervention." She earned extra money by baking and selling her famously delicious peach and apple pies to the boys in her dormitory. After graduating in 1939, Parthenia took jobs as a substitute teacher for a short time before marrying Jerry Earl Edmonds Sr. and settling in Beckley, West Virginia, a small picturesque town in Appalachia. With her sister, Lucinda, Parthenia opened Jerry's Grocery at the corner of Bostick and Hartley Avenues, the dividing line between the black and white communities. Jerry's Grocery, perfectly located at the crossroad, was a place where people from both communities could peacefully gather.

A savvy businesswoman, Parthenia also sewed children's clothes and sold them at the store, along with her famous homemade dill pickles. "People told me that my dill pickles tasted better than the ones bought in the store!" she said with pride.

"When you learn something good and helpful, pass it on to someone else."

Jerry's Grocery was so successful that Parthenia and Lucinda were able to build another store from the ground up near Piney Oaks Elementary School, where the parents of the schoolchildren were her main customers. At the same time she was running her stores, Parthenia also raised three boys: Jerry, Benjamin (now deceased), and Timothy. Indeed, she worked hard, but Parthenia still gave generously to her community. She volunteered at the voting polls until she was ninety, and helped patients at Pine Crest Sanatorium until she was ninety-two. In 2011, she started the East Beckley Ward V Education Fund with the Beckley Area Foundation to help children achieve higher levels

of education. Parthenia's generous spirit and advocacy for the advancement of civil rights were honored in 2015 by the State of West Virginia, Office of the Governor, and Human Rights Commission.

Parthenia is a devout Christian. She studies the Bible every day, making notes in her journals about scriptures or personal observations. She also spends time caring for her plants—both indoor and outdoor. She has always had an affinity for nature and still likes to walk in the woods, listen to birds, and tend a garden. In addition to harvesting vegetables, she grows medicinal herbs, a skill she learned from her grandmother who was a medicine woman and midwife. She has relied on herbal remedies for health throughout her life, even selling a number of her herbs and teas at Jerry's Grocery. "When you learn something good and helpful, pass it on to someone else," she said.

Her niece, Pamela Moore, remembers drinking her aunt's sassafras tea and thinking it tasted terrible. Still, she appreciates Parthenia's knowledge, as well as her green thumb. "I gave her a birthday party last year and she got two poinsettias as a gift. Do you not know those two poinsettias are thriving. She talks to them!" she said.

Parthenia has remained in her home in Beckley with help at times from her nephew, Albert, who lives in the apartment below her. Pamela stops by daily to help with the cooking and cleaning or run errands. She adores her aunt and appreciates the time they spend together. Although Parthenia has slowed down a little, she still enjoys her daily walks in nature and stays up on what's happening in the world by watching the news. She sticks to a diet of mainly natural foods and exercises her legs before getting out of bed each morning. She never expected to live such a long life, but she's grateful nonetheless. "I'm so happy I don't think I have words to describe it!" she said.

CATARINO ROMERO

Mineral, TEXAS
April 30, 1909

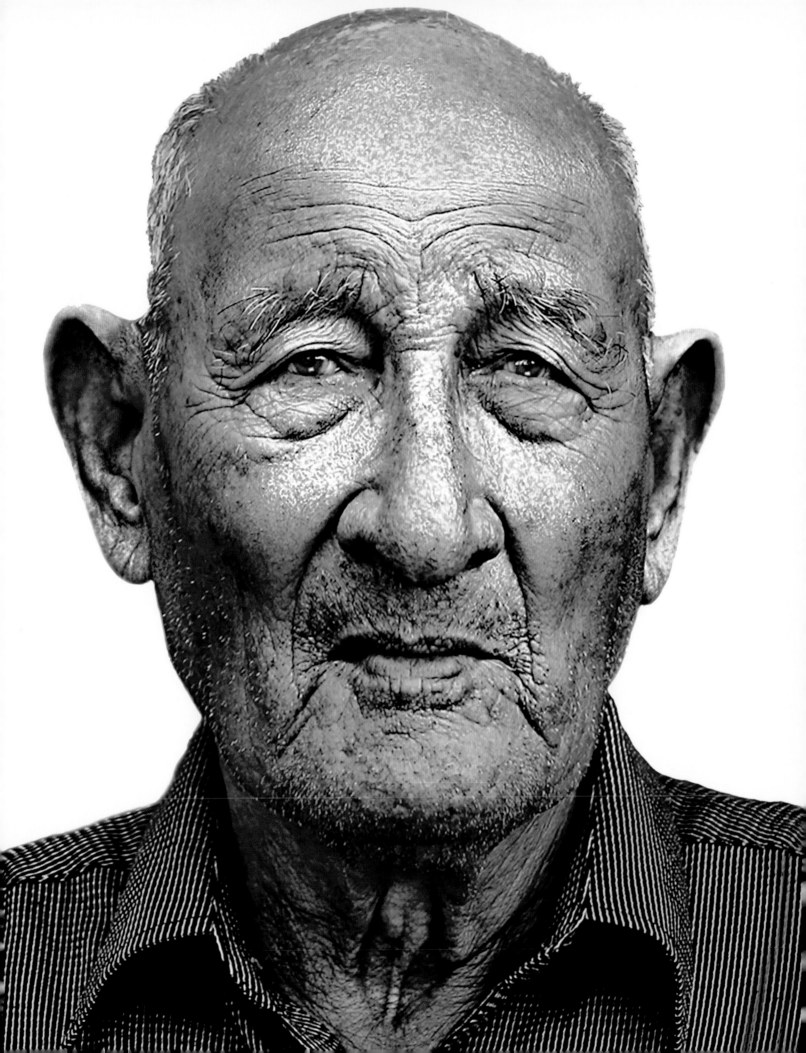

ETHEL WEISS

Brookline, MASSACHUSETTS
August 23, 1914

ETHEL WEISS HAS BEEN WORKING IN HER store almost every day for more than seventy-five years. And that's how she wants it. She would rather be there than anywhere else. As a young girl she prepared to be a secretary, and after graduating from high school worked as a bookkeeper for a fruit wholesaler. Then she met and married Irving Kravetz—the day before her twenty-third birthday. The couple started a family and opened Irving's Toy and Card Shop within a block of Edward Devotion School in Brookline, Massachusetts. For generations, children have made a beeline to the store after school and Ethel has been there to greet them and, at times, share a bit of wisdom.

Ethel's parents emigrated from the United Kingdom in 1914 and settled first in Virginia, then in Portland, Maine. Born in Newport News, Virginia, Ethel was an only child, and a happy one. She was very focused on academics. Each year in high school she won an award for scholastic achievement. After graduating, she had several jobs before she met Irving. The couple married in 1937, at first living in Roxbury, Massachusetts, and then Allston. After Irving lost his job in shipping during the Great Depression, the young couple decided they'd strike out on their own. Irving wanted to buy a bowling alley, but it was beyond their means. In fact, they could barely afford the small grocery business they purchased instead.

At first, Irving's Toy and Card Shop sold staples such as milk and loaves of bread, in addition to sweets such as Jolly Ranchers and Jaw Breakers, which sold for a penny each. It also sold toys, board games, and puzzles. Soon Irving and Ethel were able to purchase the building and the attached apartment building where they lived. They expanded the store and also narrowed the scope of their merchandise, focusing only on candy and toys, much to the delight of their young patrons.

Two years after Irving's death in 1960, Ethel married Abe Weiss, who helped her in the shop until he died in 1981. Ethel has handled all aspects of the business since his passing: bookkeeping, finance, customer service, and public relations. Although she hoped one of her two daughters (Janice and Anita) would take over the business, neither was interested. Instead, both successfully pursued other careers.

Overall, Ethel has been immensely happy working in her shop. The daily interactions with people, especially children, are what keep her going. Adults who frequented her store when they were young come in with their children and grandchildren to revisit the tiny shop with the candy-striped awning—and to see Ethel. She's an institution in Brookline, and a celebrity of sorts. Over the years she has amassed an impressive collection of news clippings that tell the story about her shop and devotion to her customers, and she has been profiled on local and national television. She displays this affection on a handmade button she wears on her lapel: "I love my customers."

"My mother is living a long, independent, purposeful life in the community that she loves," said her daughter Anita. "She always says, 'Brookline is the best place in the world to live.'"

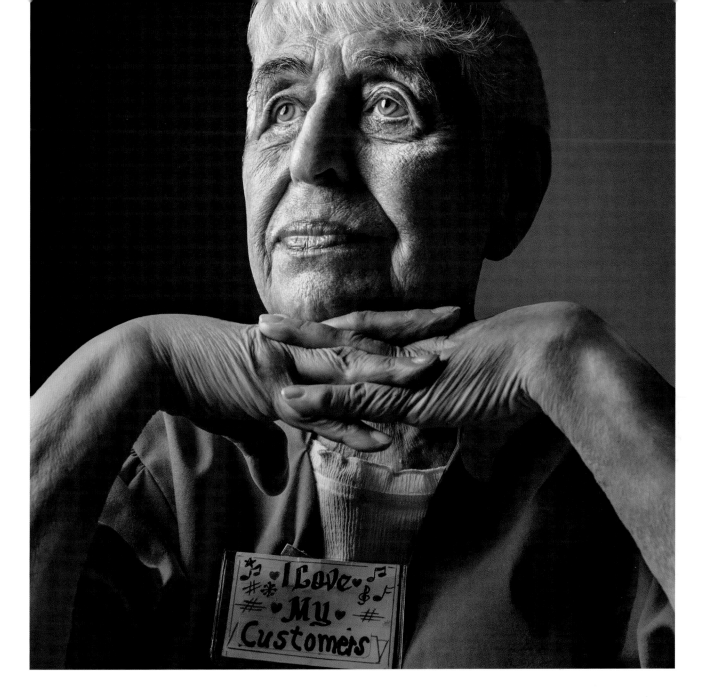

In the early 1990s, Ethel was asked how she managed to look so good for her age. In response, she wrote down a list of things she believed contributed to a happier life. She had the list adapted for a poster and titled it "Thoughts for a Happier Life," and then hung it on the wall of her shop.

Sometimes she would have the children read a line or two: Think pleasantly about your work, and do the best job that you can. Don't try to be perfect, just do the best you can. Enjoy being yourself. In 2009, she followed that one with a poster titled "How to Be Old and Still Happy." The posters sell for six dollars and Ethel will gladly sign them with a personalized message.

In addition to two daughters, Ethel also has a stepdaughter, Arlene Silverstein, twelve grandchildren, and sixteen great-grandchildren. "Our mother is a warm and loving person who believes in the Golden Rule," said Janice. "Her kindness will be remembered by her family and wonderful customers."

MARGOT LERNER

New York, NEW YORK
July 18, 1908

IN 1939, JUST WEEKS BEFORE WORLD WAR II BROKE out, a stylish Margot Baruch Rosenthal boarded a ship in Rotterdam with her husband Adolf and their daughter Ronnie. Behind them was an escalating war, and ahead the safe shores of the United States. In New York City, the family was greeted by relatives and friends who had made it out of Europe ahead of them. They settled shortly after in an apartment on West End Avenue and Ronnie entered public school.

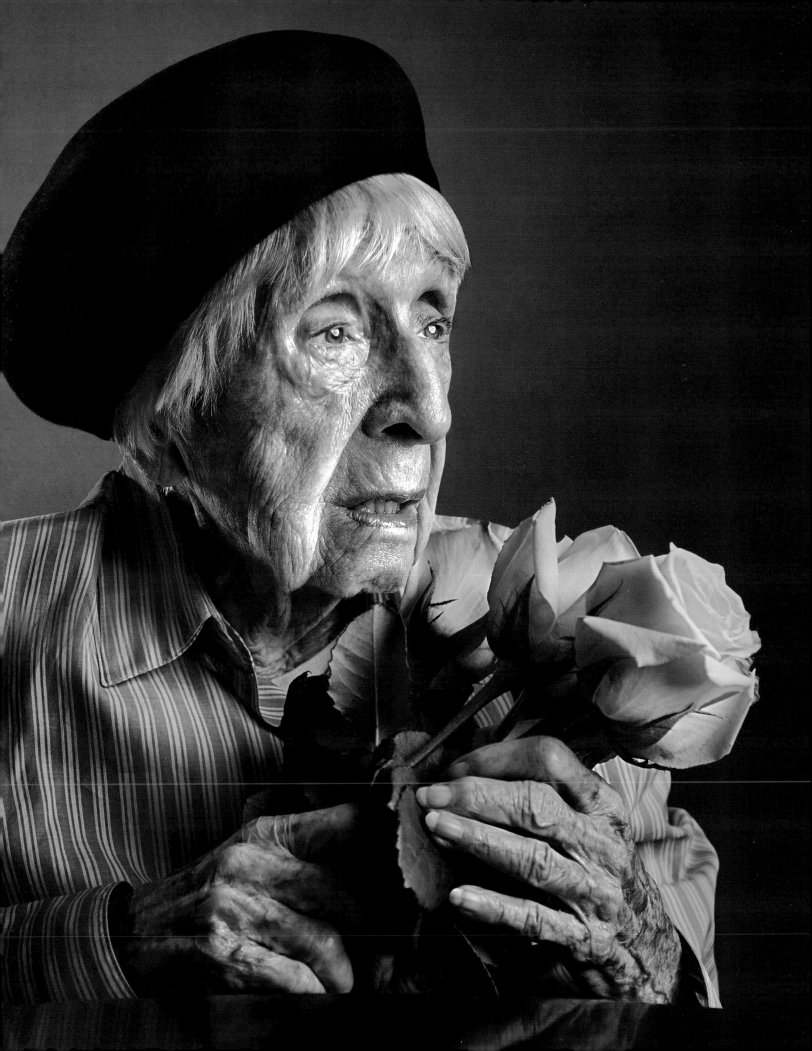

Although they faced new challenges in the United States, the young couple was resilient and determined to thrive. And they did. With their experience and contacts in the clothing industry, Margot and Adolf launched their own business. When the United States entered the war and resources became scarce, they transitioned to a niche market—manufacturing headpieces, flowers, and snoods for department stores and boutiques. Their fine products were seen by the editor of *Brides* magazine, who approached them about making bridesmaids' headpieces in new spring colors for a photo shoot. Their pieces were a hit and it wasn't long before their business, A & M Rosenthal, was catapulted to notoriety in the bridal business.

Margot was just shy of her fiftieth birthday when Adolf died. By then, she'd tired of running the business, so she handed the reins over to her daughter Ronnie and son-in-law Andrew Dessy. (Ronnie and Andrew married in 1950.) A few years later, A & M Rosenthal became Dessy Creations and, with the third generation, transitioned to the Dessy Group. The present company manufactures bridesmaids' dresses, wedding gowns, men's and women's tuxedos, and accessories. (It has also remained in the family: Margot's granddaughter, Vivian Dessy Diamond, and grandson, Alan Dessy, are now at the helm.)

After retirement, Margot poured her energy into helping care for her young grandchildren, Vivian and Alan. With their parents running the family business, the children were often with Margot—or Omi, as they called her, an endearing German name for grandmother. Vivian and Alan fondly remember those years. They thought their grandmother was very smart and open-minded and interested in everything. She read a lot and spoke to her grandchildren about philosophy. "She took us on adventures in the city and baked for us," said Vivian. "And she was very frank and open about life. She talked about doing everything, as long as it was in moderation. This made an impression on us."

Margot loved to travel and she returned to Europe often to visit her family. After remarrying in 1964, she continued globe-trotting with her second husband, Milton Lerner, often spending months at a time in different locations. After Milton died, Margot continued to go to Europe to visit family, and spent winters at her Florida apartment. Through her eighties and most of her nineties, Margot was on the go, always willing to travel or learn something new. She was ninety-nine years old when she took her last trip to Florida. "She was the happiest when she was traveling," said Ronnie.

At 107, Margot still lives alone. "She's so resilient," said Ronnie of her mother. "And very independent." Ronnie has an apartment in the building too,

and so does Vivian and her family. They've lived there since the 1990s and for many years, while Vivian's two children were growing up, four generations shared a meal together several times a week. Ronnie still dines with Margot every night.

They are a close-knit family and Ronnie surmises that being surrounded by loved ones has probably contributed to Margot's long life. Family has always been important to her. Even as a child in Berlin, she was very close to her parents and siblings, as well as aunts, uncles, and cousins. Leaving them in Europe at the start of World War II was very difficult for Margot. Although her parents made it safely to Denmark, where they joined her sister and brother-in-law, she did not like being separated from them by such a vast distance.

Margot still reads *The New York Times* every day. She continued to read books on philosophy and other subjects that interested her until it became too difficult to see. "Reading is not for pleasure," she said. "It is a quest for self discovery and self invention." She hasn't taken to modern electronic devices, but she's intrigued by their capabilities. She took her first selfie with her great-granddaughter, Charlotte, at 107 years old.

"Old age is the most unexpected of things that can happen to a person."

Margot still fixes her hair, puts on makeup, dresses beautifully, and doesn't pass a mirror without taking a second glance. On good days, she'll take the elevator downstairs and slowly walk outside, even if it means standing in the sun for only a few minutes. Until recently, she took daily walks in the neighborhood.

In fact, most days of her life included some type of exercise, whether it was walking, swimming, or following along with exercise instructor Jack LaLanne. She has also managed to evade major illness. Margot still doesn't take any medications, and she'll eat almost anything in moderation. "She has always eaten small portions. And she restricts sweets to one a day. Can you imagine? Just one cookie!" said Ronnie.

Margot didn't plan to be a centenarian, nor did she try. She has just gracefully transitioned from one decade to the next. "Old age is the most unexpected of things that can happen to a person," she said.

"The best is yet to come."

ELLIS GUSKY

Los Angeles, CALIFORNIA
December 18, 1914

ELLIS GUSKY CAN SAY HE HAS FLOWN IN HOWARD HUGHES'S private jet. He played with the Pittsburgh Symphony and in the NBC radio orchestra. He also created and led the Bob Ellis Orchestra, which backed Rat Pack performers like Frank Sinatra in Las Vegas clubs. The orchestra also appeared regularly at the posh Beverly Hills Hotel and the Claremont in Oakland, California.

The son of Polish immigrants, Ellis grew up in Pittsburgh, Pennsylvania, in a large family. By the time he was thirteen, his parents knew he was a gifted musician and they let him play in the local bars. "I used to practice playing my instruments so much at night that it drove the neighbors crazy. My parents eventually had to ask me to stop practicing," he said.

Ellis attended the University of Pittsburgh, Carnegie Mellon University (then known as Carnegie Institute of Technology), and University of California, Berkeley, but received his degree in music education from Duquesne University. For many years, he traveled the country as a musician (he played clarinet and saxophone) in the Russ Morgan Orchestra.

Ellis first caught sight of his wife, Ruth, at one of his gigs. Smitten, he searched for several months before finding her. They were married for almost fifty years and had a daughter, Anita. After Ruth passed away in 1993, Ellis met Leila Davidson and they shared a decade together before she passed away in 2005. Ellis was introduced to Susan Lindenbaum shortly after, and the two centenarians have been together since. Remarkably, the couple knew of each other in high school, but never met. Ellis can't hear well now, but he still enjoys listening to music and accompanies his grandchildren to orchestral performances at the Hollywood Bowl or Walt Disney Concert Hall. His interest in the world around him has hardly waned. "The best is yet to come," he said.

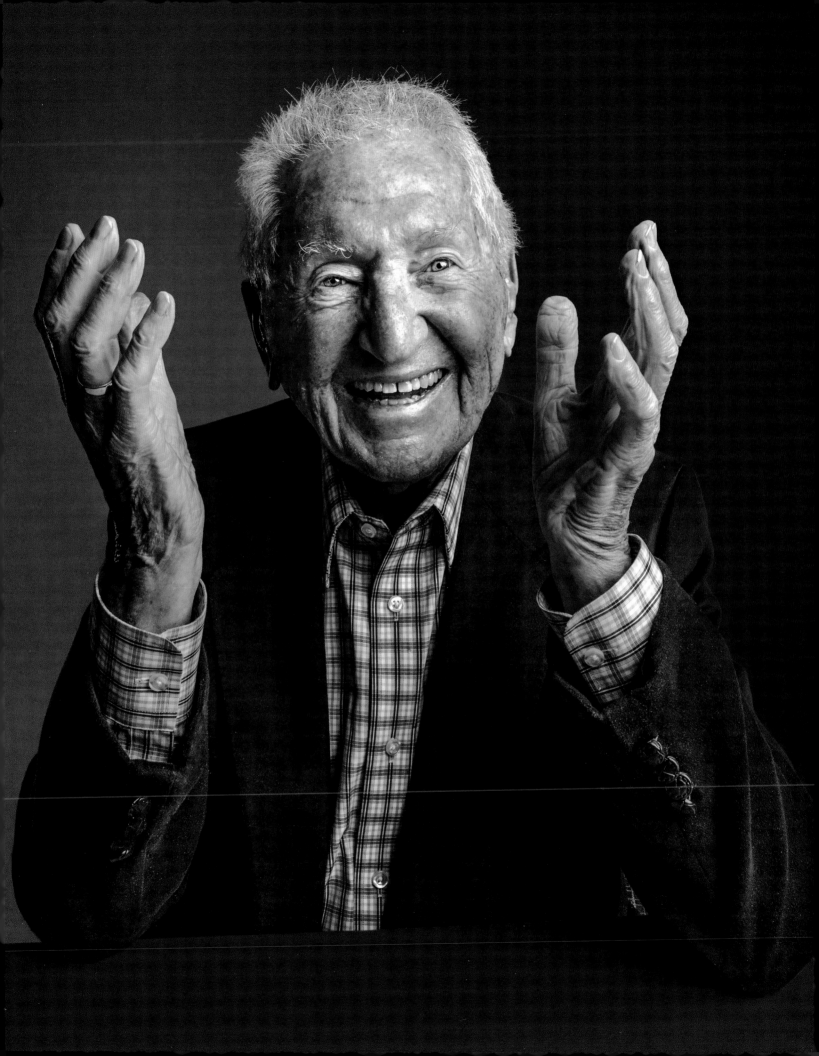

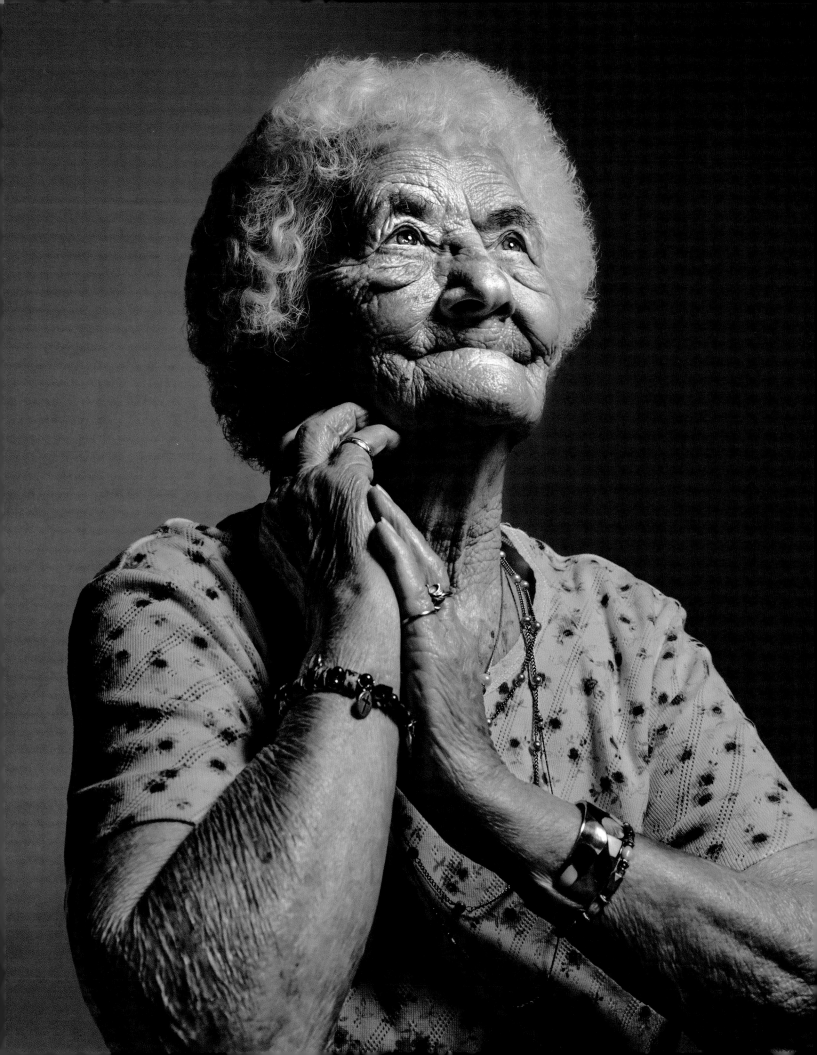

JOSEFITA HERRERA

Durango, COLORADO
June 20, 1914

JOSEFITA HERRERA WAS BORN INTO A BIG FAMILY IN NEW MEXICO, and after completing second grade, she dropped out of school to help her parents. Josefita, known to friends and family as Josie, was the eldest sister and it was her responsibility to look after her ten siblings. After she got them up, dressed, and fed, Josefita drove them to school in a horse-drawn wagon.

Then, at the age of twelve, she started working outside the house to earn money for the family. She was paid twenty-five cents an hour to iron clothes at COD Laundry, and she paid twenty-five dollars a month for room and board. On weekends, Josefita would return to her parents' home with some of her earnings. It was not an easy life for a young girl, but Josefita doesn't resent the hardships she endured.

In 1948, she married her childhood sweetheart, Jose, and they lived on a farm in Ignacio, Colorado. "I liked to be outside," she said. She tended a garden, rode horses, and worked cattle and sheep alongside her husband. "I was a tough lady sometimes," she said. They didn't have much time for entertainment, but Josefita liked to dance and Jose would accompany her at the Grange Hall dances on weekends.

Josefita and Jose didn't have any children, but they were always surrounded by their families. They also liked to travel together. They visited Italy and Spain, and went to Mexico on numerous occasions. Josefita can't name a favorite trip because she enjoyed every one, especially the food.

Josefita was a talented seamstress and she liked to make quilts. She still has some of her own handiwork, but she donated many quilts to charity. Jose died in 1985 and she has lived alone since. She cares for herself, making her own meals and baking fresh bread every week. She still likes to have guests over so she can share her cooking with them and, when possible, she likes to go on mini road trips with her family. A diabetic for many years, Josefita is careful about what she eats. But aside from the medication for her diabetes, she doesn't take anything else.

Josefita remains active in Sacred Heart Catholic Church. Overall, she said she has had a happy life. When asked what advice she offers others seeking a bit of wisdom, she said, "Keep working hard. And be happy."

JACK SOKOLOV

Overland Park, KANSAS
April 25, 1915

JACK SOKOLOV STILL PUTS IN A COUPLE OF HOURS A day keeping track of his investments. An education in accounting, running a business, and more than fifty years of investing has served him well. "I have investments in forty states and the thing I'm most proud of is that I have never had a default or a major loss," he said.

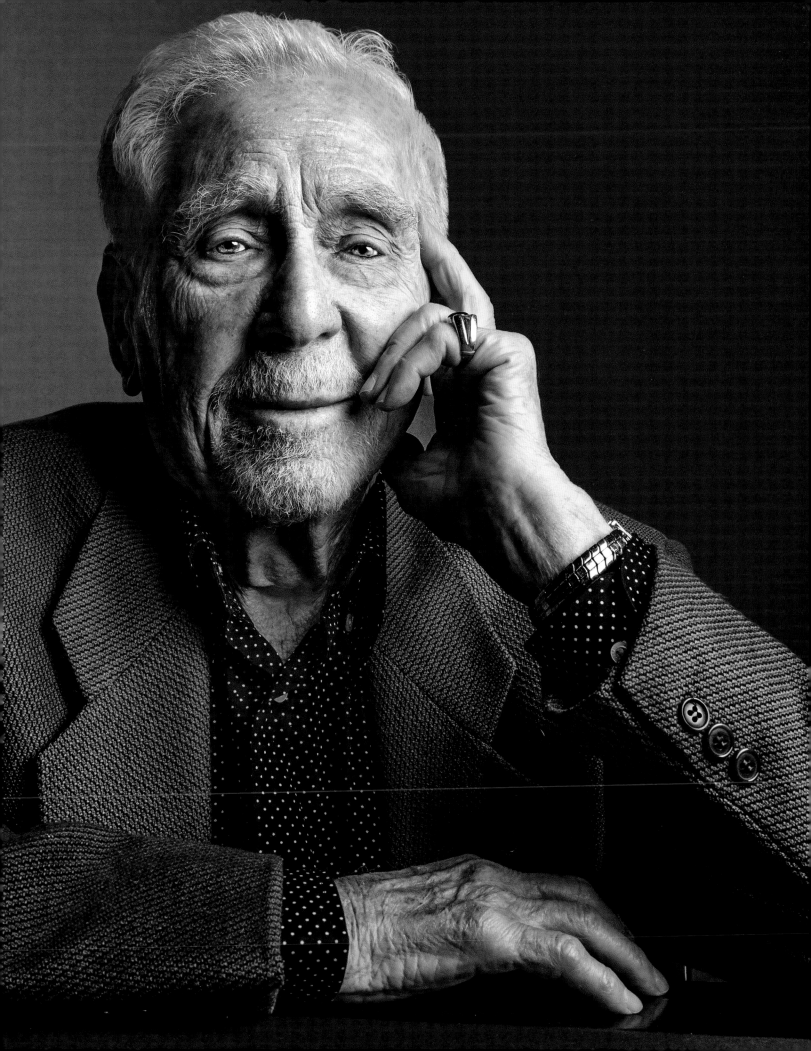

Jack's parents emigrated from Russia in 1897 at the age of seventeen and were married in Kansas City, Missouri, in 1903. His father had left Russia as an apprentice cabinetmaker but didn't immediately find a job in his adopted city. Instead, he and his wife went to Canada so he could work on the Canadian Pacific Railway, manufacturing Pullman cars. Within a few years, however, he found a job as a draftsman in Kansas City and they moved back to be with his newly emigrated relatives. Jack and his two sisters were born and raised there. Although his parents were Orthodox, Jack said they weren't particularly religious and in the United States they adopted "American ways" and only observed major Jewish holidays.

Jack graduated from high school in 1932, when the country was in the throes of the Great Depression. Banks were closing, unemployment was soaring, and the country was demanding a change. The change would come later that year with the election of Franklin D. Roosevelt. Jack had planned to attend college the next year, but those plans were foiled when his father's firm collapsed and he couldn't afford the cost of attending City College.

Instead of attending a university as he'd hoped, Jack worked odd jobs during the day and attended night classes at Kansas City Junior College and Rockhurst College, where he took courses in accounting and commercial law. An employment counselor told him he'd have a better chance at getting into a corporation and eventually the accounting department if he had secretarial skills. So Jack took his advice, enrolling in shorthand and typing classes at a business college. Within a week after finishing his classes, he got his first job with the Union Pacific Railroad. Although it was a temporary position, it was the beginning of Jack's long and successful professional career.

Several years later, while working as an accountant at Ready Mix Concrete Company, Jack met Bess, a medical technician. They were married in 1940 and had their first child, Carole Ann, two years later. Bess left her job to become a full-time housewife and three years later she gave birth to Linda. In 1949, their third daughter Hedda was born.

"While I was content and happy at Ready Mix, I was beginning to have serious doubts and thoughts about my future and my family," Jack said. "My children were growing and I became concerned about educational costs." Jack's father-in-law had been trying to get him to join him as a business partner, thereby offering a more secure and lucrative future. Finally, Jack took him up on his offer. They purchased an operating auto parts and salvage business in Leavenworth, Kansas, in 1944. By 1948, Jack's father-in-law had retired, leaving Jack at the helm. For almost five decades, Jack grew Leavenworth Auto Parts, and by the time he retired in 1987, his company consumed a three-acre site

that included a 30,000-square-foot store. Their operations included a full-service distributorship and machine shop employing dozens of people. Jack eventually gave the reins of the business to his son-in-law, Bernard, and he and Bess moved back to Kansas City, where they built a new home. After sixteen years in their home, they downsized to an apartment on a golf course, where they lived for four years before moving into a senior living complex.

Jack attributes his longevity to his loving wife of seventy-three years and his family. He also exercised and played tennis and golf on a regular basis. In fact, when Jack met Bess, she also played tennis, but after they married, Jack spent so much time on the golf course on the weekends that she decided to learn to play golf too. Bess played golf until she was ninety years old.

While he has had good health for most of his life, Jack hasn't been immune to illness. In 1998, he had a mild heart attack, followed by a quadruple bypass. After that, he started weekly exercises for cardiac rehabilitation at Saint Luke's South Hospital. Although he considered quitting after his 100th birthday, Jack had second thoughts after he received a pacemaker to increase his heart rate. Now that he has regained his energy, he has no plan to quit his exercise routine. His father wasn't so lucky. "My father had a heart attack when he was sixty-four years old and died a year later because there was no such thing as bypass surgery at that time. So medicine is what really made the difference of longevity in my family," said Jack.

"[The Great Depression] was the greatest event that was out of my control that affected my life."

Jack said he has had a good life, yet he still regrets how the Great Depression deprived him of attending a university and getting a degree. "That was the greatest event that was out of my control that affected my life," he said. "That's one of the reasons my father-in-law made it easy for me to accept his offer to join him and leave the accounting field. I didn't want my children to ever experience what I had. My number one priority was to take care of my family, to give them the opportunity to go to school, to get an education, without doing it like I did."

IRVING KAHN

New York, NEW YORK
December 19, 1905

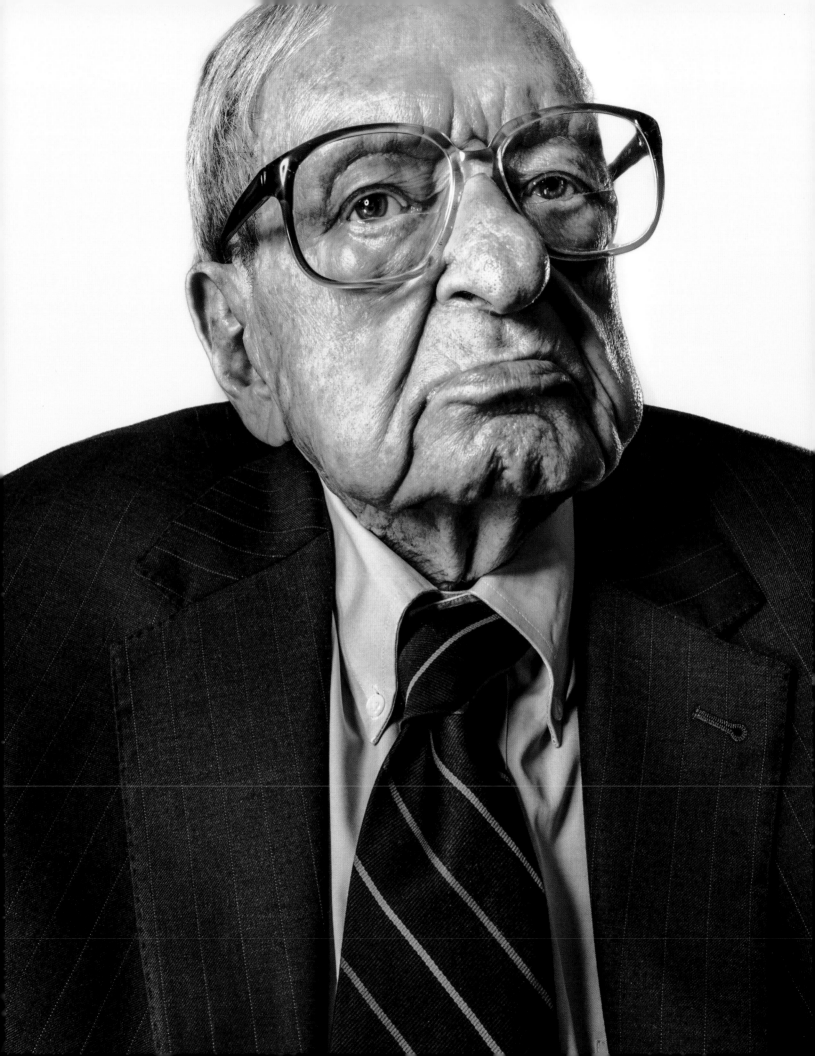

BERNARD &
BEATRICE HIRSH

Dallas, TEXAS
July 18, 1916 / April 3, 1914

I N 1978, BERNARD AND BEATRICE MET AT LOS ANGELES
International Airport as they joined a group of friends
traveling to Asia on vacation. They were the only sin-
gles in the group, so they were seated together on the
flight to Tokyo and on every bus ride for the rest of the trip.
When they returned from their vacation—Bernard to Dallas,
Beatrice to Los Angeles—they continued to correspond for
several weeks. Finally, Bernard invited Beatrice to visit him.

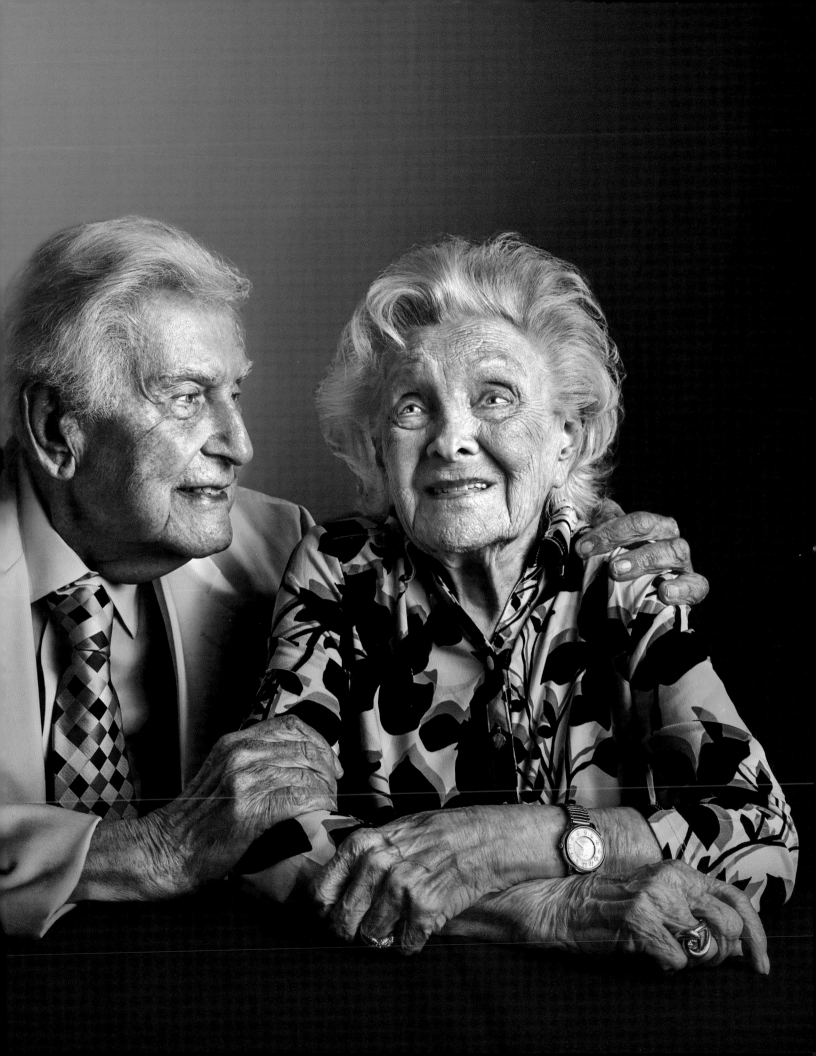

"I met her at the airport and took her to lunch," Bernard recalled. "It was a good ole Texas barbeque." They were midway through their sandwiches when Bernard popped the question: "I said, by the way, would you like to get married?" She nearly choked from the shock, but then she put her sandwich down and answered. "That's how we got together," he said. They were married on February 11, 1978.

It wasn't the first marriage for either of them. Bernard lost his first wife, Johanna, to lung cancer in 1977 after thirty-six years of marriage, and Beatrice lost two husbands, Albert Eskin and Herbert Gottlieb—one from a stroke, the other from lung cancer. Bernard had four children (twins Richard and Robert, Terry, and Cristy); Beatrice had two (George and Edward). They had a lot of common interests, too, such as travel, cards, and sports—especially professional football and baseball. They also liked to play golf. Beatrice was especially good at the game. Over the years she won a lot of trophies—some of which are still displayed at their home.

The couple shared a Russian heritage as well. Bernard's father was from Kobryn, Belarus, and immigrated to the United States when he was a young single man. A doctor recommended he live in a warmer climate to improve his health, so he moved to San Antonio, Texas, learned to speak Spanish, and married a Texan.

Beatrice's father was an opera singer from Russia. He ended up in Baltimore, Maryland, where he was a professor of voice at the Peabody Institute. He married a concert pianist—Beatrice's mother—but died in his forties from an infection following a surgery. Beatrice grew up in Baltimore and remained there through her first marriage, but moved to Los Angeles when she married her second husband.

"Always keep a smile on your face no matter how you feel internally." —Bernard

Bernard is a Texas native. His father owned a grocery store in Seguin, Texas, and he spent a lot of time there as a boy. He remembers the dark days of the Great Depression, when people would walk through the streets barefoot, in ragged clothes. His family wasn't poor, but it wasn't rich either. Poverty always seemed too close for comfort. "I remember one occasion a man came to my dad and said he owed fifteen dollars but he had a beautiful Jersey cow. Would my dad take that cow and cancel the debt? My dad said yes," said Bernard.

Those events made an impression on Bernard and he lived in fear of being in the same bad situation. As a result, he was frugal throughout his life.

After high school, Bernard studied law at the University of Texas and then moved to Dallas. It was a difficult time to land a job in his profession, so he accepted a position with the federal government doing investigative work. Then, an unusual opportunity presented itself: Johanna's family offered him a position in the family business. Bernard accepted. It was a millinery supply business in Dallas, and shortly after starting, he was made president. "So instead of becoming a lawyer, I was a businessman," Bernard said. But at the same time, he also invested in real estate in Dallas. It was a savvy business decision that has served him well. Bernard's investments afforded the couple a good life, one free of worry, which also included a lot of travel.

Even after spending time in different states and globe-trotting, Bernard and Beatrice love Texas the most. In fact, when Bernard's children were growing up he struck a deal with them; they could attend any university they wanted as long as it was out of state, and as long as they returned to Texas after graduation. "I love Texas and I wanted them to be Texans. But I felt they needed to see different cultures and then come back and live in this great state," Bernard explained. Each of his four children took him up on his offer.

Family is important to the Hirshes, and they get together on a weekly basis. Beatrice's sons and their families live in California, but they see them regularly as well. Overall, simple pleasures and being with loved ones make the couple most happy. They've experienced their share of heartache, but Bernard said he learned that it's wise to be cheerful and not morbid. "Always keep a smile on your face no matter how you feel internally," he said.

Beatrice shares his attitude. "She's so easygoing, just the easiest person I've ever known. She's wonderful," said Bernard. In thirty-eight years of marriage, the couple has never had a major argument. Perhaps their smiles explain it.

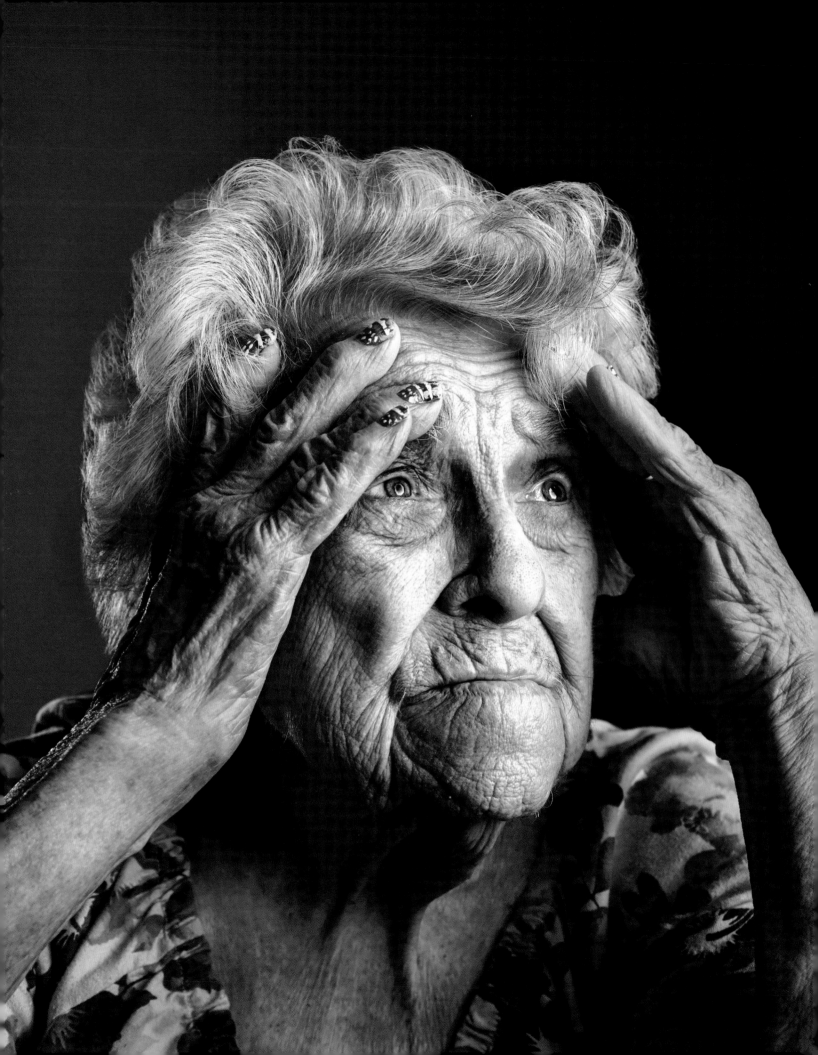

GERTRUDE VIRGIN

Augusta, MAINE
December 28, 1908

GERTRUDE VIRGIN HAS NEVER OWNED a car. In fact, she has never driven one. Nonetheless, she always managed to get around. Her grandson Harold wonders if all the walking she did—especially up and down the hills of the Maine town where she has lived most of her life—may have contributed to her long life. While employed at Maine General Hospital, she walked a couple of miles to work each way, no matter the weather. She didn't complain; that was just the way it was.

Gertrude was born in Orono, Maine, to French Canadian parents. She and her nine siblings grew up in a French-speaking Catholic home. Gertrude was a tomboy, always happiest when she could be out playing rough-and-tumble with her brothers. She preferred to leave the housework and doll play to her sisters. Their father worked in one of the mills in the area. During the nineteenth century, French Canadian families moved to New England in droves for the plentiful textile and paper mill jobs. Gertrude's family was part of the wave of immigrants that settled in Orono, although the family moved to Augusta when Gertrude was in her teens. Devoted to family and community, all but two siblings remained in the area throughout their lives.

Gertrude had two children, Irene and William. Her husband abandoned her when the children were young, leaving Gertrude responsible for their upbringing and welfare. She moved back in with her parents and went to work at a mill. After a few years, she took a job at the hospital, where she remained until she retired at the age of seventy-eight. It wasn't easy being a single mother in the 1930s, but Gertrude's parents and siblings were of immense help and support. And later, when her parents weren't able to care for themselves, Gertrude was there for them.

She never remarried. Instead, she filled her days with family and friends. She liked to take road trips with her friends, and enjoyed playing cards and board games. She danced at parties—and she walked. Whether visiting friends or shopping downtown, Gertrude always walked Augusta's steep hills. Although she was by all accounts a teetotaler for most of her life (she was partial to tea with milk), she did imbibe on occasion. Her drink of choice was 7 and 7 (Seagrams Seven Crown whiskey with 7Up soda), which she enjoyed with her cousin, Cecile. Every year they gave it up for Lent, but come Easter dinner they always had a brand-new half gallon waiting in the cupboard.

Gertrude's son William died in a motorcycle accident at the age of twenty-one while on leave from the military. After that tragic event, Gertrude put most of her energy into her four grandchildren (Harold, Jeffrey, Elizabeth, and James). She loved to tease and play games. "She has never been cynical in spite of her challenges. She has always been a spitfire. She has kept herself going," said Harold.

Gertrude has enjoyed a life of good health. She has never broken bones or had a stay in the hospital. Although her hearing is gone and she requires a walker now, she was still dancing at the age of 100, making an especially big splash at her great-granddaughter's wedding. "She attracts everyone's attention," Harold said.

VERNON ZICKERT

Deerfield, WISCONSIN
October 25, 1914

VERNON ZICKERT KNOWS A LOT ABOUT THE SOIL AND CLIMATE of his native Wisconsin. A farmer for nine decades, Vernon raised crops and livestock, tended sheep, and ran a dairy. But most of those years were spent caring for his apple orchards. He has seen the market's fickle tastes swing from yellow to green, Delicious to McIntosh, heirloom to new varieties—and back again. When dwarf trees became popular for their shorter growing periods, he replaced his standard-size trees with the smaller ones. Then his crop matured in three years, instead of six.

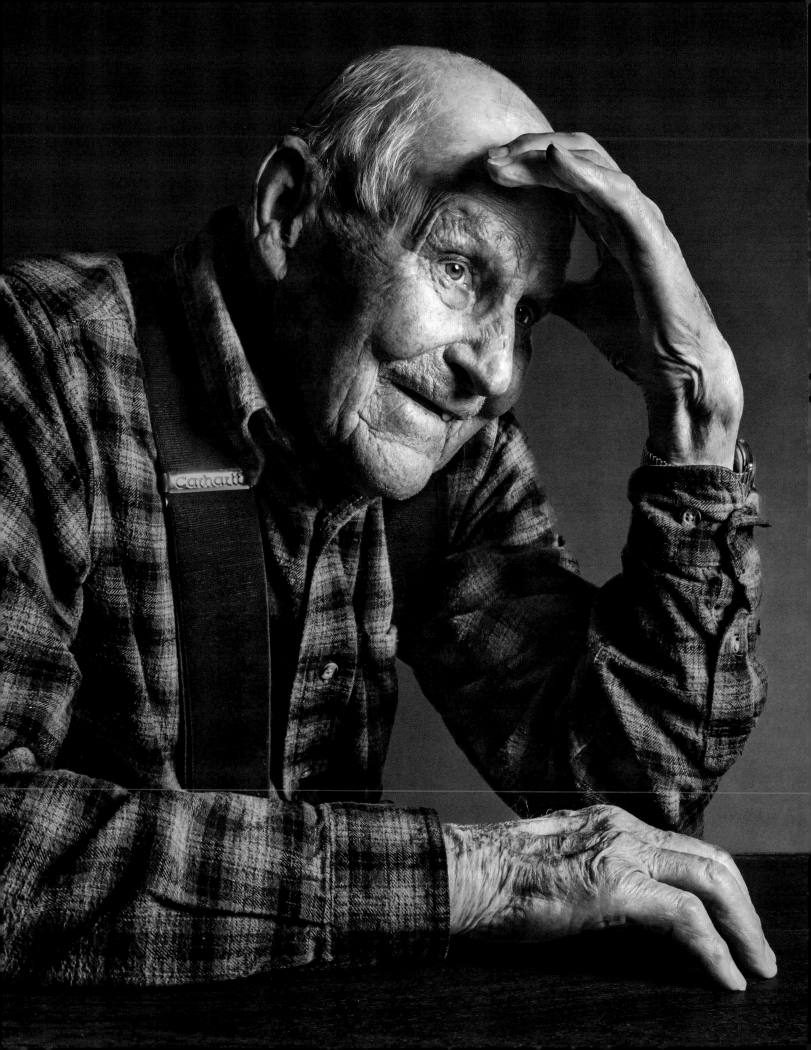

Vernon has lived within the same five-mile radius his entire life. He was born in 1914 to John Zickert and Amanda Zenk in a log cabin in the town of Deerfield, not far from his current farm. Vernon was one of six boys. His parents had built their home around the base of an old log cabin, and during the first years of his childhood they used candles and lanterns for light. Finally, his father strung electrical wire from a battery to the barn and house. "It was nice. We didn't have to use lanterns to go to the barn anymore," said Vernon.

Vernon's longevity may be partly attributed to his genes; three of his relatives—two cousins of his father and an uncle—lived to be 103 years old. His father lived to be ninety-three and his only living brother, Leslie, is ninety-four years old. But there are other factors to consider: Vernon has rarely been sick, never had a desk job, always eaten fresh food, and always maintained a positive outlook.

As the oldest son, Vernon helped on the farm during summer and went to school in the winter, walking two miles each way, even in the snow. By the eighth grade, Vernon was working on the family farm full time; school was a childhood memory. Although he would have been glad to stay through high school, farming was in his blood and it was what he expected he would do.

Even as a young man during the Depression, Vernon had a job and the wherewithal to save money, although it wasn't always easy. "I'd saved 200 dollars in my bank account and when I went to get my money out, the bank could only give me seventy dollars," said Vernon. He used it to buy a good pair of boots. He also bought a car with money from his father's small tobacco crop. During the Depression, tobacco prices dropped to three cents a pound and, rather than take a loss, his father stored it in the shed for a couple of years and then gave it to Vernon to sell. With the earnings he bought his first car, a 1932 Model A. Vernon said it wasn't much of a car—it was all he could get from the paltry tobacco sale—but it gave him a little freedom.

Vernon met his wife, Margaret Holzhueter, the daughter of one of his bosses, at church and they were married in 1939. Four years later, they bought 190 acres and a house built by Margaret's relatives for 12,000 dollars. They raised their six children there: Louann, Roxann, Annola, Annita, Sueann, and a son, Burleigh, who tragically died at seventeen in a car accident. Two daughters have remained in the area, and the other three reside in Arizona, Texas, and Florida.

Outnumbered by women, Vernon tried to enforce quiet time during the dinner hour. His daughter Annita recalled the sisters having laughing fits, much to the chagrin of their father, and being sent to separate porches to finish their dinners alone. Although the girls helped in the orchard and with farm

work while growing up, their parents encouraged them to go to college, and one by one they all left the farm for school and jobs. But each summer they'd return, eventually with spouses and children, to help with the harvest.

In 1997, Margaret had a debilitating stroke. Vernon brought her home from the care facility at her request and for seven years he cared for Margaret around the clock. When she died in 2004, Vernon continued working in his orchard. Even in his nineties, Vernon was climbing ladders and tending to his fruitful trees. Eventually, it became too much to manage alone. His daughters took care of the trees and apple sales until 2014, when finally the orchard was left to take care of itself. Vernon continued puttering around the farm and often drove his tractor, but he has now retired that as well. Now he maneuvers a riding mower through the rows of trees. There are 175 standing—fourteen rows. It's difficult for him to walk now, but Vernon does get daily exercise riding up to a mile a day on his stationary bike. He also stretches to help ease muscle tension and pain. "He doesn't realize how old he is," said Annita. "He's still got a good attitude."

It has been several decades since Vernon sent his giggling daughters to separate porches during dinner just for a few minutes of peace and quiet. Now, Vernon enjoys the ruckus his big family creates when they get together. There are fourteen grandchildren and nineteen great-grandchildren—but not a farmer in the bunch. When asked if he'd be a farmer all over again Vernon replied, "Oh, I don't know. I guess I was brought up that way and I've stayed that way."

MANDY ROBINSON

Slidell, LOUISIANA
April 10, 1915

WHEN MANDY ROBINSON LEFT rural Mississippi as a young woman, she didn't just move across the county or to the next town over; she went big. Ms. Mandy, as she is affectionately known, moved to New York City. She settled in Harlem at the tail end of the Harlem Renaissance and got a job at the famous Cotton Club.

Harlem in the 1920s and 1930s was abuzz with artistic expression and an intellectual movement that sparked a new African American identity. Being at the epicenter exposed Ms. Mandy to opportunities she wouldn't have had in Monticello, Mississippi. Ms. Mandy met greats like Duke Ellington, Cab Calloway, and other artists, attended rallies, and heard the speeches of some of the most influential African American leaders at the time.

Eventually, the South called Ms. Mandy back and she returned to be closer to her family. She moved to Texas, where one of her older sisters lived, found employment, and started to build a new life. Ms. Mandy had been married for a short period before moving to New York, but after that experience she decided marriage wasn't for her. A feminist in her own right, Mandy became an advocate for young women, particularly her nieces, great-nieces, and great-great-nieces, promoting education, independence, and positive self-esteem. "Pretty doesn't get you far," she often said. "You need to have some brains in your head."

Her great-niece Jean said Ms. Mandy was her "greatest champion" when she was growing up and as she pursued a career as an educator. Ms. Mandy shared pearls of wisdom and gave encouragement. And she was fun. Infatuated with sports cars, Ms. Mandy bought herself a 1957 Thunderbird, which she loved to drive. Jean remembers thinking her aunt was so jazzy cruising around in her pretty T-bird. "She has always been caring, loving, and full of life—a real character," said Jean.

Ms. Mandy moved to Slidell, Louisiana, in the late 1940s and eventually was able to purchase her own house. She took in one of her nephews, Charles Jackson, and raised him as her own son, even putting him through college. After Ms. Mandy retired at the age of eighty-four, she was able to become more involved in Starlight Missionary Baptist Church and activities at the Slidell Senior Center. Even now, she makes it to the senior center three times a week. "Don't just get old after retiring," she said.

Ms. Mandy might still be driving, too, if one of her great-nephews hadn't encouraged her to stop. She was eighty-five years old when she parked her Buick Cutlass for good. Even if she's not behind the wheel, Ms. Mandy still likes to get out. She'll ride along with Jean on day trips just to spend time together in the car and enjoy the scenery. She and her caregiver, Barbara Hollins—also known as "Thelma and Louise"—also keep the highway hot.

When Hurricane Katrina hit in 2005, Mandy was evacuated with her grandson Eric and his mother to

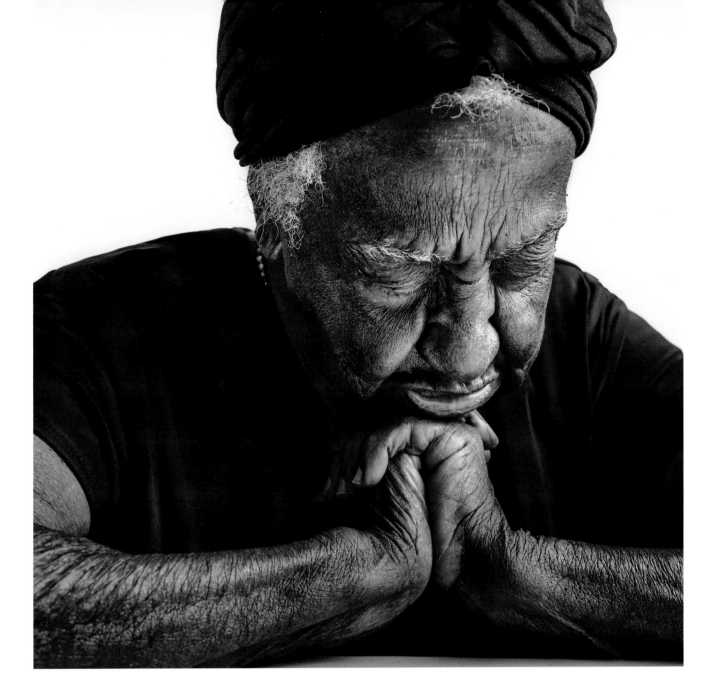

Houston, Texas. It was a stressful situation, as it took some time to get in touch with the rest of the family to let them know where she was. After some time, she was able to return to Slidell, and her home was eventually rebuilt with help from Habitat for Humanity. This experience left Ms. Mandy badly shaken. Jean said Katrina and the weeks following count as one of the most difficult times in Ms. Mandy's life.

Surrounded by a large and loving family, church members, neighbors, and friends, Ms. Mandy is always doted on. After a lifetime of giving so much to others, it is their turn to happily reciprocate. "Even the kids in church give her hugs and kisses," said Jean.

Ms. Mandy had a fall in 2015 that resulted in a broken hip. Although she healed from it, she's a little less steady on her feet now, but is getting stronger every day. Aside from a daily aspirin, medication for her blood pressure, and a vitamin, Ms. Mandy's health is buoyed by her positive attitude and gratitude for a good life. "She is truly a rock star in her family's lives and in the lives of anyone who meets her," said Jean.

"I believe that God let me survive. After singing for many, many years in opera concerts ... I turned my whole life around. I became a singer for the Lord."

FRIEDA ROOS-VAN HESSEN

Charlotte, NORTH CAROLINA
April 24, 1915

ON MAY 8, 1940, FRIEDA ROOS-VAN HESSEN WAS GIVING A concert in Enschede, Holland, on the border of Germany, when halfway through the performance the sound of gunfire could be heard outside. The concert went on, but afterward the performers were told Queen Wilhelmina had declared a state of emergency: Germany was poised to attack. Two days later, Germany invaded Holland, destroying the Dutch army and killing thousands of citizens.

During the first year of Nazi occupation, Frieda continued to perform, one time at Amsterdam's world-famous Concertgebouw, the equivalent of America's Carnegie Hall, but primarily in the "Jewish theatres." The venues were the only places the Nazis allowed Jewish artists to perform and Jewish audiences to enjoy the arts. It was many years before Frieda returned to public theaters and was able to perform without fear of being deported.

Frieda received her classical training at the Amsterdam Conservatoire for Music, strategically waiting to start her training until she was seventeen, after her voice had fully matured and stabilized. Before she was twenty,

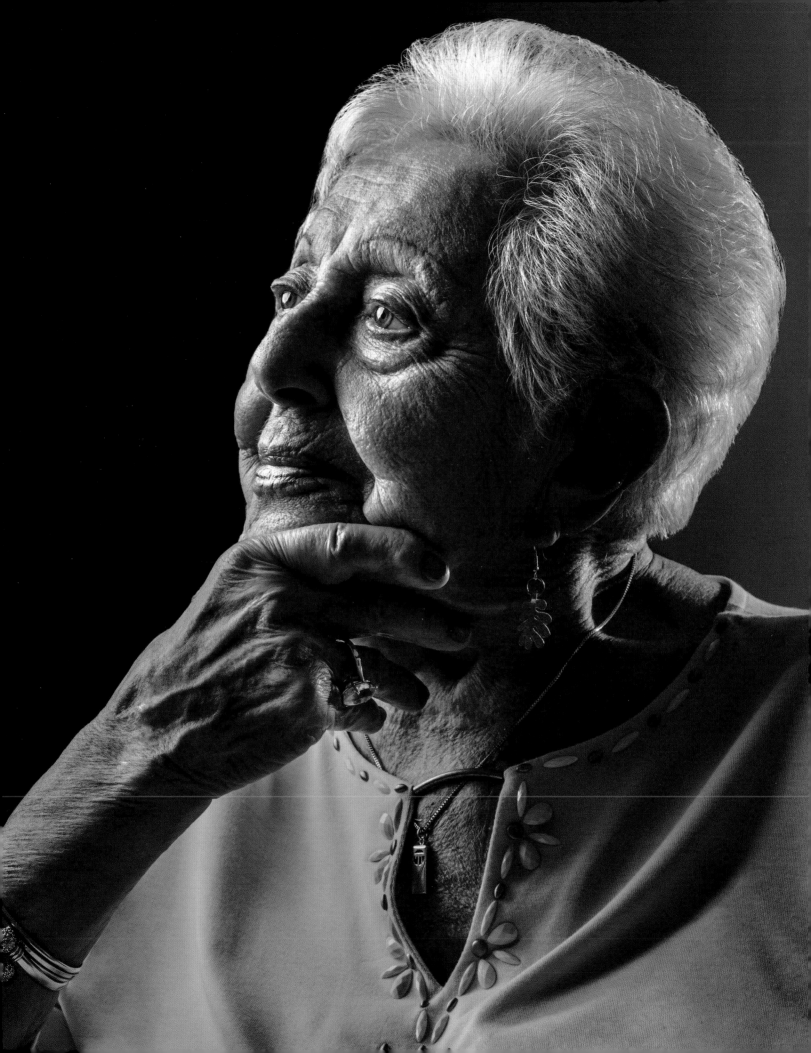

Frieda had sung the lead for the Dutch version of Walt Disney's *Snow White*, and at the age of twenty-four she was the soloist in a performance of Verdi's *Requiem* for the Dutch royal family. That year, Frieda also won the Grand Diplome at the World Contest in Geneva, Switzerland. She was judged one of the eight best female singers in the worldwide contest.

Frieda grew up in a musical home in Amsterdam: her mother had a beautiful soprano voice that she inherited from her father; her younger brother Eddie played the violin; and her older brother Bernard was a pianist. By age six, Frieda knew she wanted to be a performer. The family often played together and with friends in "house concerts" at the family home, which sat up to forty people. Although Frieda's father, a businessman and captain of the Corps of Engineers with the Dutch Army Reserve, did not play an instrument, he encouraged his family to pursue their musical talents.

On Sundays, the family went to the zoo to listen to concerts in the big music tent. "That really laid the foundation for my career as a classical singer, as well as our parents taking us to concerts and operas as we grew up," Frieda wrote in her compelling memoir, *Life in the Shadow of the Swastika: An Incredible Story of Survival, Bravery, and Renewal*. The zoo concerts also provided an opportunity for Frieda to see the animals, which she loved. The exotic birds in particular were enchanting and memorable.

Growing up, Frieda was a tomboy, preferring to roughhouse with the boys. She was also vivacious and funny, which sometimes got her in trouble. "I was always seated at the back of the class so I was not affecting the other students," she said. In spite of her tomboy ways, Frieda wore her hair in long lovely curls with a ribbon or bow. Her mother made her feminine clothes by hand. "I had beautiful dresses," she said. "Even today I remember the clothes I was wearing when I was five and six years old. I can still see them." After Frieda became a professional performer, her mother made her lavish evening gowns, which she wore in her performances with much pride.

By 1942, Frieda was no longer performing. The Jewish theatres had been closed and Frieda's focus was on survival. She was living with her friend Mieka, whose husband had been arrested by the Nazis, when the two were forced into hiding, barely escaping an unexpected house search near midnight by the Gestapo. After the war, Frieda learned her ex-boyfriend, who had joined the German SS, had betrayed her by telling the Gestapo where she lived.

During their first weeks on the run they received help from members of the Dutch underground resistance. But eventually they were forced to go deeper into hiding, surviving on their wits and savvy. For four and a half years, the young women moved from one safe house to another carrying only a small

suitcase each. They stayed one step ahead of being discovered by the Nazis, or betrayed by those they knew, and on several occasions barely escaped death.

Frieda's memoir provides chilling details of those years, including a heartbreaking account of the last time she saw her parents. Both perished in Auschwitz, along with her brother Eddie and uncles and aunts. Other family members and friends were also annihilated during the war—some in the concentration camp at Bergen-Belsen.

Her brother Bernard and his wife Daisy managed to survive. While in hiding during the war, Bernard worked bravely with the resistance. Later, he was awarded the Medal of Honor and US citizenship for helping two American pilots escape after their plane went down.

Frieda met her husband Keith Saunders, a Canadian soldier, after the war, when the Allied forces arrived in Holland. Theirs was a whirlwind courtship. They married in November 1945 and in less than a year Frieda was pregnant with her only child, Felicia, and on her way to a new life in Canada. It was also during this time that Frieda converted to Christianity.

After arriving in the "new world," as she refers to North America, Frieda devoted her time to her daughter and a great deal of her life to sharing the gospel and her story of survival during the war. "I believe that God let me survive," she said. "After singing for many, many years in opera concerts, I sang for the Lord in maximum-security prisons. I sang on the street for homeless people. I turned my whole life around. I became a singer for the Lord."

In 1952, Frieda moved to the United States to revive her singing career. She also believed it was safe from anti-Semitism. Keith unfortunately passed away, and eventually she married Ben Roos and settled in North Carolina. Her daughter Felicia lives in California and has two grown daughters.

After losing a great deal of her hearing in her nineties, Frieda stopped singing and listening to music altogether. "It was very painful," she said of adjusting to life without music. But Frieda has not allowed this to stop her from experiencing other forms of art. Frieda taught herself to paint and still creates exquisite tapestries of nature and animals. Her specialty is birds— brightly colored and exotic, like the ones she admired as a child.

Frieda has slowed down some since turning 100, but she has not retreated from public life. She is often invited to speak about her experiences, and receives numerous requests from the media for interviews. She also keeps up regular e-mail correspondence with a lot of people. "Now that I am 100 years old, many think I am around sixty or seventy, and I would like to believe that, but the aches and pains that come with aging . . . we learn to accept them but it is indeed quite a learning process," she said.

ELI ZEBOOKER

Philadelphia, PENNSYLVANIA
April 4, 1913

D R. ELI ZEBOOKER AND HIS WIFE JANET HAVE THOUSANDS OF photographs from their travels. There is nary a corner of the globe they haven't visited, and some more than once. Traveling was their shared passion. Every year they would set out on a new adventure, and in between there were also short trips. The Zebookers took their two children, Evan and Nina, along when they were young, and they continued to travel the world well into their nineties.

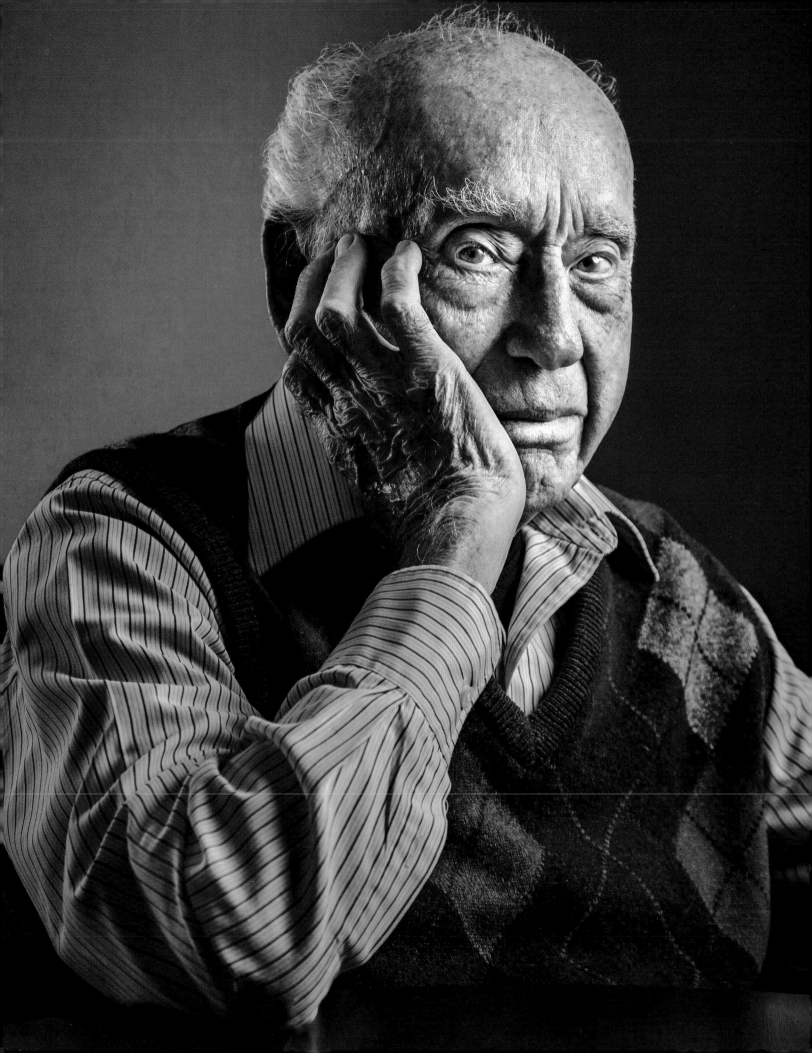

Because he had his own dental practice, Eli was able to schedule his time around the trips that Janet planned. It wasn't a seasonal schedule; rather, the Zebookers went whenever they wanted to go, or based on the best time to visit their desired destination. "Our whole life was doing my job as a dentist and traveling," he said.

Raised in New Jersey with four older siblings—two brothers and two sisters—Eli graduated from Franklin and Marshall College in Lancaster, Pennsylvania, in 1935, then attended the University of Pennsylvania dental school. During that time, Eli was a member of the US Army Reserve Dental Corps. Then, in 1940, he was called up for active duty. World War II was underway.

"We know our time is short... We don't worry about what is going to happen."

Eli served in the 20th Armored Division in Europe and his unit arrived at Germany's Dachau shortly after it was liberated in 1945. Eli was the first dentist to examine survivors in the concentration camp. He remained in the area with his division for a few days while waiting to be transported to Japan via the United States. But the war ended before they reached Japan and within days Eli's military career came to an end—as quickly as it had started five years earlier.

Eli and Janet met in Philadelphia—she was a patient in his brother-in-law's office and he was practicing nearby. They fell in love, married in 1947, and raised their two children. Eli opened his own practice and for fifty years ran a successful dental office, caring for patients of all ages. He has never regretted his decision to be a dentist. "I loved to do it and fortunately I had a relationship with everyone," he said.

Although the Zebookers continued to travel after his retirement, they chose cruises, which allowed the chance to explore places they didn't want to navigate by car. The couple cruised the Mediterranean, the Polynesian islands, the Alaskan coast, the Amazon, and even up the Yangtze River in China and the Danube River in Europe. That's just a partial list. The Zebookers were on the go for many years until it became too difficult for Janet to travel.

Now, they do a lot of reading. They subscribe to *The New York Times*, *The Wall Street Journal*, *National Geographic*, *Smithsonian*, and several other publications. "I keep up to date, I know what's going on, I read them all," Eli

said. Still, he doesn't allow the prevalence of bad news to get under his collar. He considers himself a "passerby" now. "At my age you try not to worry," he said. "In fact, you should not worry because there is nothing you can do about it anyway. I can't change anything in Europe, Africa, or Asia. I can't change anything that goes on in America, or that goes on in Philadelphia. I can't change anything. I am an individual. I can't go out and get people together."

When Eli isn't reading, he's researching. And when he's not researching, he's writing. Recently, he completed his third book and he's looking for a publisher. The topic is ancient Greek history, prior to 1194 BC, and it contains all of the myths. His first book was an illustrated handbook for young dental patients and their parents. His second was a departure from dentistry: *Heracles, a Tragedy: William Shakespeare from His Complete Works*, written under his pseudonym, Philip Ely, in 2004. In this work Eli selected lines from the works of William Shakespeare to create a tragedy in five acts depicting the life of Heracles.

Even with his writing endeavors and voracity for reading, as well as his active hobbies, such as golf and tennis, for many decades Eli made time to collect rare books, prints, and maps on Philadelphia's history. In 1976, he became a shareholder of the Athenaeum of Philadelphia, and in 1998 endowed a book fund there. Finally, in 2010, Eli donated his entire collection to the Athenaeum. It's known as the Eli P. Zebooker Collection. An exhibition featuring selected pieces was held at the Athenaeum in 2011.

Indeed, Eli has had a rich, rewarding life, and he doesn't see an end in sight. "I am an optimist at 103," he said. "Janet and I will celebrate our sixty-ninth anniversary this year." Eli has barely slowed down in 100 years. He has remained healthy, walking one and a half miles every day, rarely needs a cane, and still eats and drinks without limitation. And his memory is exceptional. He clearly remembers marching in parades with Civil War veterans in 1922, and celebrating the end of World War I in 1918.

He prefers phone calls and handwritten letters to e-mails—in fact, he doesn't use the Internet at all. "I communicate with someone when I talk on the telephone," he said. But even better? Visiting in person, especially with his family. Although two of the Zebookers' three grandchildren live outside of Philadelphia, they see them regularly. The family is close-knit and gathering together is a favorite pastime. "We [Janet and I] know our time is short. We enjoy what we are doing and what we can. We don't worry about what is going to happen," he said.

MOSELLE ROSENTHAL

Garden City, SOUTH CAROLINA
July 11, 1909

MOSELLE ROSENTHAL WAS EIGHTY-six when she retired from her job as a travel agent, and that was only after the agency burned down. For more than thirty years, Moselle explored the world, meeting interesting people in exotic cities. She remembers a trip to Africa when a monkey jumped in the backseat of the car she was riding in. Luckily, she was in the front seat. In Afghanistan, she was strip searched for drugs. Then there was the one and only time she used her Latin skills. She met a Portuguese woman and neither spoke the other's language, so they reverted to Latin and had a long conversation about life and family.

Moselle was raised in the Midwest by parents who encouraged all of their daughters to get an advanced education. The family moved from a small Kansas town to a larger one, and then to Austin, Texas, to be close to the University of Texas. Moselle's mother, Rose, and all her sisters attended the university—three of them graduated from the business school. Although it wasn't common at the turn of the twentieth century for women to pursue advanced degrees or a career, there was never a question in Moselle's mind that she'd forsake either just because she was a woman.

When it was time for Moselle to go to college, she chose to pursue a bachelor's degree in journalism at the University of Nebraska. She was at the top of her coed class, earning her a liberal arts scholarship to New York University. After graduating, she was offered a job as a journalist, but turned it down when she learned she'd be covering parties, weddings, and funerals. "That's what women did in those days. But I didn't want to be on the sideline," she said. Instead, Moselle accepted a job in marketing and advertising at B. Altman, a major retailer in New York.

When the Great Depression hit, Moselle was laid off from her job. She moved back to Texas to get her bearings, but returned to New York a year later and married a journalist who worked at *The New York Times*. They had two daughters (Harriet and Carol), lived on Long Island, and were settling into a nice family life when her husband unexpectedly died at the age of forty-seven from a heart attack. Suddenly, Moselle was a single mother in need of work. With her journalism degree Moselle was able to immediately land a job at the *Times* as a stringer—her deceased husband's replacement. She covered the police beat. She said it was OK but the job was nothing like what she'd imagined as a journalism student.

Realizing that her opportunities as a female journalist were limited, Moselle left the profession and took a job at a travel agency in New York. She never looked back. "I was a great traveler. I loved to go to new places and meet new people and see new customs. That was the thing I liked the best," she said. Moselle made her way around the world multiple times. She's pretty sure she went on every cruise in the world at some time during her career.

After retiring, Moselle moved to South Carolina to be close to her family. It was a big change in lifestyle after spending more than fifty years in New York. Still, she managed to settle in, make friends, and find ways to exercise her rabble-rouser spirit. She became interested in genealogy and formed

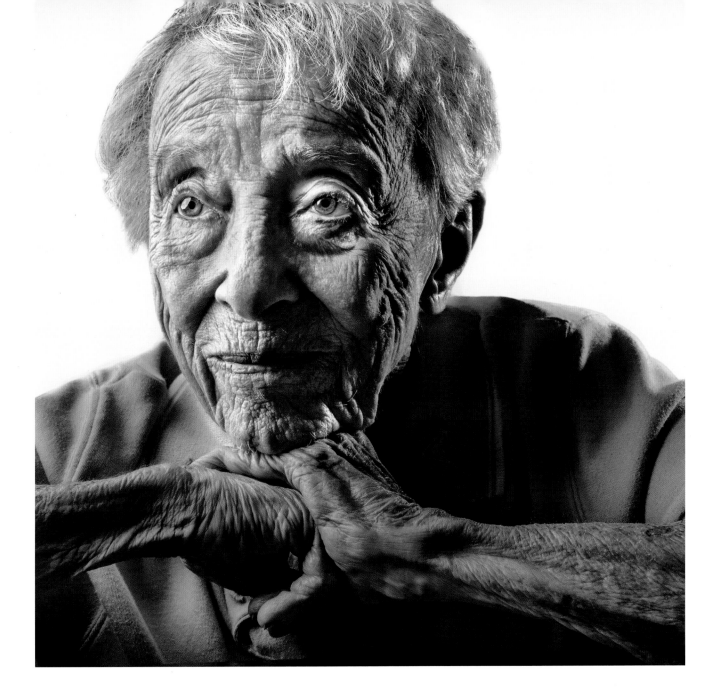

clubs in her complex. At the age of ninety-nine she got her first tattoo—a small butterfly on her ankle. When she turned 100, Moselle decorated the other ankle with a flower. "I decided to walk on the wild side," she said. Tired of lifting her pant legs up to show them off, she splurged on her 101st birthday and got a larger sunflower tattoo on her forearm. Although she hasn't traveled for a number of years, Moselle satisfies her wanderlust in daydreams, and likes to listen to others tell their travel stories or offer trip advice to friends who ask.

If given the opportunity, Moselle would like to take a trip to the moon. Many years ago she'd been on a tour and saw a landscape that looked like the surface of the moon. "Of course, that was long before anyone went there. But it was just the thought of it that got me interested," she said.

Moselle doesn't have any regrets; she has experienced the full gamut of life and her plucky spirit is still intact. She wakes each day happy to see the sunrise. "As long as I keep doing that, I'll be fine," she said.

JOHN STEPHENSON

Santa Fe, NEW MEXICO
August 3, 1914

J OHN STEPHENSON DIDN'T RETIRE TO PURSUE A LIFE OF LEISURE. Instead, he started farming, a dream he'd had since childhood. He dedicated the operation to sustainable agriculture and charitable giving, and now Santa Fe Community Farm is the oldest and one of the last remaining farms in Santa Fe, New Mexico.

John was born in Santa Fe in 1914. New Mexico had only been a state for two years, and the city was a small agricultural community with plenty of water sources and a good growing season. His parents had moved to the Southwest from Iowa hoping to cure his father's tuberculosis, but he died when John was two. His mother remarried and she and John's stepfather worked for the Santa Fe telephone company—his mother as the operator and his stepfather handling all outside work. "They *were* the phone company," said John.

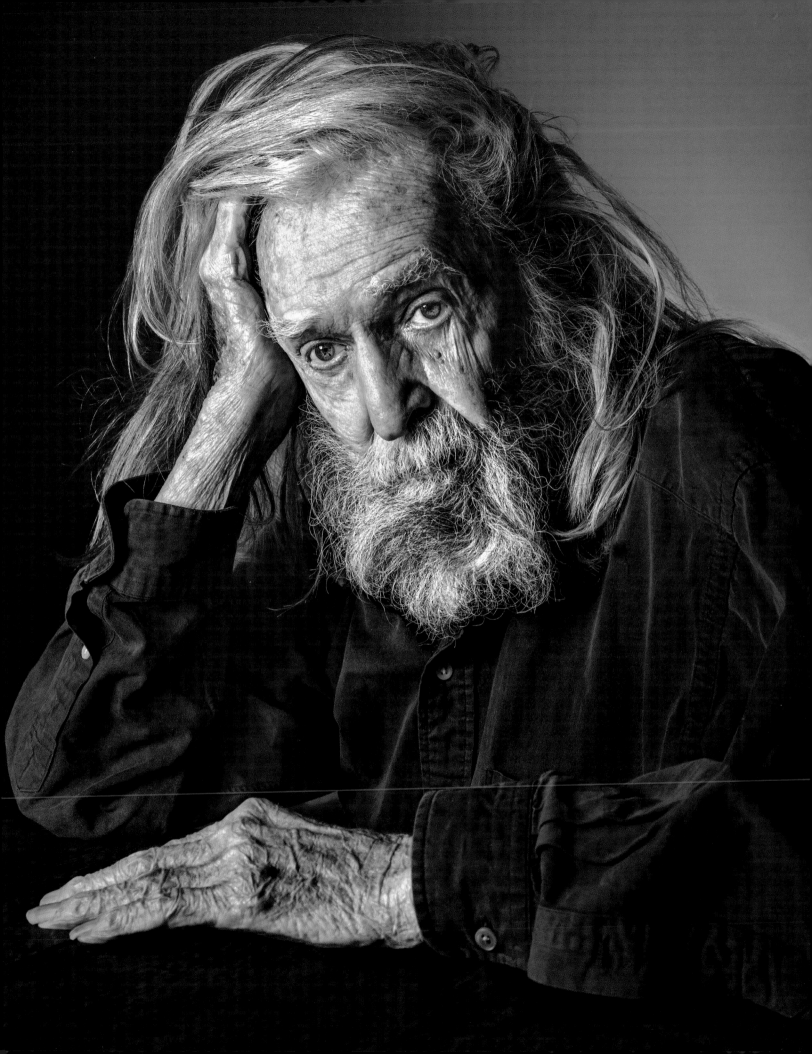

Athletic and ambitious, John played sports in high school and was one of the first boys in New Mexico to become an Eagle Scout. After studying forestry at Colorado State University, he took a job in Deadwood, South Dakota, as a member of a field crew for the Rocky Mountain Experiment Station. He joined the US Cavalry so he could ride horses and later became an instructor for the ROTC at Colorado State University. But six years into his military career, World War II broke out.

John was sent to Europe and on three separate occasions unwittingly escaped death and injury. The first time, he was spared from the infamous Bataan Death March in the Philippines because of a last-minute change in his unit assignment. Then his unit was split into three parts; he was not in the one that perished on a torpedoed ship. In Marseilles, he was told he was going to Japan as the war shifted to the Pacific. But he avoided that hazardous assignment when, instead, he was sent to the small town of Arles in the south of France.

Feeling that he'd been spared for some purpose, John decided he'd return home and give back to his community. He took a job with the US Forest Service patrolling the backcountry on his horse, Ginger Ale, during the summers and on skis in winter. While John and his wife, Katherine, were raising their two sons, Roy and David, they acquired five acres of land and then sold it to purchase a larger and more fertile piece of property in an area called Agua Fria. They drilled a six-foot well at Agua Fria Springs, securing groundwater for a farm, planted new trees, and purchased a flock of chickens. For several years, they ran an egg business and Katherine delivered the goods to grocery stores in Santa Fe.

After retiring at age fifty-one, John dedicated his time to running the farm. He took up ceramics and swam at the public pool every evening at 5:00 p.m. There he became acquainted with a group of children with various disabilities. One season when the farm produced an abundant crop, Katherine suggested that he invite the children out to the farm. After sending them home with heaps of fresh, organic food, John and Katherine decided they would give more to their community. Within a short time they were regularly donating their surplus produce to various organizations. In 2014, Santa Fe Community Farm gave 15,000 pounds of fresh, organic produce to the hungry and homeless in Santa Fe. That's an impressive legacy to create in one's retirement years.

Even in his sixties, John was still athletic and fit. He took up weight lifting to rehab an injured shoulder and within a couple of years he was competing on a national level. Then he went international and won. By the time he retired

from competitive weight lifting in his eighties, John had several shelves lined with trophies.

Still, the farm flourished, and John and Katherine increased their giving and added educational and volunteer programs. People came to help on the farm, working side by side with strangers from around the world. "Families, people doing community service work, college kids coming for spring break—all sorts of different groups and individuals still come out to be a part of John's legacy and farm," said Roy. "And it has helped a lot of people."

In 1986, Katherine died following a tragic car accident. She and John were the same age and had been married for forty-six years. Following her death, activity slowed at the farm for several years, but then it eventually regained momentum and started producing and donating more food than ever before.

John continued to give generously to his community—both at the farm and at other nonprofit organizations. His charitable spirit did not go unnoticed. In January 1994, Santa Fe recognized him as a "Living Treasure." In 1999, John was named one of the "thousand points of light" by President Bill Clinton, and then Oprah Winfrey featured him and his farm in a two-minute segment on her program. He has also been named as one of *The Santa Fe New Mexican*'s "10 Who Made a Difference."

John has slowed down considerably since his days of weight-lifting competitions, but he still goes out to the fields to visit with the volunteers when he can. He eats the produce fresh out of the ground—as he always has. (Roy said his dad rarely sat at the table.) The kids and young adults who come to the farm are drawn to him. He's often asked what has contributed to his longevity and he'll say his healthy diet and working outdoors. Or, it could be the well water he has been drinking his entire life. His son, Roy, said it's related to his dad's strict diet and healthy lifestyle: "He didn't smoke, didn't drink—never did. He was always exercising, always walking around." John once told a reporter he thought that farmers lived longer lives. Maybe so. Or maybe it's John's unflappable spirit, his ability to survive and thrive, even in the most difficult times.

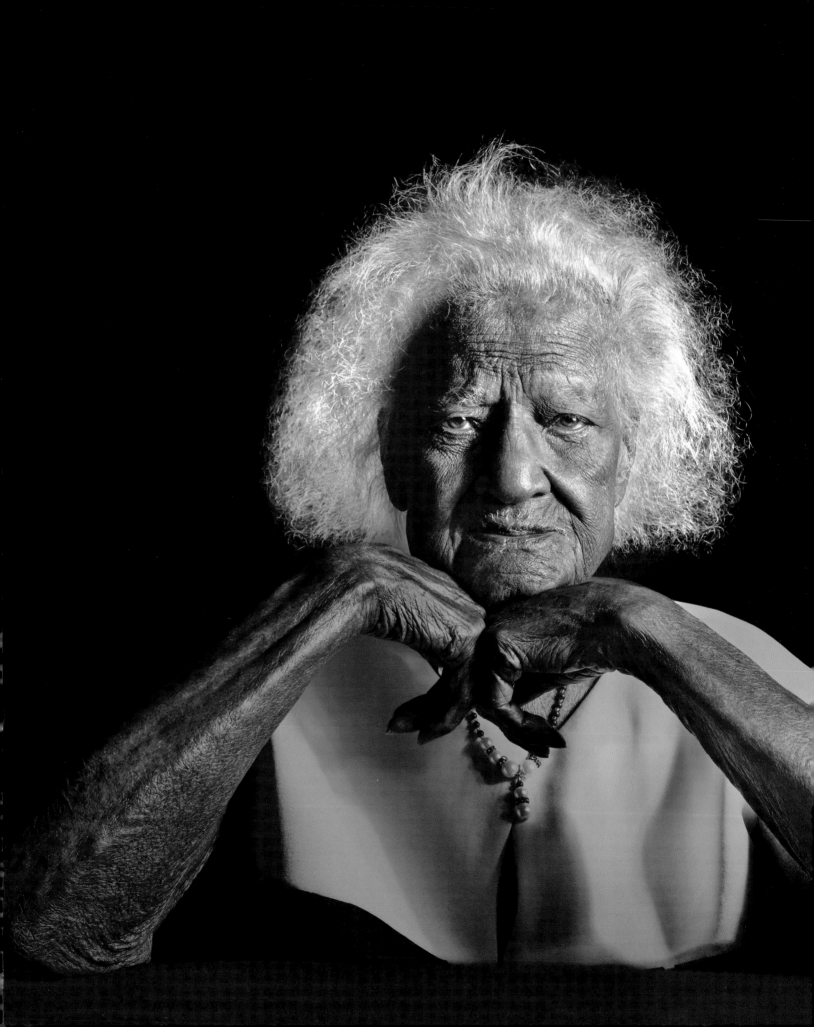

"I'll be here as long as [God] lets me be here."

JERALEAN TALLEY

Inkster, MICHIGAN
May 23, 1899

THE LAST TIME JERALEAN TALLEY WENT BOWLING WITH FRIENDS, she scored a 200. Impressive, considering she was 106 years old. Although she has since given up that sport, she's not yet ready to lay down her fishing rod. Once or twice a year she goes out with her friend Michael Kinloch and her godson, Tyler, and she returns home with a fresh catch every time.

At 116 years, Jeralean has slowed down a bit, but her supercentenarian status hasn't diminished her spirit or enjoyment of life. On most Sundays, Mother Talley, as she's known by the congregation at New Jerusalem Missionary Baptist Church in Inkster, Michigan, prefers to take the stairs to the church sanctuary, rather than the elevator. She still makes her specialty—headcheese, a jellied loaf made of various pig parts—to share with her friends, and she reads the daily newspaper. Until recently, it wasn't unusual for her to spend time in the yard, plucking weeds out of the flower beds.

Born Jeralean Kurtz in 1899, one of eleven siblings, she can say she has lived in three centuries, through numerous world-changing events and life-altering inventions. Jeralean was twenty-one years old when American women earned the right to vote, and as an African American, she spent more than half of her life subject to Jim Crow laws that legalized racial discrimination. She witnessed the civil rights movement, and in 2008 proudly watched Barack Obama be sworn in as the nation's 44th president.

As a young girl, Jeralean spent a lot of time outdoors working in the family gardens picking cotton and digging up sweet potatoes. Even after marrying Alfred Talley in 1936, Jeralean continued to work outdoors. By then, she'd moved from her birthplace, Montrose, Georgia, to Inkster, where she and Alfred grew vegetables and cared for livestock on a small farm.

Her only child, Thelma, was born in 1937. Thelma says her mother never complained. She has always been easygoing, happy, and charitable. She sewed clothing for her family and made quilts, many of which she donated. Her faith has guided her life and she has always been involved in the church. Alfred was a member of the 33rd Degree Green Eastern Stars, a Freemason order, and because of his status the family traveled throughout the country once a year to participate in various Masonic events.

After Alfred died in 1988, at the age of ninety-five, Jeralean lived alone for almost twenty years in the home they had built in 1963. Surrounded by her community and close friends from church, she managed on her own until 2007, when she experienced numerous ministrokes.

Her daughter Thelma had lived most of her adult life in Detroit, where she raised three children and helped raise several grandchildren. When she returned to Inkster to care for her mother, she continued to nurture her grandchildren and great-grandchildren. At times, five generations were living under one roof. But Jeralean enjoys the company of her extended family. She's especially close with the youngest family member, Armmell. While the toddler was living at Jeralean's house, he'd visit her room each morning, telling her that it was time to get up. "They understand each other," Thelma said. "That's her heart."

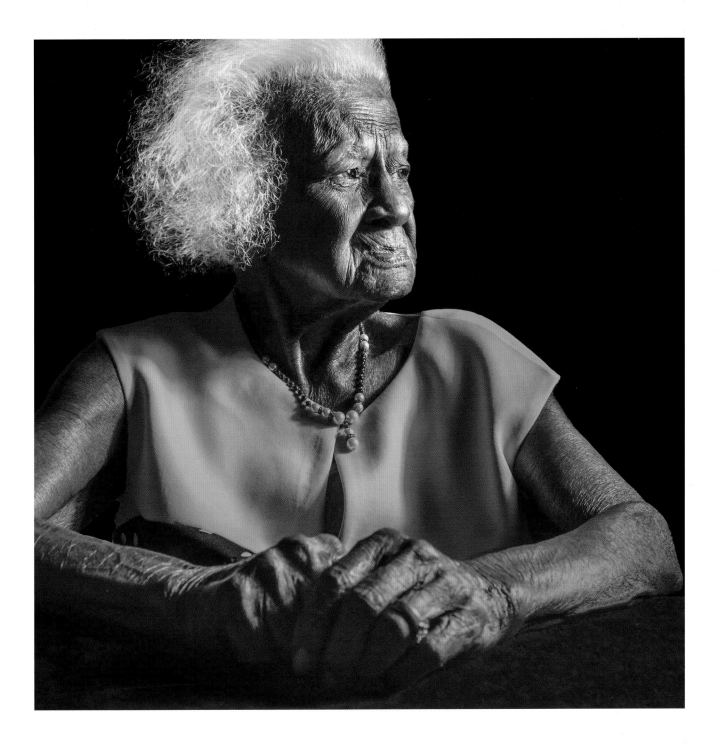

Jeralean's not sure why she has lived this long and she's not in a hurry to go. But she has put that call in the hands of God. "I'll be here as long as he lets me be here. But when he tires of me, he'll take me away," she said. Although her health is good, and she still has a hearty appetite and a lot of spunk, Jeralean accepts that she could go any day. Thelma said her mother prays that she's taken in her sleep. "But the man up there," said Jeralean, "that's who decides."

IRVING PHILLIPS

Los Angeles, CALIFORNIA
October 10, 1914

I**RVING PHILLIPS HAS ALWAYS FELT A DEEP SENSE OF CIVIC RESPONSIBIL**ity. As a young graduate out of Brooklyn Labor College, he became a labor union organizer. After World War II, he attended Harvard University on the GI Bill, and then received a master's degree in economics at the University of Chicago. As a student, Irving remained engaged in civic activities and continued to do so even after taking a position at the United States Department of Labor in Washington, DC. A proud democratic socialist, Irving helped government unions organize and fought for the rights of minority families and individuals.

Irving married Estelle in 1951 and they had three children: Audri, Jonathan, and Mark. For many years, the family lived in one of the few integrated DC neighborhoods. Irving championed integration and led the effort to support it in his area.

After retiring, Irving and Estelle continued to volunteer their time at libraries and civic organizations. Irving had a stroke at the age of ninety-five and subsequently moved to Los Angeles, where Audri resides. Estelle joined him at Belmont Village a couple of years later. Audri described her father as a gracious and kind man. "He is most proud of being a labor union organizer," she said.

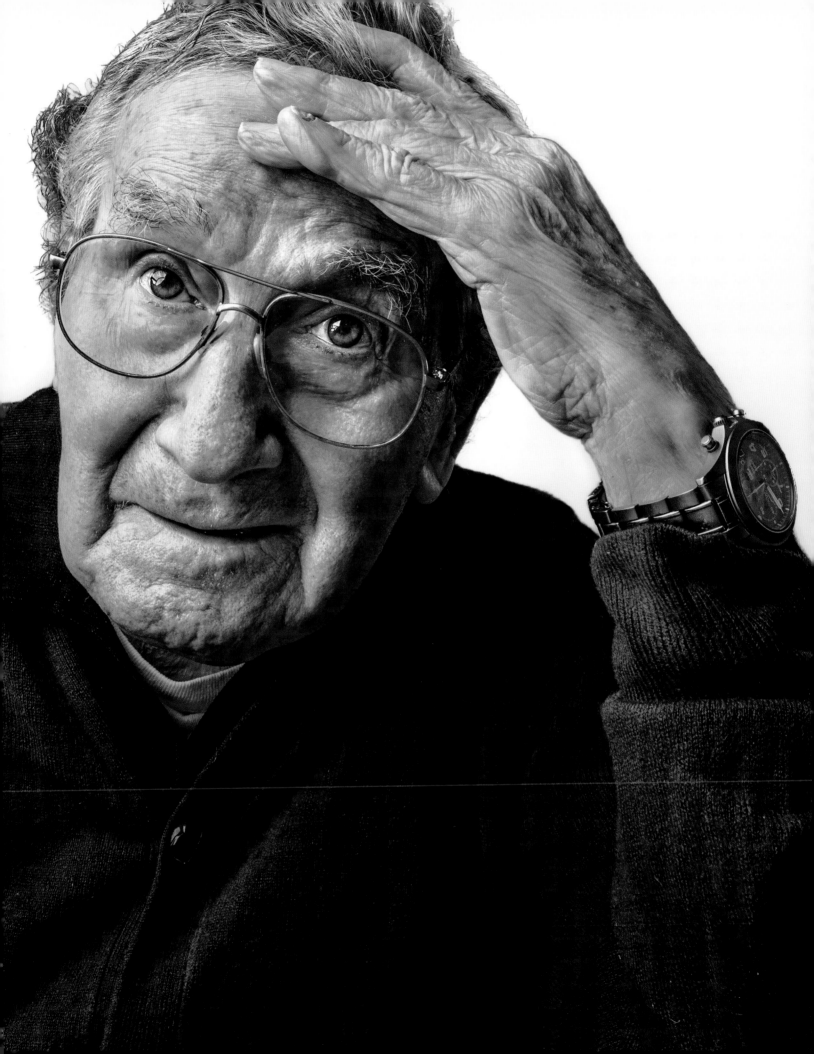

WALTER BREUNING

Great Falls, MONTANA
September 21, 1896

FOR A SPELL, WALTER BREUNING HELD the title for the world's oldest living man on record and the third-oldest living person. He was 114 years old at the time of his death in 2011, and he still holds the title of the third-oldest verified American man.

Walter attributed his longevity to several things: maintaining a healthy weight; keeping his mind and body active; helping others; and always embracing change. He also had longevity in his genes. His paternal and maternal grandparents lived into their nineties and one of his siblings reached 100 years. His supercentenarian status, sharp mind, and ability to recall details from his childhood made him popular with the media. For several years before his death, he was regularly featured in national news stories, and he was the subject of a documentary about supercentenarians titled *Walter: Lessons from the World's Oldest People*.

Walter was a plain-speaking, gregarious gentleman with a penchant for giving advice. He was born in Melrose, Minnesota, one of five children. In 1901, the family moved to De Smet, South Dakota, where Walter went to school until 1910. Walter referred to this time as "the dark ages," because his family was so poor that they lived without electricity, water, or plumbing.

Walter dropped out of school at the age of fourteen and began scraping bakery pans for two dollars and fifty cents weekly. Although he signed up for military service during World War I, Walter wasn't called to duty. By the time World War II broke out, he was too old to serve. In 1918, Walter moved to Montana. By then, he'd been working for the Great Northern Railway for several years as a clerk. Walter had only been sixteen at the time he was hired, but they didn't know. He'd lied about his age. Working seven days a week for ninety dollars a month, Walter was able to purchase his first car in 1919—a secondhand Ford. He paid 150 dollars.

Walter met Agnes Twokey, a telegraph operator, in Great Falls, Montana. They married in 1922 and remained together until her death in 1957. They did not have children. Walter worked for the Great Northern Railway for fifty years and he remained the manager/secretary for the local Shriners club until he turned ninety-nine.

Although Walter had good health throughout most of his life, he did have a health scare in his sixties. In 1960, he was diagnosed with colon cancer. Remarkably, he was treated and the cancer never returned. "They took all the cancer out of me, took out my spleen, mud machine, everything," he once told a reporter.

Walter sailed through the next fifty years in good health. Even after breaking his hip at the age of 108, which required eight days of hospitalization, Walter had a complete recovery. In fact, he remained mobile without the help of a walker or scooter until the last year of his life.

Walter seemed to thoroughly enjoy his supercentenarian status and the notoriety that came with it, but he was also realistic. "We're going to die," Walter told the Associated Press in a 2010 interview. "Never be afraid to die. Because you're born to die."

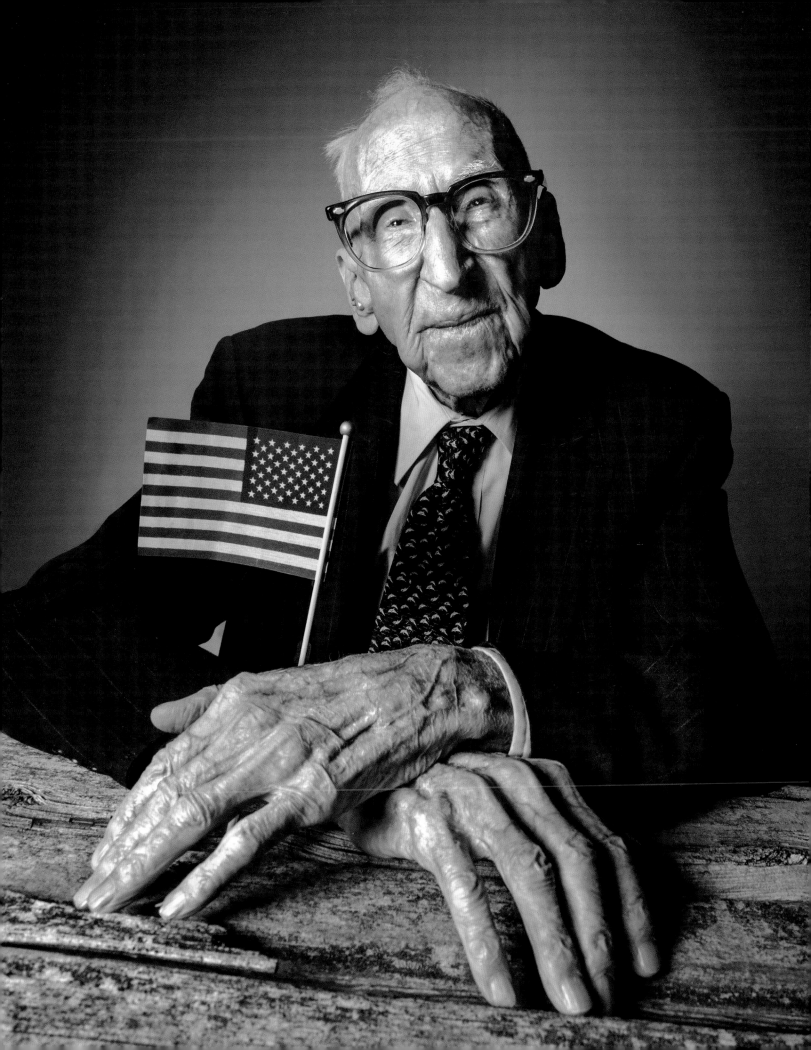

AFTERWORD

Paul Mobley

THIS PROJECT STARTED AS AN EXTENsion of my previous book, *American Farmer*. As I traveled around the country meeting farmers, I was surprised to find that quite a few of them were centenarians. I had always thought if someone lived to age 100, it would be bittersweet—yes, they would hit a milestone that most people would never hit, but I pictured those late years as full of sickness and hardship. I wasn't sure I wanted to live that long myself. But the farmers I met were not only surviving, they were thriving—still working the land, contributing to their family's livelihood, engaging with their local communities. I was completely fascinated by these elders; I found myself wanting to learn all the details of their lives, to find out what inspired them to keep going. At that point, I knew I had found my next project. *I would travel to all fifty states and photograph at least one centenarian in each.*

The challenge I set for myself was a big one: not only the logistics of finding, traveling to, and photographing more than fifty centenarians, but also making sure the photo itself did each subject justice. At this point in my career, I think of myself as a storyteller as much as a photographer, and telling these subjects' stories was really important to me. That said, when you break it down, these photographs consisted of two people who had never met in a small room with a backdrop. Nothing else. That's not a lot to work with. *How could I possibly sum up a century's worth of living and learning in a single portrait?* I knew these images needed to have depth and power, needed to go beyond just a striking image and offer viewers a glimpse of the real individual lives behind each pair of century-old eyes.

Another thing that was important to me during this project was doing most of the traveling on the road rather than by plane. In addition to checking off a bucket-list dream of a cross-country road trip with my wife, I thought it was worth it to take the extra time and effort to explore where these subjects lived. What was a centenarian's life like in rural North Dakota versus metropolitan New York City?

Paul and his dog, Jessie, with Irving Olson, age 102.

Before I even met the subject and took the photo, I wanted to breathe the air, see the scenery, eat lunch at the local diner—get a sense of the community that this person was living in. It wouldn't have been the same project if I had flown in and out of each location in a matter of hours.

The people I encountered during this project were truly incredible. I met a fellow photographer in Arizona, a barber still cutting hair in Michigan, a Nebraska woman who traveled the vaudeville circuit as a dancer in the 1920s—the list goes on and on. I was even incredibly blessed to photograph some *supercentenarians*—a few of which were the oldest people alive at the time of the photo. When I first had the idea for this book, my dad told me to ask everyone, "What's the key to your long life?" I was delighted at the range of answers I received: "Eat three pieces of bacon every day," "Put one foot in front of the other," "Never go to the doctor," and— one of my favorites—"Don't forget these three words: basic human kindness." And I will never forget 114-year-old Goldie Steinberg telling me the key to her long life was a simple phone call from her son at the same time every day.

Throughout this experience, I was often struck by the same thought: all of these people were so full of life! Not once did I walk into a sitting to find someone who was out of it or barely hanging on. Every single person was engaged and eager to share his or her stories. While the facts of each person's day-to-day life differed depending on where they grew up, they all seemed to have one thing in common: *they stayed active.* Not always physically, but they all had something to look forward to—a game of chess with a friend or a daily walk around the neighborhood. I even met a man who was still driving! In the process of meeting these people and taking their photographs, I started to revise my preconceived notions about old age. Rather than anything

Paul with Will Clark, age 109.

depressing, I started to view it as a celebration. Maybe I did want to live to be 100 after all!

Saying good-bye to the subjects was always difficult, as I knew I would most likely never see them again. I was often filled with a profound sadness even though I had just met them. If people would take the time to listen, all of these centenarians still had a lot to say. Inside those small rooms with nothing but a backdrop, I found a vault, and when I opened it I discovered a treasure trove of ideas and lessons on how we can all live gracefully and with meaning as we travel toward our final sunset.

After I finished photographing my last subject on the breathtaking island of Maui, the entire project came together for me. As I drove off, looking at the big orange Hawaiian sky, with some beautiful luau music playing softly on the radio, it felt like the perfect ending to the perfect project. I reflected on the more than two years I had spent photographing people who had lived to be at least 100 years old, and I realized the subjects had all taught me one thing: *to simply live my life.* And that's what I would share with you, the reader. No matter how young or old you are, just live and be happy. If I live to be 100, I can only hope my life is as rich and complicated and wonderful as the subjects in this book.

FOR MY TWO BEAUTIFUL GIRLS, CAMDEN AND PAIGE

ACKNOWLEDGMENTS

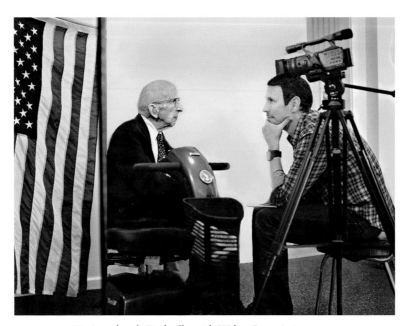

During a break, Paul talks with Walter Breuning, age 114.

I'D LIKE TO GIVE SPECIAL THANKS TO:

Walter Farynk, my college professor who taught me everything I know. I'm still inspired by your invaluable teachings and your reminder that "good isn't good enough."

Lessandra MacHamer, for your friendship and encouragement along the way.

Lena Tabori, for believing since day one.

Norman Lear, for your foreword and participation in my project. It was fun laughing and reminiscing about all of the good times!

Bob Wheeler, Tim Garner, and everyone at Airstream, for all of your support during my journey. Traveling our great country in an Interstate was a dream come true. There is no better way to see the world than in an Airstream.

Chris, Kevin, and Joe at Schumacher Airstream, for all of your assistance and for keeping the bus healthy and happy on the road!

Paul and Vivian Diamond, for your gracious hospitality, friendship, and constant support. Everyone should be so lucky to have friends like you. It was an honor photographing Margot.

Jeff DeBevec and everyone at Belmont Village, for your kindness and hospitality. Your facilities are first class and second to none!

Charlie Grover, for doing all the amazing video footage and being an awesome "road warrior."

Jennifer Kilberg, for being there during the good times and the bad. There is no one better to consult with about this crazy business.

Carl Shortt, for your friendship, assistance, and all the fun in Oklahoma.

Stephen Saunders and everyone at Hidden Light.

Bob Schmidt and everyone at Hoodman.

Ty Hutchinson and everyone at Crossfit, for keeping me healthy throughout this long journey.

Marina Dean-Francis and Rocky Montez Carr, for all of your tireless efforts and incredible talent making my photographs as gorgeous as possible.

The entire team at Rizzoli/Welcome: I am especially grateful to my associate publisher James Muschett, who understood the importance of this work and the lives we touched making this book. Candice Fehrman, my editor, who has been my partner since the start. Your kindness and hard work were seamless during our crazy travels. Even during the toughest times, you were truly an inspiration. It was a joy working alongside you during this project. My writer, Allison Milionis, for your compassion, dedication, and gift with words. My extraordinary designer, Gregory Wakabayashi, who I am truly blessed to know. Your talent continues to astound me. Working with you again has been another highlight of my career. And my publicist, Jessica Napp, for all of your media magic.

Rich Tiller, David Ockerlund, Hunter Weeks, the Bruley family, Jay and Dawn Schlott, Bob Bortnick, Denise Walton, Alex Conley, TC Conroy, Reid Callanan, and Mike Campau, for their friendship, support, and advice along the way.

Mom, Dad, Shawn, and Todd, for a lifetime of love and encouragement.

Jessie, my shar-pei rescue, for all the unconditional love. One of my subjects said one of the keys to long life was to "always have a dog in the house." I understand completely.

My wife, Suzanne. I realize that this life journey would not be the same without you. I'm reminded every day how blessed and lucky I am to have met you. I look forward to living 100 years with you every step of the way. What a road trip it was!

Finally, all of the centenarians I was privileged to meet and photograph. Your stories will stay with me forever. I hope I can share your examples with others I meet along the way.

—PAUL MOBLEY, 2016

The photographer, writer, and editor would also like to thank the following people for their invaluable help and support in connecting us to the subjects in this book:

Judy Abalos • Julie Agan • Gary Agron • Richard Amend • Tara Arancibia • Bonnie Bartlett • Doug Bauer • Greg & Lana Bell • Jordyn Berg Kellie Blue • Debbie Booth • Maya Booth-Balk • Phyllis Boros • Lorraine Boyd • Mary Brewster • Barbara Brotman • Tina Bundtrock • Ted Burfict • John Burgeson • Joe Carroll • Eileen Chao • Anne Chase • Haley Clapp • Rick Cohn • Casey Conley • Paul Cooper • Craig Crosby • Sheila Curley • Allison Currie • Kim Davis • Mark Davis • Blake Deshazo • Ronnie Dessy • Rachel Dickerson • Liz Dietz • Ruthann Dobek • Kelcy Dolan • Jon Ebelt • Harold Elliott • Carole Ellis • Chelsea Embree • Robin Erb • Jeremy Faulkner • Aubrey Ferguson • George Ferriell • Karla Flak • Allyson Floyd • Natalia Fomin • Pete Fontaine • Paige Frank • Rocky Fritz • Belinda Fuller • Christina Galloway • Steve George • Randy Giancaterino • Sunny Gibbs • Laurel Gifford • Donna Gilson • Susan Gold • Sue Grayson • Chris Green • Roger Gregory • Ola Griffin David Grunfeld • Janelle Hackett • Sherry Haddaway • Janice Hamm • Moishy Heller • Shirley Henri • Carol Herrmann • Elaine Higgins Jim & Lynn Higley • Thelma Holloway • Loren Holmes • Chris Houck • Cindy Hudson • Ron Hudson • Bonnie Huey • Vicky Ingersoll • Greta Jacobsen • Anita Jamieson • Flo Jaramillo • Stephanie Jenkins • Kim Jones • Lamona Jones • Stepheny Keith • Jill Kelton • Dan Kittredge Anne Koedt • Richard Koyama • Jeremy Krashin • Allison Krug • Peter Kutner • Setsy Larouche • Joy Leach • Eric Levenson • Stephanie Levine Bobbi Lochansky • Robert Lucas • Ed Maglisceau • Carmela Malerba • Doug Manning • Jim Massey • Meredith McCarthy • Heidi McNeeley Natasha Menier • Lorna Miller • Taylor Missan • Kiyomi Mizukami • Kathy Montgomery • Pamela Moore • Robert Morrison • Sue Mulder Brandy Murray • Hans Neas • Robert Nott • Crystal O'Gorman • Connie Oldham • Jean Oldham • Carmela Olguin • Connie Owen Don Parker • Sandra Pennecke • Alecia Perez • Mary Perez • Rob Perry • Sherry Petera • Carl Peters • Audri Phillips • Camille Phillips • Joe Pierpont • Sarah Plummer • Kristin Puckett • David Quick • Ruthy Rabyne • Kathryn Ray • Greg Reilly • Annita Reimer • Dennis Ricci • Tyler Richardson • Jean Robinson • Dale Rodebaugh • Mary Rossetti • Julian Saul • Matthew Saul • Richard Saville • Ellen Schneeweis • Alexia Severson • Bill Sexten • Brian Shane • Pam Simpson • Jennifer McGowan Smith • Dan Spinelli • Carrie Stadheim • Roy Stephenson • Sheryl St. George • Kristi Thielen • Samantha Vicent • Mark Vieth • Lonna Vopat • Claudia Warner • Sarah Webster • Cate Weeks • Jody Weinberg Connie Weishaar • Janice White • Ed & Mary Williams • Paul Woody • Morgen Young • Nina Zelevansky • Richard Ziglar • Anthony Zompa

SENIOR LIVING

This book would not have been possible without the support of Belmont Village Senior Living.

AIRSTREAM

Paul Mobley's travel for this project was done in an Airstream Interstate.
A special thank you for their support.

———————————————

Welcome Books®
An imprint of Rizzoli International Publications, Inc.
300 Park Avenue South
New York, NY 10010
www.rizzoliusa.com

Additional photography credits:
Pages 212, 213: Suzanne Bruley; Page 214: Cindy Cieluch

Book Design: Gregory Wakabayashi
Project Editor: Candice Fehrman
Essays and Interviews: Allison Milionis

2016 2017 2018 2019 / 10 9 8 7 6 5 4 3 2

Printed in China

ISBN-13: 978-1-59962-135-7

Library of Congress Catalog Control Number: 2016938441